Contemporary Calligraphy

Contemporary Calligraphy

How to Use Formal Scripts Today

GILLIAN HAZELDINE

*For Jean
with love
Jilly*

Robert Hale • London

© Gillian Hazeldine 2011
First published in Great Britain 2011

ISBN 978-0-7090-8745-8

Robert Hale Limited
Clerkenwell House
Clerkenwell Green
London EC1R OHT

www.halebooks.com

The right of Gillian Hazeldine to be identified as
author of this work has been asserted by her
in accordance with the Copyright, Designs and
Patents Act 1988

A catalogue record for this book is available from the British Library

10 9 8 7 6 5 4 3 2 1

Design by root2design
Layout by Eurodesign
Printed in China

Contents

Acknowledgements

Special thanks to Stan Knight, who allowed me to copy parts of the manuscripts in his book *Historical Scripts* for use in the chapter 'A brief history of writing', for his help with that chapter and for lending me the images of the manuscripts used throughout the book.

The manuscripts are reproduced by kind permission of the following:

The Victoria & Albert Museum, London. Sonnets of Pietro Bembo in Italian (Ms. L. 1347–1957)

The British Library, London. The Ramsey Psalter (Harley Ms 2904), The Benedictional of Aethelwold (Add. Ms. 49598), The Stonyhurst Gospel (Loan Ms. 74)

The Society of Jesus. The Stonyhurst Gospel (Loan Ms. 74)

Bibliothèque Nationale, Paris. The Second Bible of Charles the Bald (Ms. Lat. 2)

The Mobium Corporation, Chicago. Photograph of the Catich cast of the Trajan inscription

The Welsh englyn used in the chapter on Uncials is from *A Celtic Miscellany*, translated by Kenneth Hurlstone Jackson, published by Penguin Classics in 1971 (page 126, no. 75)

Thanks to my colleagues who generously lent their work for inclusion in the book.

Thanks also to Chris Holmes for his photography, Studio Arts, Lancaster and Lamberts Print & Design, Settle.

Last but not least, thanks to my students for their enthusiasm and encouragement.

MP 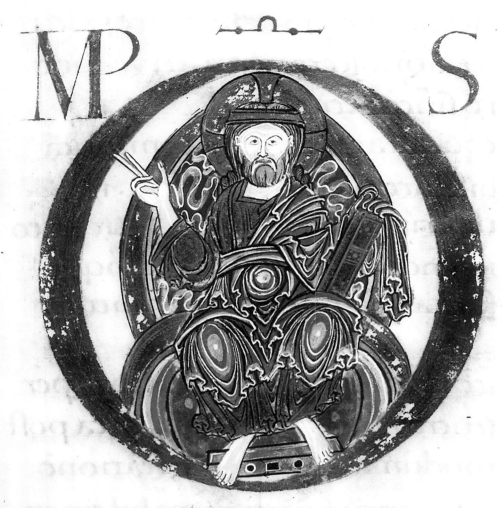 S

TRINITAS

VNVS ET VERVS

DS · PATER ET FILIVS ET SS SCS ·

Introduction

Calligraphy in the twenty-first century is both a craft and an art form. The professional scribe today needs to be able to design and execute formal documents such as a Freedom of the City Scroll or a Roll of Honour. These will perhaps incorporate heraldry and/or illustration, requiring drawing and painting skills. There might also be gilding, the careful laying of gold leaf on an expertly laid base of gesso, as used by medieval scribes, or on a modern medium such as PVA.

He or she will also be required to produce work for exhibitions and to work to commission, solving the design problem that is a client's brief.

During the twentieth century the emphasis was on formal skills, but at present calligraphy is being pressured more and more to shed its formality and become part of what is loosely named the 'Letter Arts'. Painterly techniques are used, layering and collage, with lettering often of secondary importance in the work. Legibility is now not necessarily important and 'gestural mark making' is admired and taught. There is some very fine work being done which is painterly in the extreme, but the best work is made by those who are highly trained calligraphers in the first instance, so they know absolutely how far they can push the boundaries. Aesthetics are still paramount.

A craft or art which doesn't change with the times dies, and it can only be healthy that there is a lively debate in lettering circles as to what the future should be, especially in this age of the computer. But there *has* to be a place for good lettering done with passion and the skill acquired through training.

This book has two aims. The first is one to help the beginner to start and then to progress. There is basic information on tools and techniques that you will need to begin. There are careful exemplars of some of the major scripts mentioned in the historical section. It is hoped, too, that the person with a bit more experience will find these exemplars useful to fine-tune their writing and help to eliminate the careless habits that slip into everyone's work from time to time. It never hurts to go back to basics. Second, the scripts in the book have been carefully chosen as being those capable of most adaptation and variation for contemporary interpretative work, and if you work from the formal script, you will be able to move on to use your letters better to express emotions or circumstances through words.

It should be emphasized that you need to master the historical scripts first. Only through a complete understanding of these forms and how the pen works in the making of them can you begin to adapt them, assess what you are doing and make informed design decisions. In any skill you need to learn the rules thoroughly before you can begin to bend them. There is, unfortunately, a misconception that because calligraphy is 'just writing' and we can all write, it will be easy. It isn't. The most frequent remark made to me when students begin in my classes is 'I had no idea there was so much to it'. It requires regular *purposeful* practice and, as in anything, the more you practise, the better you will become. When I say purposeful, I mean, as soon as you can, write words you enjoy and make things, small things for friends or family. Don't just copy out alphabets and *never* practise one letter again and again in isolation.

Opposite:
Trinitas page from the Benedictional of Aethelwold, written in southern England in the tenth century

Gillian Hazeldine
Sit in Reverie
(Text by Henry Longfellow)

Letters based on the display
capitals of the Bury Bible

Gouache, metal nibs
23 x 17.5 cm

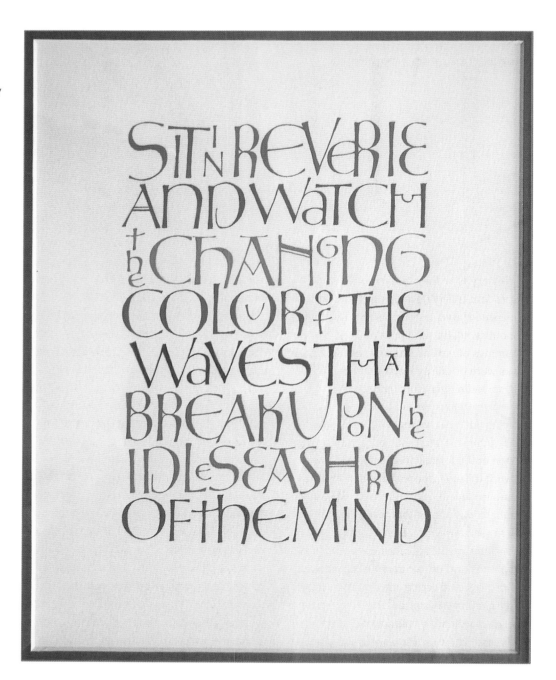

Calligraphy is a technical skill, an intellectual pursuit and a sensuous craft. There is nothing quite like the feel of a sharp nib on good paper, the smell of freshly ground ink, or colour flowing freely through the pen, making beautiful shapes.

Add to that working with words you love, and you have the perfect creative experience.

I hope this book will help you to achieve this.

A brief history of writing

TRIB

Roman capitals

The history of writing is fascinating, with scripts continually developing and changing, influenced by factors such as religion, economics, society and politics. From the beginnings of writing on papyrus and vellum, books were primarily made in the service of God, spreading his Word, and those who wrote them, monks in scriptoria, were carrying out a sacred duty. By the end of the Middle Ages the Word of God was still being written in the formal bookhands of the day, but with the emergence of the merchant classes trade and commerce had increased and there was a need for more people to be able to read and write. Businesses had to be run, estates managed, commercial and legal documents drafted, written out and copied. The professional scribe emerged, and alongside him the 'stationer', the bookseller whose co-ordinating role supported the scribe and who was also able to commission books for sale.

As calligraphers, we model our formal writing on historical scripts; the letters we use in contemporary work are based on those in manuscripts written from the Late Antique period and the Renaissance. But the single most important letterform, that from which so many written scripts derive, is the monumental Roman capital, the finest example of which is the inscription on the base of Trajan's Column in Rome. This inscription was designed using a flat-edged, chisel-shaped brush, which established the distribution of weight and the serif form, and was then carved into the stone. Scholarly opinions vary as to whether the design and cutting were done by the same person. W.R. Lethaby says in his preface to Edward Johnston's seminal book *Writing and Illuminating & Lettering*, 'most of the great monumental inscriptions were designed *in situ* by a master writer and only cut in by the mason, the cutting being merely a fixing, as it were, of the writing'. Nicolete Gray, in her book *A History of Lettering*, disagrees, arguing that the great letter cutters of the twentieth century, Eric Gill and Reynolds Stone, designed and cut their own letters and so 'there is no reason why the *ordinator* and the carver should not have been the same person'.

It is testament to the superb design of the Trajan letters that they are the basis of many of our current typefaces and we use these capitals, almost unchanged, nearly two thousand years after their design in ad 113.

Scribes throughout the centuries have looked back in admiration to Roman Monumental capitals, in particular during the ninth century, when Caroline scribes adopted them for use, using similar proportions, but perfecting the 'building up' of these letters, using compound strokes. Humanist scribes also used Square capitals and some of the most beautiful examples from the Renaissance are the letters of Bartolomeo San Vito, a late fifteenth-century writing master.

The Romans used two formal bookhands, Rustic capitals and Square capitals. Fine examples of Rustic Capitals still survive painted on the walls of Pompeii, which was destroyed by the eruption of Vesuvius in AD 79.

Square capitals share some of the proportions of Monumental capitals, with letters falling into width groups, but the **M** and **N** are very wide. In one of the only two surviving manuscripts written entirely in Square capitals, Codex Augusteus, the **R** has a thin upright and the **A** is written without a crossbar, both features of Rustic capitals. These letters create an imposing texture on the page and were very slowly written with many changes of angle. In complete contrast, the Rustic capitals written in Codex Palatinus are compressed, elegant forms, taking up much less space on the page (and using less precious vellum). Again, the pen angle is

Square capitals

Rustic capitals

changed a great deal in the writing of the letters of this manuscript. The stems are slim, done with a high pen angle, swinging in the course of the stroke to a lower one to make the characteristic feet. Rustic capitals, too, were copied by scribes in the eighth and ninth centuries for use in headings and they appear as late as the eleventh century in the Arundel Psalter.

In the fourth century, Christianity was adopted as the official religion of the Roman Empire and the monasteries that were built after that time and the monks who lived and worked in them are largely responsible for the preservation and development of writing in the West.

The period after the break-up of the Roman Empire in the fifth century is known as the Dark Ages. During this time there was, given the difficulties of travel at the time, a surprising amount of traffic between the monastic communities of north-east England and Rome, and books were brought back from Rome to be copied and the Word of God spread.

The dominant script of this period is the Uncial, a majestic, very round and very legible form. The British Library has in its collection the Stonyhurst or St Cuthbert Gospel, which was found in the tomb of St Cuthbert in AD 1105 (he had died in AD 687) in perfect condition. The writing in this little book is a 'natural' Uncial, written with an edged tool held at a slight angle to the writing line. Other Uncial forms, such as that in the Vespasian Psalter, written between AD 725 and AD 750, are 'artificial': that is, written

'Natural' Uncial

'Artificial' Uncial

with a flat pen angle, with a great deal of manipulation of the pen on serifs and additions of hairline strokes done with the corner of the quill on letters such as **a**.

In the years following the break-up of the Roman Empire, many different scripts developed throughout Europe. Ireland was never conquered by Rome so remained outside its influence, and Irish scribes developed a beautiful and singular script called the Insular Half Uncial, which they then brought, via Iona, to the north-east of England. The two outstanding manuscripts in this script that survive today are the Book of Kells, written c. AD 800, it is thought at Kells, County Meath, and the Lindisfarne Gospels, written c. AD 710–21 at Lindisfarne.

At least four scribes were responsible for the writing in the Book of Kells, but a tenth-century colophon to the Lindisfarne Gospels, written by Aldred, a monk describing himself as an 'unworthy and most miserable priest', tells us that 'Eadfrith, Bishop of Lindisfarne Church, originally wrote this book, for God and for Saint Cuthbert ...' Both books are

astonishing in their artistry, ingenuity of design and execution of the great decorated pages, with the need on the part of the scribes among all their other skills to understand chemistry in the preparation of pigments.

The Lindisfarne Gospels was 'glossed' by Aldred, with an English translation of the Latin, written in an Anglo-Saxon minuscule, inserted between the lines of the main text.

In 768 Charlemagne became king of the Franks, assuming control of an empire which included what is now France, Germany, Austria, the Low Countries, part of northern Spain and a large part of Italy. Under his influence, one of the most important developments in the history of writing came about; the first minuscule script.

Charlemagne initiated a revival of education and learning and a revision of church service books. He encouraged a huge increase in the copying of books, not only liturgical but also the classics. He surrounded himself with scholars and intellectuals, including the

Insular Half Uncial

Englishman Alcuin of York, one of the foremost scholars of the time, who became Abbot of St Martin's in Tours from AD 797 until his death in AD 804.

In the scriptorium at Tours a new script with its roots in Half Uncials was perfected, the first fully developed minuscule, which later became known as Carolingian or Caroline minuscule.

This new minuscule, based on a round **o** shape, was capable of being written more quickly than capitals, leading to a slight forward slant and an absence of pen lifts between some letters. Ascenders and descenders were long, 1½ times the height of the **o**, so arrangement on the page was spacious. Ascenders were clubbed.

The scriptorium at Tours produced nearly 100 bibles between AD 800 and AD 850, among them the magnificent Moutier-Grandval Bible. This very large manuscript clearly shows what is known as 'the hierarchy of scripts' where several scripts were used, with precedence being given to the oldest. Thus Square capitals were used for headings followed by Uncials, with the main text being written in the Caroline minuscule. Capitals within the text are Uncials and small built-up Square Capitals, set into the margins, begin the verses.

By the tenth century, England was beginning to recover from the ravages of the Viking raids, and monastic life, which had been severely damaged, began to be revived. Winchester became a centre for learning and

Carolingian minuscule

con folari

English Caroline minuscule

angeli dni

the copying of books, and it was here in the late tenth century that an English scribe wrote the Ramsey Psalter in an English version of the Caroline minuscule. This manuscript is important to contemporary calligraphy because Edward Johnston, who rediscovered the art of the broad pen at the beginning of the twentieth century, chose it as 'an almost perfect model' for a modern formal hand. The writing is more upright than Carolingian, less cursive, larger and supremely legible.

By the twelfth century, writing was showing the beginnings of Gothic compression, Romanesque roundness giving way to angular shapes. By the fourteenth century lateral compression had become extreme and the predominant script, Gothic Textura, very difficult to read. In words such as 'animam', with the exception of the letter **a** every stroke was the same, becoming **m** or **n** or **u** according to a small linking hairline at top or bottom. The round minuscule **s** came into common use during the Gothic period, used only at the end of words, the long **s** being used at the beginning or in the middle of a word. With all the austerity of writing during the Middle Ages this was the high point of painting and illumination, and manuscripts such as the Sherborne Missal, with its naturalistic paintings of birds, and the Luttrell Psalter, which through its marginal paintings of everyday life at the time

Gothic Textura

Bastarda

provided valuable information for scholars, are outstanding examples of the skill and artistry of the men who produced them.

In the fourteenth century, with the increased ability of the layman to write, a script developed that was a blending of informal cursive writing and Textura. This flamboyant script, Bastarda, became extremely popular, eventually being elevated to bookhand status, used for many large and lavishly illustrated volumes.

Italy and Spain didn't adopt the extreme compression of the Northern European script, developing their own version, Rotunda, a curious blend of roundness and angularity.

In the early fifteenth century, Humanist scribes, in an attempt to restore clarity and legibility to writing, looked back to Carolingian manuscripts as models. Humanist minuscules are the basis of many of our modern Roman typefaces. Eventually, through the skill of scribes such as Niccolo Niccoli and the writing masters Arrighi, Tagliente and Palatino, a more rapidly written Humanist minuscule developed and was perfected as the forward sloping, and therefore more compressed, extremely elegant script we call Italic.

The invention by Johannes Gutenberg of printing using moveable type between 1450 and 1455 began the decline of writing books

Rotunda

Italic

by hand, although initially there was still plenty of work for illuminators and those scribes who produced legal documents. The secretary hand became predominant in sixteenth-century England. By the seventeenth century writing with the edged tool had died out, being replaced by the engraver's burin and later by the flexible pointed metal nibs that came into use in the nineteenth century. The current revival in edged-pen writing was begun by William Morris, but the 'father' of modern calligraphy is Edward Johnston, who studied manuscripts in the British Museum, leading to his being asked to teach at the Central School of Arts and Crafts in London. Many of the leading scribes of the twentieth century were his students and in Britain, if not in the US, his influence is still considerable.

In the last thirty years computer technology has revolutionized the printing industry and desktop publishing has replaced much of the work of the modern scribe. But there is, among the best graphic designers, the recognition that handmade letters are unique, with a life and character that a computer font or 'script' cannot imitate. Many contemporary scribes have embraced the computer as a valuable design tool in commercial work. But there is still a place and a need for calligraphy of the highest quality at both professional and personal level, and long may this continue.

Tools and equipment

Board

Your board and how you sit at it are important both for the quality of your writing and for your physical well-being.

A sloped board is essential as you will be using a dip pen; gravity will pull too much ink out of the pen if you write flat and you won't achieve the characteristic thicks and thins of calligraphy.

Your board can be a fairly expensive piece of equipment, adjustable for height and with a parallel motion, or you can use a piece of MDF Light (Medium Density Fibreboard) to begin with. If you opt for MDF, have it professionally cut to size and the edges sanded smooth. It should be at least A2 size (60 x 42 cm).

Contact between a metal nib and a hard surface is unpleasant, so pad your board with at least two sheets of blotting paper. (Ensure you buy it flat or rolled; if it was folded, the crease will be right in the middle of your writing surface.) Tape the blotting paper all round with masking tape. When you are working, it is important to protect your paper from the natural greases in your skin. Use a guard sheet at all times, either a sheet of paper taped across the board or, if you prefer, a piece of folded paper under your writing hand (see Figure 1)

If you begin with an MDF board, you can sit with the edge of the board in your lap and prop it against a table or desk. This arrangement will suffice until you progress to finished writing on larger paper. Then the

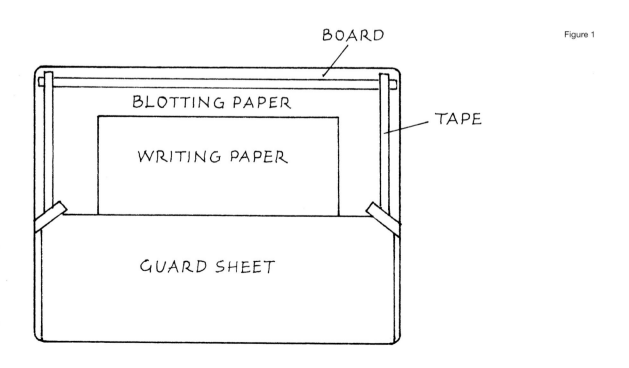

BOARD

Figure 1

BLOTTING PAPER

TAPE

WRITING PAPER

GUARD SHEET

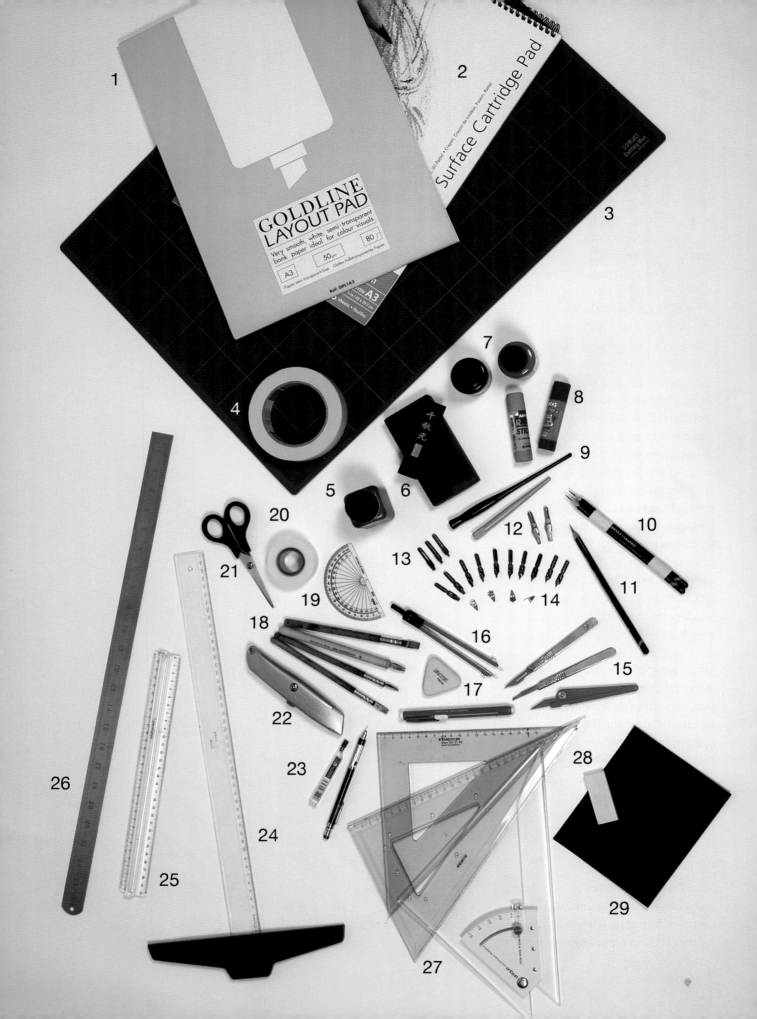

GOLDLINE
LAYOUT PAD

Very smooth, white, semi-transparent
bank paper ideal for colour visuals

80

A3 50gsm

Ref: GPL1A3 A3

Surface Cartridge Pad

board will have to be propped against some books or similar objects on the table so that the length of paper can pass between the edge of the board and your lap as you write. Be careful not to crease the paper with your forearms. To avoid the board slipping, use some Blu-Tack under the foredge. With either type of board, the table or desk on which it rests mustn't be too high. You should be able to sit comfortably with your forearms on the board, writing at a point about two-thirds of the way up the board, without hunching your shoulders. Sit with your back as straight as possible with your feet flat on the floor. It is also important to move your paper as you write, so that you are writing directly in front of yourself. Twisting the body from side to side will cause back, shoulder and neck problems. If you are right-handed, have the light source from your left and if you are left-handed, from the right. Daylight is best, particularly when working in colour, but you may well need some supplementary light, in which case try an Anglepoise-type lamp with a daylight bulb.

Many medieval images of scribes writing depict an almost vertical board, but for our purposes, using metal nibs, an angle of around 30° from the flat surface is ideal. Steepen this angle if you want to limit the ink flow, for instance if your pigment is thin, or if you want to write very slowly, and flatten it slightly if you are using gouache, which, being thicker, might require a bit of help from gravity to flow well.

Nibs

Roundhand steel nibs come in ten sizes, from 0, the largest, to 6, the smallest. There are two manufacturers, William Mitchell and Leonardt. These nibs need a reservoir affixed to the underside so that they hold a pool of ink. William Mitchell nibs, when new, have a protective coating which helps prevent the steel from rusting prior to purchase. This needs to be removed before use as it causes the ink to retract, and you can do this in one of two ways: either dip the nib in boiling water or pass it briefly through the flame, of a match (have the nib in a holder for this). A quick count of four, turning the nib in the flame will suffice – don't cook it! Leonardt nibs don't have this coating and the sizes vary very slightly from Mitchell, which can be useful.

The reservoirs for both these nibs are made from thin, flexible brass, so don't expose them to flame. They are not inter-changeable, so you will have to buy the dedicated reservoir for your make of nib.

The reservoir sits on the underside of the nib and its fitting is very important. Too tight on the nib and it will not allow the tines of the pen to open, restricting ink flow; too loose and it will fall off, and there is never a convenient time for that to happen! Adjust the fitting by easing apart or tightening the small lugs on the underside of the reservoir. You should be able to move the reservoir back and forth with your fingers, encountering *some* resistance, and its tip should sit lightly touching the nib, about 2 mm back from the end (see Figure 2). Two other types of nibs are available from mail order calligraphy suppliers, Brause, manufactured in Germany, and Speedball, an American nib. These nibs are right-oblique as opposed to square cut and both have reservoirs supplied with them, on top of the nib. They are very different in performance, the Brause being stiff and inflexible and the

Opposite:
1 Layout pad; 2 Cartridge pad; 3 A3 cutting mat; 4 Masking tape; 5 Higgins Eternal black ink; 6 Chinese stick ink and stone; 7 FW acrylic inks; 8 Glue sticks, both permanent and repositionable; 9 Penholders; 10 Two HB pencils put together as double pencils; 11 H pencil; 12 Speedball nibs; 13 Brause nibs; 14 Mitchell nibs and reservoirs; 15 Scalpels and craft knife; 16 Dividers; 17 Erasers, both soft plastic and 'click' eraser; 18 Automatic pens; 19 Protractor; 20 Removable magic tape; 21 Scissors; 22 Stanley knife; 23 Propelling pencil and leads; 24 T-square; 25 Plastic ruler; 26 Long steel rule; 27 Set squares including adjustable set square; 28 Arkansas stone; 29 Crocus-grade emery paper.

Figure 2

Speedball, at least in the bigger sizes, very flexible indeed. I wouldn't recommend either nib for the absolute beginner, but for the more experienced they allow for variable pressure, twisting and manipulation.

Ink

For most practice and for formal work you will require black non-waterproof ink. There is a wide variety of bottled inks on the market, ranging from very thin (fountain pen ink such as Quink) to thick and glutinous. My own preference for practice is Higgins Eternal, a thinnish ink which flows well through the pen and which washes off my hands at the end of the day. There is nothing worse than inky fingers for days! Avoid acrylic inks for the most part, although FW is useful for some techniques, and waterproof ink. Acrylic is a type of plastic and waterproof ink has shellac in it; both, when dry, will be impossible to clean off the pen. 'Indian ink' generally means waterproof. 'Permanent' means lightfast. Higgins Eternal is permanent, non-waterproof ink.

For finished work I grind my own ink from a good quality ink stick. Be careful when buying an ink stick; too cheap and it will produce a gritty substance which will never go truly black. You will need an ink stone,

and in order to achieve black ink you will have to roughen the surface of the stone with some 400–600 grit wet and dry paper. Drop a measured amount of distilled water from a dropper on to the stone and then, holding the stick upright, work the end in a circular movement in the water. Time the length of grinding and note the number of drops of water used and you will be able to reproduce exactly the density of ink next time. Freshly ground ink will keep in cold weather for a few days, but in summer it will need to be ground every day. The smell of Chinese ink is one of the pleasures of being a calligrapher.

Essential equipment

Try, when you first start, to limit your purchase of equipment and tools to what you will actually need. The following is a list of what I would consider necessary. Throughout the book I will tell you about other materials that are needed for various projects and techniques.

Penholders

It will be to your advantage to have each nib you use in its own penholder, with its own reservoir attached. My preference is for a short, round, plastic holder, with plastic housing. If you buy a holder with metal housing, ensure that you don't allow it to get wet, otherwise nib

and housing will bond together with rust. The nib should be pushed into the holder so that you have about 3 mm between the holder and the shoulder of the nib.

Pencils

An H or a 2H pencil for ruling lines. An HB for drawing letters; two HB pencils for double pencil letters. A propelling pencil with spare leads is a clean, accurate tool.

Protractor

Essential for checking pen angle.

Ruler

Buy at least an 18 in or 46 cm ruler, preferably a 24 in/60 cm.

Set square

For ruling lines and for right angles and vertical lines.

T-square

If your board doesn't have a parallel motion, this will make your life much easier; ruling up will require measurements at only one side of the paper.

Automatic pens

Automatic pens come in larger sizes than nibs. The most useful, I find, are the no. 3, the no. 3A and the no. 4.

Metal straight edge or ruler

For cutting. Don't use plastic rulers or set squares to cut, you will damage their edges.

Self-healing cutting mat

At least A3 size.

Eraser

Scissors

Craft knife with spare blades

I use a Swann Morton handle size no. 3 with no. 10A blades for cutting, no. 15 blades for erasing.

Stanley knife

For cutting thick boards.

Glue sticks

Both permanent and repositionable.

Masking or low-tack tape

Scotch Removable Tape is extremely useful.

Dividers

These can be useful for ruling measurements.

Small Arkansas stone or some very fine wet and dry paper

For sharpening nibs.

Paper

There is a separate section on the wide range of paper available to the calligrapher (see page 173), but for initial practice work you will require a good quality A3 layout pad. Don't buy anything smaller than A3; you must be able to work without the edges of your paper making you feel constrained. As soon as possible, buy some good quality cartridge paper, so that you experience what it is to write on paper that has a 'tooth'. The paper you eventually write finished work on will have a 'tooth', and moving from layout paper to good paper for the first time on a finished piece of work is a recipe for disaster. Never work on cheap paper where the ink bleeds through to the back and feathers.

Getting started

The first thing to say about starting calligraphy is, don't be impatient. It's a skill similar to learning to play a musical instrument, and if you started the piano today you would not expect to be able to play a Mozart concerto in a couple of weeks' time. You need to learn the scales before you can improvise!

When you work first with a pencil, make sure it is sharp and treat it as a drawing tool, using light pressure. It is preferable to learn to sharpen pencils with a craft knife instead of a sharpener; they will stay sharper longer and the wood will be cleanly cut.

Working in pencil for first practice letters, don't rub out if you make a letter you consider is less than the perfection you are aiming for. Make another one, so that you can compare and see if you are improving. Try to compare every letter you make with the one before and the one after, so that, from the start, you are developing your critical faculties. The difference between a beautiful form and a not-very-good one can be minuscule. You need to be able to *see* that tiny fault, analyse what has caused it and then correct it.

Keep your nibs clean. Have a jar of water to hand and from time to time, especially in warm weather, rinse the nib and reservoir. Dry nibs thoroughly when you have washed them. They are made of steel, and will quickly rust, left wet. Use an old toothbrush and warm water, but no soap, to clean nibs if, for instance, you are changing from using ink to paint. Soap leaves a film on nibs which acts in a similar way to the protective coating mentioned previously and will affect ink/paint flow.

Pen hold

If you are right-handed, hold the pen between thumb and forefinger without any overlap, resting on the second finger. You can either curl the ring finger and little finger into the palm of your hand or you can rest the second and ring finger on the little finger so it is the little finger and the side of your hand that is on the paper. The shaft of the penholder should cross just above the knuckle of your index finger. This high pen hold is important as it gives you a clean contact with the paper and any pressure on the nib won't distort it. Many beginners to calligraphy hold the pen with the holder resting in the 'valley' between thumb and forefinger. With this position you are writing on the underside of the nib, giving a 'spongy' feel, and if you press hard the nib will splay open, limiting ink flow and causing frustration. Make a fist of your fingers; you must have the flexibility to pull from the top of a stroke to the bottom using only your fingers. If you are right-handed your index finger should be convex.

If you are left-handed, all of the above pertains, but your index finger will be concave. Left-handedness should not be a problem; many of the top calligraphers are left-handed, but your board set-up and the way you work will have to be different. The right-handed person writing with an edged tool has freedom of arm movement, the elbow being held slightly away from the body. To achieve a similar freedom, the left-hander needs to work out to their left. Look on this as something of an advantage; working thus, you have to *feel* what you are doing, almost more than seeing. Too often the right-handed scribe forgets to concentrate on feel.

Almost all calligraphy is done with the pen held at an angle to the line. The biggest potential problem for you as a left-handed scribe will be achieving the higher pen angles. Using a left-oblique nib, rather than the square cut, will help. Tilting the paper up to the left may also help although this can cause problems with vertical strokes.

In all formal scripts letters are made by pulling strokes towards you. The underarm position is to be recommended for a left-handed calligrapher, but some left-handed people write using the hook position. In this case, strokes are pulled away from the body instead of towards it. It's not impossible to be a calligrapher and write thus, but it makes gauging letter widths and spacing much more difficult.

Experiment to find what working position suits you best. Be assured that a lot of the initial difficulties in starting calligraphy are common to both right- and left-handed people.

Height/weight ratio

If you look at several manuscripts from the same period, so comparing the same script,

the writing will differ in that it was written by different scribes and perhaps even in different countries, but generally the weight of the letters will be similar in relation to their height. This is called height/weight ratio, which simply means the height at which a letter is written relates directly to the size of the tool that was used.

Height/weight ratio is one of the great variables in calligraphy, allowing us to change the essence of a word on the page from fragile and delicate to heavy and aggressive, using the same script, but in order to learn from the formal scripts we need to imitate the original scribe. The formal exemplars in this book are written at, or very close to, the height/weight ratio in the manuscript the lettering is based upon.

The measurement for height/weight ratio is the nib width, the measurement across the end of the square-cut nib. To calculate the correct height and weight for your letters, and thus the width of lines that you will need, turn the pen to make a right angle with a horizontal line and carefully create a set of 'stairs' with one stroke accurately set on another, not overlapping and keeping them

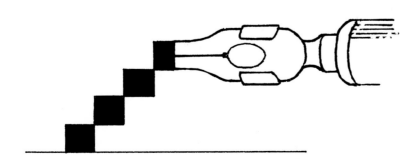

Figure 1

all horizontal. Figure 1 shows the process for a height/weight ratio of 4 nib widths, which is the weight you will be using for the first script in the book.

To rule up at this height, you need to transfer the measurement to your page. Accurately rule horizontal lines top and bottom of your 'stair'. Fold a piece of paper cleanly on its long edge and, using a very sharp hard pencil, transfer the measurement to the folded edge. Move the folded paper up, matching and transferring marks until you have quite a few marked measurements along the fold. Now transfer these measurements carefully to one side of your writing paper and using a T-square or a set square and ruler, rule your lines. For the transferring of marks, use a small, light horizontal line. Twirling a pencil for a dot will put a graphite mark into a little depression and it will be impossible to erase. Measurements for ruling should be done outside the writing area but on occasions they will need to be within and will need subsequently to be erased.

I won't pretend that I don't use a ruler to measure up. I do, but for formal work I will do as described above to ascertain the height/weight ratio and then if it corresponds *exactly* to a measurement in millimetres I will proceed with that, marking off a ruler edge. You must be very accurate (and use a good ruler) using this method; you'd be surprised at just how much visual difference there is between a letter made at 6 mm high and one made at 5 mm, or even 5.5 mm. You must always know what your height/weight ratio is.

A word about lines

Lines are used to keep your writing straight and are important if your letters all need to be the same size, for example on very formal work. As your level of skill increases and you begin to do more personal work, you will want to write more freely, with perhaps only one guideline or without any guidelines at all. It's impossible even for the most skilled calligrapher to write without lines and achieve letters of *precisely* the same size, but the rhythm of writing and the physical sense of the tool on the paper as it makes its mark will produce letters that vary only slightly in height, and that variation makes the letters appear to move, to dance on the page, very different creatures from letters contained within lines.

Asking someone near the beginning stage to write without lines is asking them to stand on shifting sand; you need lines. What you have to learn is to *use* them, not to let them constrain you. Try from the outset to break through the lines slightly, top and bottom, on circular letters. Figure 2 shows the optical illusion that occurs with an o and an n written within the same lines; the o looks

Figure 2

smaller. Break through the lines only a small amount on the o and the letters look the same size.

Try to learn to enjoy the business of ruling accurate lines; you are going to be doing a lot of it! It's a good way to start your work, to switch the brain off from the outside concerns of your life and clear it for concentration. Never try to work if you are tired, distracted, anxious or upset.

Ruling lines

Tape your paper to your board with strips of masking tape across the top corners. Use a hard, e.g. 2H or H, sharp pencil and don't press too hard. Lines should be visible but not dominant. Hold your pencil at right angles to the page, so that the lead is snugly against the edge of the ruler or T-square. Interlinear space, the space between lines, is another great variable, but for formal work in minuscules you will need twice your writing measurement between writing lines, obviating a clash of ascender and descender. (This space is variously known as 2 'o' spaces or 2 'x' heights.) Do this even for practice; you will feel better about what you are doing if there is space around and between your writing lines. From the outset, rule margins at the sides of your paper so that you don't write from edge to edge and always start your first line at least 25 mm/1 in from the top of the page.

First marks with the pen

To load your pen with ink, you can either fill with a brush, stroking the brush against the edge of the underside of the nib to allow the ink to flow underneath the reservoir, or you can simply dip into the bottle. If you fill with a brush, your ink will have to be at your left

and you will hold the brush in your left hand. If you dip, have the bottle to your right. (Reverse these instructions if you are left-handed.) Dipping is often frowned upon, but I have always dipped into the bottle when practising, not having been told to do otherwise when I started! Working with ground stick ink for finished work, I fill with a brush. Filling with a brush has the advantage of controlling how much ink goes into the pen; if you dip, don't put the nib any further into the ink than the depression on its top; ink in the housing of the penholder will make for messy fingers. Having dipped, shake the nib sharply once over the bottle to expel excess ink (the true test of the reservoir fitting!) and you can if you wish wipe the top of the nib clean.

Now the pen is loaded with ink, the next task is to make it write. Holding the pen as described earlier, with the shaft crossing the knuckle on the index finger, and the full width of the nib in contact with the paper, exert some pressure on the tip of the nib and work it slightly from side to side. This will open the slit sufficiently to allow ink to flow to the edge of the pen and you will achieve a wet, black mark. Pull downwards towards yourself, using the whole arm, not just the fingers, making a vertical stroke. Try another one, again using the little 'wobble' stroke to start the ink flow. This small movement must become part of your writing; every time you put your pen on dry paper it will need encouragement to write. The mark will, in letters, be incorporated into the start 'serif'. Serifs have three important functions: one, they hide the start stroke; two, they neaten the strokes, making them more pleasing aesthetically; and three, they help the eye along the line from letter to letter, aiding legibility. The shape of

the serif in any script usually echoes the shape of the letter **o**, e.g., circular, elliptical, sharpened, and so on. If you put your pen into wet ink for the overlapping of shapes that make up most letters you will find there is no need to use the 'wobble'; wet ink draws ink out of the pen.

Examine your initial strokes. Are both sides crisp, or is one side crisp and the other ragged? There are two sides to the nib and even pressure must be exerted on both to achieve a stroke with sharp, clean edges. The ragged edge means that side of the nib is not in complete contact with the paper (see Figure 3). You may have to adjust the way your hand rests on the paper to correct this.

Pen angle

Pen angle is what edged-pen writing is all about. Hold the pen with its end flat to a ruled horizontal line, make the ink start and pull downwards. You will achieve a stroke that is the full width of the nib. Without taking the pen off the paper and without any movement of your wrist or elbow, pull sideways, parallel to the line, and you will achieve the thinnest mark the pen will make, a hairline. In making this mark you have used a pen angle of 0° . Do the opposite of this: hold the pen at right angles to the horizontal line (you will have to alter your pen hold for this, so the pen itself is at right angles to paper), make the ink start and pull down towards you. You will achieve a hairline. Again without wrist or elbow movement, pull sideways. Your mark will be the full thickness of the nib. As you lift the pen off the paper,

Figure 3

Figure 4

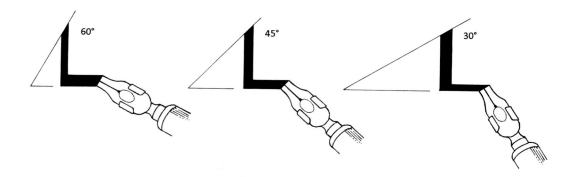

the end of your mark should be a right angle. For this mark, you have used a pen angle of 90° . These two are the extremes. There is only one historical script written with a completely flat pen angle, the Insular Half Uncial, and only the constructed Versals use an angle of 90° for horizontal strokes. The more usual range is between 45° and 25° .

The angle at which you hold the pen to the line governs the weight distribution on a letter. Above an angle of 45° vertical strokes will be thinner than the horizontal. At 45° both strokes will be the same thickness, and below 45° the vertical will be the thicker stroke (see Figure 4). When you begin to write, draw a line at the requisite angle, using a protractor. It is a good idea to rule lines either side of a ruler at that angle across your page so that you have a visual check on what you are doing. More important than this is to look at your letters critically. Is the weight in the right place? If it isn't, your angle is wrong and you will need to work out whether it is too high or too low and adjust it accordingly. Look at Figure 5. It shouldn't be difficult for you to pick out the aesthetically pleasing letters from the two sets of three, even before you have begun to make letters for yourself.

Play around with the pen at this stage, finding out how it feels and what it will do. Try pushing vertically upwards and you will realize why all strokes in making letters are pulled towards you, not pushed away from you.

Practising

When you begin to practise the scripts in this book, use the largest nib that you can, no smaller than a no. 1½ Mitchell nib or the equivalent Speedball or Brause. Those new to calligraphy often think that it will be easier to write small than large, but this is not the case. Writing larger letters makes you *feel* the shapes you are making, and you will soon come to recognize that when your movements feel right, the letter you make will look right. When you are confident of your shapes, you can move down in nib size. Practise the letters in the order they are given as in all cases they are grouped into 'families' in which each letter has the same characteristics. Never practise one letter over and over again; it will be impossible at the end to find which is best. And as soon as you can, practise writing words so that you are relating letters to each other and not viewing them as individual shapes.

Now you are ready to start your first script, and although you will want to make letters with the pen, have patience: your eventual letters will be all the better if you use a pencil first.

nnn ttt

Figure 5

The Foundational Hand

The Ramsey Psalter,
folio 144R

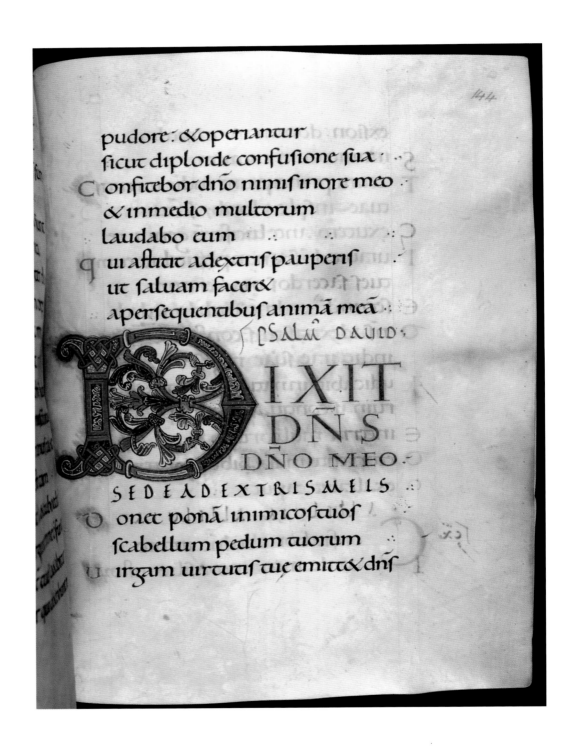

Edward Johnston chose a tenth-century manuscript, the Ramsey Psalter, as a basis for his development of a formal script, calling it 'an almost perfect model for a modern formal hand'.

It is an ideal starting place for someone beginning calligraphy as it uses a constant pen angle of around 30° which is comfortable for both the right-handed scribe and the left-handed scribe. It is also based upon a circle, a shape with which we are all completely familiar. Even if you can't draw a perfect circle, at least you have a clear mental picture of what you are trying to achieve.

Those who write the Foundational Hand supremely well have made in-depth studies of the Ramsey Psalter, analysing the scribe's every move, but as you begin to learn to write, you aren't yet equipped with the skill that this requires and will need a bit of basic information in order to start. Once you have acquired an understanding of the process of

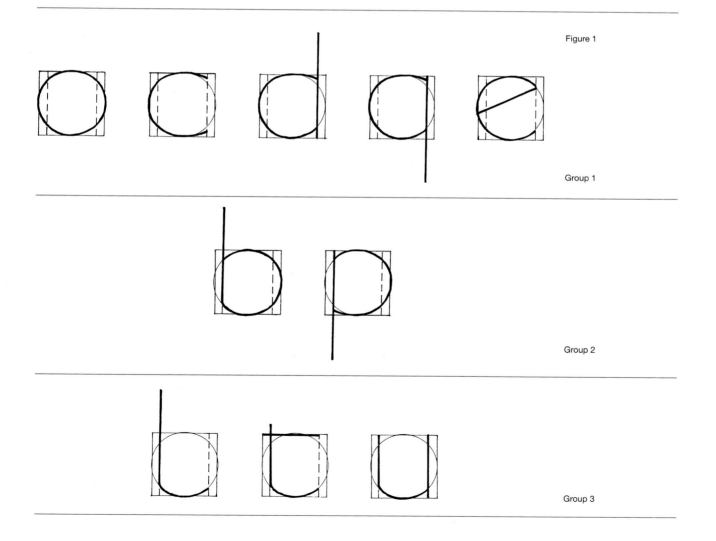

Figure 1

Group 1

Group 2

Group 3

writing a script, doing your own careful analysis of the vigorous and strong writing in the manuscript will help you to develop a personal version of this lovely formal script.

In this script and in Roman capitals, which are used with it, it is useful to work on a geometric framework using monolinear shapes, to begin to understand the proportions of the letters, the sequence of strokes which makes them and the importance of the underlying circle. Rather than work in alphabetical sequence, letters are grouped together in families in which each letter has the same, or similar, shape as part of its make-up.

Figure 1 shows the letters with an underlying geometry in their family groups.

Group 1, which starts with the full circle as the **o**, has letters where the left-hand curve of the circle is the key shape. The tops of **c**, **d** and **q** are flattened off the circle, to keep the **c** buoyant and to avoid a heavy overlap of strokes in the **d** and **q**. The height of ascenders and depth of the descenders is approximately two-thirds of the height of the **o**. The base of the bowl of the **e** touches the back of the letter *just* below halfway.

Group 2: the right-hand curve of the circle is the key shape and the base of **p** is flattened to avoid an over-heavy join. All of the letters in Groups 1 and 2 except the **o** are seven-eighths of the full circle.

Group 3: the lower arc of the circle is the family shape and the letters are three-quarters the width of the circle. The crossbar of **t** sits on the underside of the top of the box, protruding behind the stem to the edge of the square and aligning at the front with the base. The **u** has a strut at its right-hand side. (A pause, without lifting the pen, on **b** from Group 2 and **l**, **t** and **u** before you turn to pick up the circular base shape will ensure strong structure to the letter.)

Turn the **u** upside down and you have the **n**, the 'mother' of Group 4, where the top arc of the circle is key. The **m** belongs in this group as it is two **n**s juxtaposed, making it one and a half times the circle's width. The **a** has a bit of both Groups 2 and 3, having a top and base arc of the circle. Again, all these letters, with the exception of the **m**, are three-quarters the width of the circle.

Figure 1 cont'd

Group 4

Group 5 has two exceptions to the circle, **i** and **j**, both made with single strokes, excluding their dots.

Group 6 puts together three letters that offer a bit more of a challenge. The **f** has the top arc of the circle, so it is a common mistake to make this letter by starting where you would for a straight ascender and putting the curve on afterwards, thus rendering it too tall.

Begin your first stroke slightly lower than for an **h** or **b**. The **f** needs an adjustment for aesthetic purposes. Because the top is partially enclosed, if the crossbar is placed on the top writing line the space below it will look too big and the letter will appear 'hunched'. Lower the crossbar a bit and the counter shapes will balance. (A 'counter' is the space, or white shape, within the letter.) The **s** has a central division, which, if made at

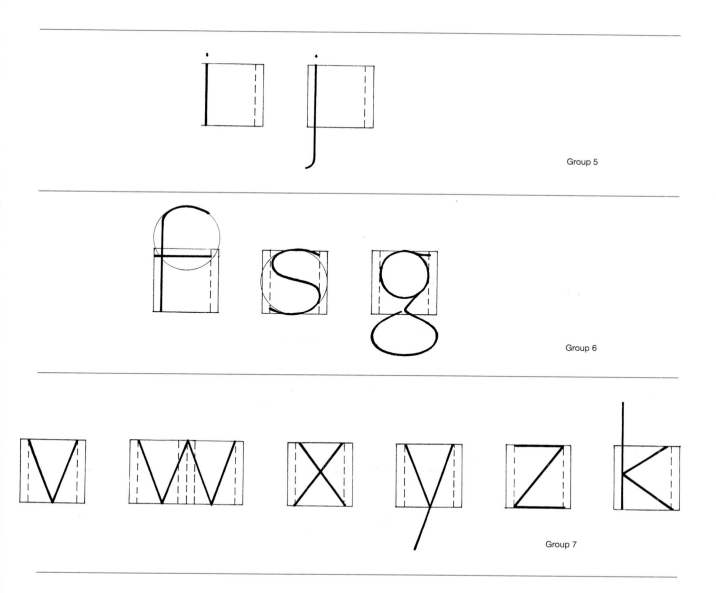

Group 5

Group 6

Group 7

Figure 2

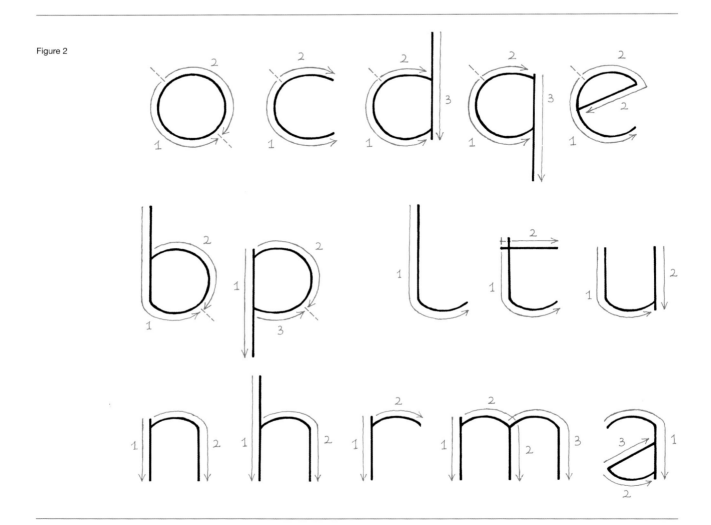

halfway, creates an optical illusion that the top is larger. Thus the top counter of **s** must be made slightly smaller than the base. The top and base strokes are flattened and the base stroke protrudes slightly beyond the top bowl. The letter **g** is complex and you need to avoid making its counters the same shape. The top counter is a circle, but three-quarters the width of the full **o**. The base is elliptical, as wide as the full circle, slightly egg-shaped in that the sides of the ellipse are not precisely the same. The 'ear' on the **g** is

important as it leads the eye on to the next letter.

The final group of letters, Group 7, consists of the diagonals **v**, **w**, **x**, **y**, **z** and **k**. Of these letters only **x** was used in classical Latin, the language of the Ramsey Psalter (although **k** was used to write words of Greek origin). The **w** comprises two **v**s juxtaposed, and so, like **m**, is 1½ times the width of the **o**. The top of **x** is made smaller than the base to balance the counters, as is the top of **k**. The base of **z**

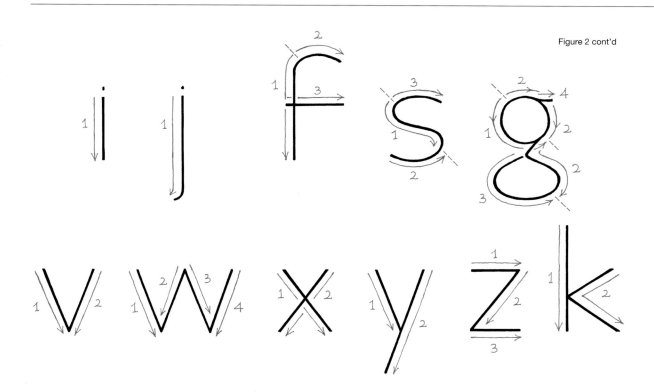

Figure 2 cont'd

protrudes slightly beyond the top to give the impression of a larger counter on the right.

Figure 2 shows the letters still in their family groups, without the underlying geometry and with the order and direction of strokes used to make them. Order and direction of strokes is always from top to bottom and from left to right. Spending time on writing these skeleton shapes will begin to give you an understanding of the relationships between the letters and of their proportions.

Spacing

The spacing of letters in calligraphy is of paramount importance. In writing letters on the page you should be producing an overall even tonal value, the black line being diluted by the white space, avoiding areas of darkness caused by letters that are too close together and holes in the texture due to too much space.

The golden rule for spacing in calligraphy is to put as much space *between* the letters as is *within* them.

Figure 3 shows the word 'ninety', badly spaced. It's difficult to read; without the dot of the **i** the **nin** could be misread as **m** and the other letters appear to be drifting, not part of the whole.

The key space in minuscule alphabets is that within the letter **n**. Between straight-sided letters, e.g. **n** and **i**, the space has to match

Figure 3

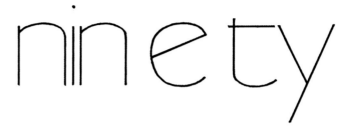

Figure 4

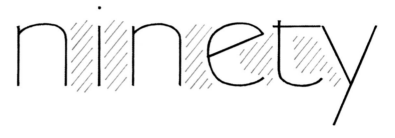

visually that of the **n**. Measuring won't help you here, as the **n** is closed at the top and the space between it and the **i** is open top and bottom. The space required is slightly less than the distance between the strokes of the **n**. Circular letters have space around them and this needs to be taken into consideration. So a circular letter needs to be placed more closely to a straight one to achieve the same visual *area* of space, and on the same principle two circular letters will sit more closely still. The difficulties in spacing arise with letters that are open-sided, that have space as part of themselves – in fact, most of the letters of the alphabet!

Look at the corrected version of 'ninety' in Figure 4. The three straight letters have been spaced with an area similar to that of the **n** between them. The **e** was, in fact, in the correct place against the **n** in the first example, but was made to look 'separate' because of the too close spacing at the beginning of the word. The **e** is open at its base and this space 'reads'. The **t** is moved closer to the **e** and it is the counter space of the **e** that becomes the space between the two letters. The **t** and the **y** both have space within themselves, so they have been placed closely together, almost touching. This closing up of joint counter spaces minimizes their visual impact and makes it look similar to the other spaces within the word. The areas of space have been hatched in so that you can see the similarity throughout the word. Spacing can't be done in the head; you have to get something down on paper first. Having written a word, try to assess it for yourself. Turn the paper upside down so that you are looking at pattern, not reading. Then rewrite, trying to correct anything that was wrong.

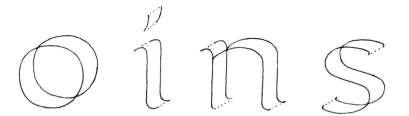

Figure 5

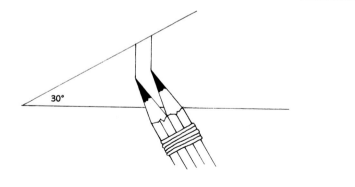

Figure 6

Figure 7

As soon as you can, for practice, move on to writing texts where you experience the way letters and words relate to each other. The space between words should be approximately an 'o' width, but counter space at the end of a word and at the beginning of the next needs to be taken into consideration (see Figure 5).

It is a common fault in those beginning calligraphy to put too much space between words. Space acts as a visual stop, impairing legibility.

Figure 6 shows how the skeleton letters relate to those made by the pen. These letters have been made using double pencils: two sharp pencils of the same grade taped together with their points aligned (see Figure 7). You can shave some of the wood from each pencil to produce smaller letters. This tool imitates the pen, but produces linear shapes that clearly show the structure of letters. Each of the letters comprises two skeleton letters that overlap, one being slightly higher than the other, the result of holding the pencils at an angle of 30° to the

horizontal. The joins of strokes are strong, the individual strokes having been overlapped, and the arch of the **n** blossoms immediately from the stem; there is no 'thin' on display.

Double pencils can be cumbersome, but once you are used to using them they are a very useful tool, helping your understanding of letterform and your ability to assess your own work.

Beginning to use the pen

The height/weight ratio for the Foundational Hand is 4 nib widths and with the exception of the diagonal letters, the pen angle is 30°. Choose a large roundhand nib to begin, either a no. 1 or a no. 1½, and find out what measurement you need, accurately stepping the marks. Rule lines at this measurement, leaving two empty spaces between writing lines. It is a good help to rule lines either side of a ruler at 30° across the page.

Fill the pen with ink, either by filling with a brush or by dipping, ensure the ink will flow with the 'wobble' stroke described earlier and try some basic shapes. The serif form in this script is called a hook, and it, too, is based on a circular shape. The top serifs, those that begin letters, are very important. When we read, we scan the top third of letters, and serifs aid legibility by taking the eye along the line. The serifs also contain the stroke

that starts the ink flow. The serifs that terminate letters are of less importance; they are neatening strokes. Internal serifs should be kept to a minimum to avoid cluttering the counter spaces. Exit serifs can be made slightly larger. (Figure 8)

Figure 9 shows the 'weighted letters', i.e. letters made with an edged pen, still in their family groups, written at a height/weight ratio of 4 nib widths. Move on to writing these letters, using the same movements that you used on the skeleton letters and using the same order and direction of strokes, overlapping your strokes: that is, putting your pen back into the wet ink of the previous stroke to begin the next. Move your arm from the shoulder, without any wrist or elbow movement, so that you achieve a constant pen angle. Look carefully at your letters as you write them: is the weight in the right place? On the circular letters the heaviest part should be across the 8 o'clock/2 o'clock track, with the white counter space tilted on the 11 o'clock/5 o'clock track. The vertical strokes should be heavier than the horizontals.

The diagonal letters require changes of angle. Look at Figure 10, where the red lines indicate the angle that has been used to make the letter: a stroke made with the pen held flat to the writing line will make a mark that is the full thickness of the nib. A vertical

Below: Figure 8.
1 Top hook serifs, with the underlying circle; 2 Basic vertical stroke, with matching serifs top and bottom. This makes the letter **i**; 3 Basic left and right-hand strokes of the **o**, and put together to form the **o**; 4 Basic vertical stroke with rolled top serif and minimal base serif. This makes the left-hand stroke of letters such as **n**, **m**; 5 An **n** where the serif is too large on the left-hand stroke; the counter space becomes less defined.

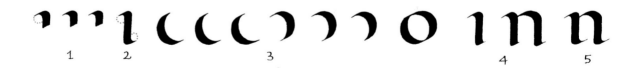

1 2 3 4 5

Figure 9

ocdqe bp

ltu nhrma

ij fsg

vwxyzk

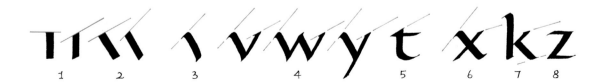

Above: Figure 10.
1 A vertical stroke made with a pen angle of 0° and a vertical made at 30°; 2 A diagonal stroke made at 30° and a diagonal made at around 45°; 3 A left-hand stroke of **v**, made at 45°. Breaking the line slightly at the base and pulling to the left will make for a good apex; 4 The letters **v**, **w** and **y** showing the angles used in their making; 5 The thicks/thins of these letters now match those of the t; 6 **x**, with the left-to-right stroke made at approximately 50° and the right-to-left at approx. 20°; 7 **k**, with its vertical made at 30° and the whole diagonal stroke at approx 20°; 8 The letter **z**, with the horizontals made at 30° and the diagonal with the pen held flat to the line.

Below: Figure 11.
A **w** and **v** made with an angle of 20° throughout. The strokes are too thick and the letters look heavy and clumsy. An **n** and an **o** made with an angle of 65°. The stems of the **n** are too thin; the top of the letter and the serifs are too heavy. The weight on the **o** is at the top and base of the letter and the white counter shape is tilted too far down to the left.

stroke made with the pen held at 30° to the line will make a mark that is approximately seven-eighths the thickness of the nib. (This is the thickness of the stems of your letters so far.) A stroke made in the direction required for the left-to-right side of a diagonal letter, e.g. **v**, with the pen held at 30° will make a mark that is the full thickness of the nib. Thus if you continue to use a 30° angle on the left-hand strokes of **v**, **w**, **x** and **y**, the letter will be heavier than any other letter on your page of writing and will stand out, spoiling the pattern on the page. Changing the pen angle to around 45° will bring the mark back to the correct thickness. The easy way to do this is to move your elbow out slightly if you are right-handed. Tuck your elbow into your side if you are left-handed.

Because of the way the pen works, right-to-left diagonals made at 30° are the same thickness as a horizontal stroke made at 30°. So on **v**, **w** and **y**, steepen your angle for the left-to-right strokes to 45° and revert to 30°

for the right-to-left. For its left-to-right stroke, **x** requires 45° and a flatter angle for the right-to-left, approximately 20°, to avoid an extreme 'thin'. The stem of **k** is made at 30° as normal and then the whole diagonal stroke needs an angle of 20° to give a thin/thick to match the rest of your letters. Never go into the stem of **k** with the diagonal stroke. And finally, the **z** needs a completely flat angle for its diagonal stroke, to produce the correct thickness.

Analysing your letters

I've mentioned previously the importance of looking carefully at your letters, assessing the weight distribution. The 'thin' at the beginning of a serif will tell you what pen angle you have used to make it. If you rule a line through the serif, matching absolutely the thin, you can then measure with a protractor the angle you have used and compare it to the correct angle for that particular stroke. If your letters look wrong, do some analysis and then try to correct your mistakes.

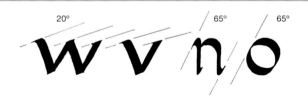

Figure 12

ea cy la rí ry tt ff fl

Figure 13

n. d, e: m; t's y? p! n-t 'ah' (by)

As soon as possible move on to writing words. The spacing rule is exactly as for the skeleton letters. Some combinations of letters can be difficult. Figure 12 shows how to deal with these. Be as self-critical as you can at this stage, checking your pen angle, the crispness of your strokes and your spacing.

When you begin to write words, you will need punctuation. Figure 13 shows the punctuation marks. Keep punctuation as unobtrusive as possible. One of the most successful ways to make something important in calligraphy is to surround it with space. If you use a full stop, pulling it away from the letter it follows, it will become far too dominant. Always tuck punctuation marks against the letter they follow and then space as normal. Keep question and exclamation marks quite small, only half again the height of the writing lines. An apostrophe should cut the top writing line so that it becomes part of the word. Use single

quote marks. Brackets work better in a square format rather than round.

You will also at some stage need numerals. Figure 14 shows the classical numerals, where 3, 5, 7 and 9 drop below the line, 6 and 8 rise above the top line and 0, 1 and 2 sit within the lines. The triangle of the closed 4 looks best if it is just short of the full depth of the writing lines, with the stem just cutting through the base line. Numerals always conform to the underlying shape of the script, in this case the circle. Numerals in dates require slightly wider spacing than letters in words.

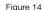

Figure 14

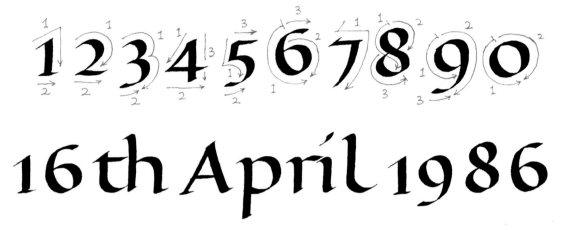

Finally for this chapter, Figure 15 shows a short quote, written with a no. 3 Mitchell nib at 4 nib widths high, with an interlinear space of two 'o' heights: that is, two empty line spaces, the optimum space for minuscules as it avoids a potential clash of ascender and descender. Capitals have been used where necessary (see next chapter). The lines have been centred on a vertical axis. You will learn more about layout later on, but notice an interesting visual occurrence in this small layout: the top line, which is actually the key to the text, has no descenders, therefore the space between the lines appears to be larger than that between the other lines, where there are both ascenders and descenders. This slight extra visual space gives an emphasis to 'The moon has risen', which is pleasing.

Figure 15

The moon has risen.
First it gently illuminates the surface
of the waters, then mounts higher and
writes upon the supple water.

SECOND · SONNET

When forty winters
 shall besiege thy brow,
And dig deep trenches
 in thy beauty's field,
Thy youth's proud livery,
 so gaz'd on now,
Will be a tatter'd weed,
 of small worth held.
Then, being ask'd
 where all thy beauty lies,
Where all the treasure
 of thy lusty days;
To say within thine own
 deep-sunken eyes,
Were an all-eating shame
 and thriftless praise.
How much more praise
 deserv'd thy beauty's use,
If thou could'st answer
 'This fair child of mine
Shall sum my count
 and make my old excuse;'
Proving his beauty
 by succession thine.
This were to be new made
 when thou art old,
And see thy blood warm
 when thou feel'st it cold.

SHAKESPEARE

Richard Middleton
Shakespeare's Second Sonnet

Gouache and steel nibs on
BFK Rives paper
49 cm x 23 cm

This is an early piece of work
by someone who writes the
Foundational Hand
supremely well

Roman Capitals

SENATVSPOPVLVSQVEROMANVS
IMP·CAESARI·DIVI·NERVAE·F·NERVAE
TRAIANO·AVG·GERM·DACICOPONTI
MAXIMOTRIB·POT·XVII·IMP·VI·COS·VI·P
ADDECLARANDVMQVANTAEALTITVDINI
MONSETLOCVSTAN IBVSSITEGESTVS

Above:
Inscription from
Trajan's column, Rome

The capitals which are used with the Foundational Hand are called Roman or Trajan capitals. The letterforms and their proportions are based on a carved inscription in Rome, on the pedestal of a richly carved column commemorating the military victories of the Emperor Trajan. The carving of this inscription was carried out in AD 113 and nearly two thousand years later these letters are still the model on which capitals are based. They have also influenced type design, Times Roman being one among many fonts whose shapes and proportions are Trajan.

The conventional use for capitals is at the beginning of a sentence and in proper nouns but these letters are supremely versatile in that their weight can be altered from light and delicate to heavy and forceful. They can

be packed tightly in textural layouts or can be more conventionally spaced. They can be highly formal or, 'freed up', can be dancing, informal letters.

The most important thing to understand about Roman capitals before beginning to learn the forms is the proportions of the letters. Look at the reproduction of the Trajan inscription and you will notice that the letters are of different widths. Look at the **C**, for instance, and compare it to the width of the **S** or **E**. It is very much wider; almost twice as wide. The reasons for the differences will be explained as we go through the letters below in Figure 1. As with the Foundational Hand, the letters are not shown in alphabetical order but in family groups, this time according to width and with an underlying geometry.

Figure 1

Group 1

Group 1 is the full, round letters, **O**, **Q**, **C**, **G** and **D**. The **O** and **Q** are the full circle; the **C** and **G** have one-eighth of the square removed at the right-hand side and the **D** has one-eighth removed at the left-hand side, making these letters seven-eighths the width of the circle. The tail of **Q** is long and straight. The top and base of **C** and **G** are flattened to keep the letters buoyant. The leg and strut of **G** begins just below the halfway line. Note that there is no strut below the base of the Trajan **G**.

Look now at the following diagram, of an **O** and an **H**, each occupying the full width of the square. The **H** looks too wide. This is because the **H** is occupying the full area of the square, whereas the circle isn't. The

solution to making an **H** which will sit happily alongside an **O** is to create a figure that has a similar area to the circle and put the letter within it. This figure is a rectangle that is three-quarters the width of the square. Look at the adjustment with a three-quarter width **H** against the **O**; the letters harmonize much better.

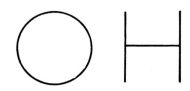

Diagram B

Diagram A

Thus the second group of letters, most of which are made up of straight lines, **H**, **A**, **V**, **N**, **T**, **U**, **X**, **Y**, **Z** sit within the three-quarter rectangle. As ever with letters, adjustments are necessary for aesthetic purposes.

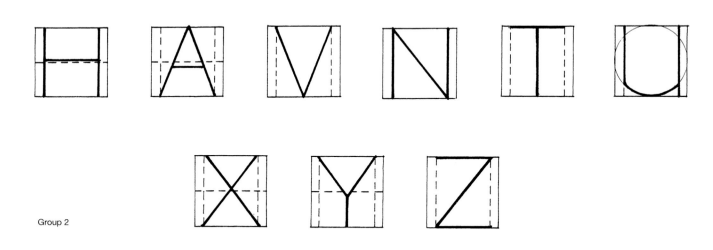

Group 2

Were the crossbar of **H** to be placed exactly on the halfway line of the square, an optical illusion would occur, making the top look larger than the base. To counteract this, the crossbar is moved slightly higher. The **A** needs to be made very slightly wider at its base than the **H**, its legs just outside the three-quarter rectangle, to balance the sharpness of the apex. The apex just cuts the line. The crossbar of **A** is moved to below the halfway line to balance the counter spaces of the letter. The apex of **V** should cut the base line by a small amount. **N** in geometric form is straightforward; its legs are on the three-

quarter rectangle and its diagonal sits between them. **T** is a completely symmetrical letter. The base of **U** picks up the underlying circle, and my preference is for a strut at the right-hand side. The top of **X** is begun just inside the rectangular box at both left and right and the strokes extend slightly beyond the box at the base. This makes the top smaller than the base and lifts the crossover point to just above halfway. **Y** looks more balanced if the apex is taken below the halfway, to the point where the crossbar of the **A** sits. The stem is vertical. **Z** sits within the rectangular box at the top, its diagonal

Group 3

aligns with the top at its base and the base stroke protrudes by a small amount at the right-hand side, to make the right-hand counter visually bigger than the left.

The next group consists of just two letters; the so-called extra wide **M** and **W**. In the case of **M** this is something of a misnomer, as the letter sits within the square, but because it is open at its base it looks wider than the circle. The centre of the **M** is a **V**, which occupies the rectangular box, thus the legs of **M** drop from the top of the three-quarter rectangle to the base of the square, making them just *slightly* off the vertical. The most common mistake in writing the **M** is to make it an upside-down **W**, with two sets of parallel limbs and three equal counter spaces. The central counter of **M** is the widest of the three and the legs act as 'supporters'. No two strokes of the letter are parallel. **W** consists of two **V**s, juxtaposed, thus two sets of parallel limbs. It is 1½ times the width of the square, by far the widest letter in the alphabet. Don't compress it.

The final group of capitals, **EFL**, **BRP**, **SJK** are half the width of the square, and this needs some explanation. Look at the following diagram, of an **O** and a **B**, both occupying the full square. The **B** looks positively gross.

Diagram C

Why? Because the letter comprises two **D**s, one on top of the other and the proportions of the **D**s making up this letter are wrong. Halving the width of the letter restores the correct proportions of **D** and the letter now sits well alongside an **O**. Because the letter is 'double-decker', were it divided in half

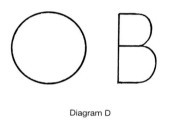

Diagram D

vertically the optical illusion mentioned with regard to the **H** would occur: it would appear top-heavy. To correct this in geometric terms, we take a figure that is half the width of the square and raise the central division to just above halfway. The lower box is then widened to become a square again and the top box is narrowed to be square. Circles are drawn within the squares. To complete the proportional construction of a **D**, a small amount is taken from the left-hand side of the figure, a compromise between one-eighth of the top square and one-eighth of the lower square. Two perfectly proportioned **D**s can now be constructed within this figure, making a beautifully balanced letter **B**. This construction is used for all the letters in the narrow group.

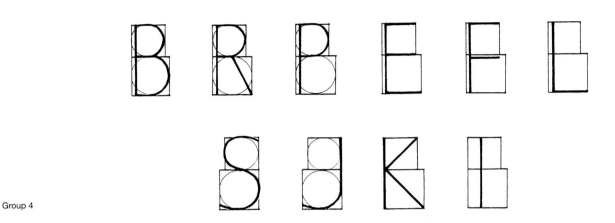

Group 4

The construction of **B** has been described. **R**, in geometric terms, has a **D** as its top bowl. The strut is on a line that runs from the top left of the letter to the bottom right corner of the lower box. The **P** has the **D** shape as its bowl.

The top and middle limbs of **E** extend to the width of the top box, the bottom limb to the width of the lower box. The middle limb sits on the division between the boxes, above halfway, and the letter looks balanced. The two limbs of **F** are the same length, extending to the width of the top box. Because the **F** is open at its base, the lower limb is moved down to the measured halfway and the counters look balanced. The base of **L** extends to the width of the lower square.

The construction shape is flipped over for the **S** so that the step is at the left. Nothing is taken off the width of the box for this letter. The base and top are flattened curves, the base starting at the left of the lower box, so that it protrudes beyond the top bowl and the top curve aligns with the lower bowl. **J** shares the same shape as the **S** at its base. This letter never has a bar at its top. Flipping the boxes so that the step is again at the right provides the basis for **K**. It too occupies the whole width, the stem being on the left-hand side. The top limb is drawn from the right of the top box to the junction of the boxes, then kicks out to the full width of the lower box. It is useful to notice that these two diagonal strokes form a right angle. Last but not least is the **I**, in monolinear terms a simple vertical.

One further adjustment needs to be made for aesthetic purposes. Look at the **R** and **P** and you might feel that they look a bit weak. This is because the **R** is open at its base, so the space that we see within the base is greater than the space within the bowl. This is corrected by making the bowl of **R** both wider and deeper, retaining the underlying circle, bringing the waist down to sit on the geometric halfway. Because **P** has nothing at its base, the optical illusion is even more apparent, the bowl looking far too small. Enlarging it, again keeping to the circle, but bringing the base of the bowl to a point

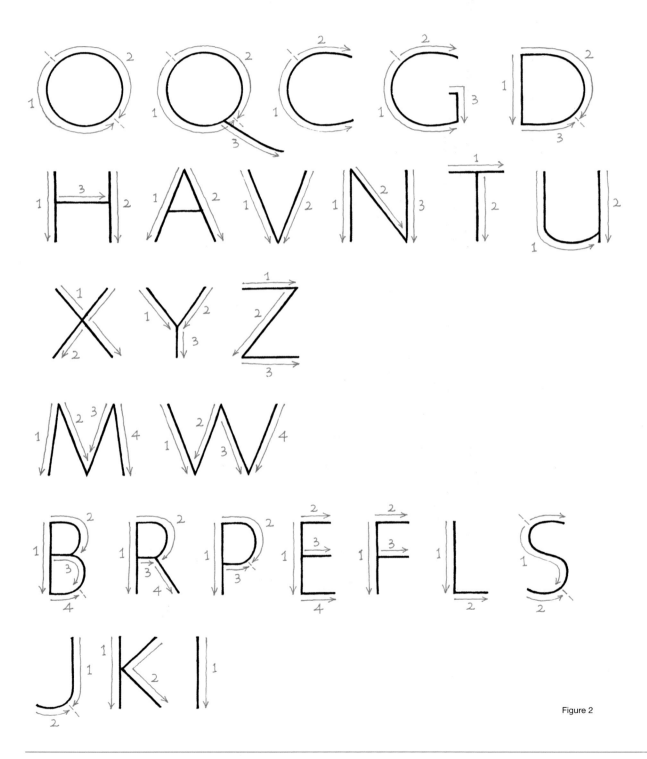

Figure 2

Figure 3

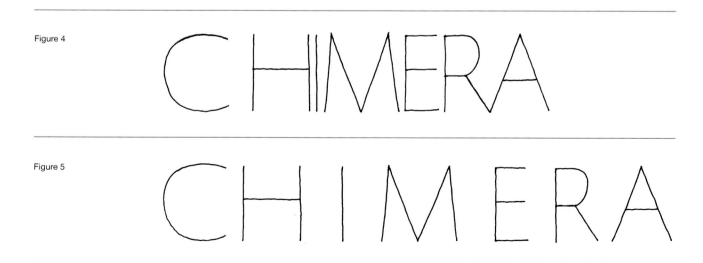

below the halfway restores the balance to the counters. It is useful to pair together **E** and **B** as their proportions are the same. Similarly **F** and **R**.

Figure 2 shows the letters, still within their groups, without the underlying geometry and with the order and direction of strokes. The **R** and **P** have been adjusted. Try tracing these letters to accustom your mind and your hand to the different widths and then try drawing them freehand with a pencil or a fineliner.

Spacing of capitals follows the same principles as the minuscule letters, but the key letter is the **H**. Two straight-sided letters

together will require the visual space of the **H** between them. This translates to roughly half the height of the letters themselves, or just less than the counter space of the **H**. From there the rule is as for minuscules; a circular letter should move slightly closer to a straight-sided one and two circular letters will sit closer still. Figure 3 shows this. The counters of the open-sided letters need to be taken into consideration when spacing words. Figure 4 shows the word 'CHIMERA', poorly spaced. The **C** looks as if it is drifting, perhaps not part of the word, and it is difficult to separate the letters **HIM**. Figure 5 shows the word correctly spaced. It now has an even pattern of line and space.

Figure 4

Figure 5

THE SNOWDROPS Figure 6
HANG THEIR
DELICATE HEADS

We can now begin to consider the main purpose of this book: the use of letters to enhance text. In the minuscule letters the skeleton forms were purely for construction purposes; the skeleton capital form is beautiful in its own right and, with the addition of fine serifs, can be used to describe something fragile or delicate. Spend time on these letters and on the addition of fine serifs, horizontal on stems and vertical when hanging from the tops of **C, G, S, E, F, T** and **Z**. The bases of **E, L** and **Z** look better with a simple lift at the end of the stroke instead of a serif. Choose a short phrase and write it out, using a no. 4 Mitchell nib or the equivalent Brause or Speedball. The base angle for Roman capitals is 30°, with the letter **N** requiring a higher angle for weight distribution. Left-to-right diagonals need a higher angle too, approximately 45°. A small nib such as a no. 4 doesn't show much difference in thickness between a horizontal and a vertical stroke, and this is how it is supposed to be. Don't press too hard in an attempt to produce thicks. Figure 6 shows a short text written in skeleton capitals.

Once you are comfortable working with a small nib, you can dress the letters up more by using a slight 'build' at the tops and bottoms of the stems: that is, adding a small amount more weight by two-stroking at the beginning, reverting to a single thickness on the middle of the stroke and two-stroking again at the base. Pressing a little harder on the 8 o'clock/2 o'clock track of circular letters will provide the extra weight on circular letters. This technique has been used on the word 'delicate' in Figure 7. Compare it with the same word in Figure 6.

DELICATE Figure 7

The script in use

Heleen Franken-Gill
Beauty is Joy

Gouache and steel nibs on Fabriano Roma paper
22.7 cm x 49.5 cm

This work shows just how sophisticated and refined the skeleton capital can be

/ O Q C G D

H A V N T U

X Y Z

M W

B R P E F L

S J K I

Figure 8

The weighted letters

Figure 8 shows the letters written with an edged pen, still in their width groups, and using hook serifs at the tops and bases of the letters. The height of these letters is 7 nib widths, which gives a similar proportion to the Trajan letters. You will be reasonably familiar with the order and direction of the strokes from your work with the skeleton letters; the changes in pen angle mentioned above are more important in the weighted letters. Flatten the angle to around 20° for the tail of **Q** to avoid it becoming too heavy. The left-to-right diagonals of **A**, **V**, **X**, **Y** and **M** need a higher angle of around 45°. The right-to-left diagonal of **X** and the whole diagonal stroke of **K** need a flatter angle of around 20°. (Never go into the stem of **K** with the diagonal stroke; simply touch it and then push slightly back into your first stroke to make the change of direction easier to achieve.)

N and **M** are the two difficult letters in capitals. Figure 9 shows an **N** written with a pen angle of 30° throughout. The strokes of the letter are almost the same thickness, so it looks heavier than any of the other letters. The legs need to be slimmed down to match the thickness of the horizontal strokes of **E** or **F** and to achieve this the pen angle needs to

be steepened. This angle is normally given as 60°, with a change to 45° for the diagonal stroke. I find that if I use a highish angle of around 55° and stay at that angle throughout the whole letter, I get a good balance of thick and thin (see Figure 10). I also prefer to make the letter in three consecutive strokes, rather than make the legs first and fit the diagonal in afterwards, which can cause problems with the apex. You can train your muscles to move your arm in the correct direction for the diagonal, and doing this, you will have no trouble with the width of **N** at other height/weight ratios. The **M** does require changes of angle to produce two thinner strokes and two thicker. The first limb is made with a high pen angle; 50°–60°. Remember the centre of the **M** is the letter **V** and it helps to switch your brain to making a **V**, with a left-to-right stroke at 45° or a bit higher and a right-to-left at 30°. The final stroke of **M** is also made at 30°. The key to a good letter **M** is to match the points at which the strokes overlap, so as you begin the fourth stroke, keep an eye on the white apex that is the counter space on the left, and try to match it. Figure 11 shows an **M** made correctly and an **M** where the counters are different sizes due to different overlap points. Try also to match the height of the two apexes of **M**, which should cut the line.

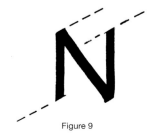

Figure 9

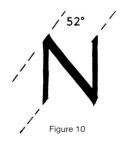

Figure 10

M M

Figure 11

Spacing weighted capital letters follows the principles used in the skeleton letters. Figure 12 shows the same word as before, 'CHIMERA', spaced poorly and properly. Notice how much more of a jumble the poorly spaced word is; it really is hard to distinguish the individual letters, and the word makes a heavy black mark. **C** again looks detached. With spacing you are aiming to produce an even tonal value on the page, with no heavy black parts and no 'holes' caused by too much space. If you find it difficult to assess your spacing, turn the page upside down, so that you view it as pattern instead of reading it. Space between words in capitals needs to be an approximate **N**, as with the minuscules, taking the counter spaces either side into consideration.

Spend time learning these letters, using a large nib such as a Mitchell no. 1½, moving your arm from the shoulder to pull down for the stems and to make the circular letters. Try to assess your widths, not by measuring but by training your eye. The most common mistake is to reduce all the letters to the same width. Look again at the beautiful proportions of the Trajan inscription and at the diagrams of **O** and **H** and **O** and **B** to remind yourself of the differences.

CHIMERA

CHIMERA

Figure 12

The script in use

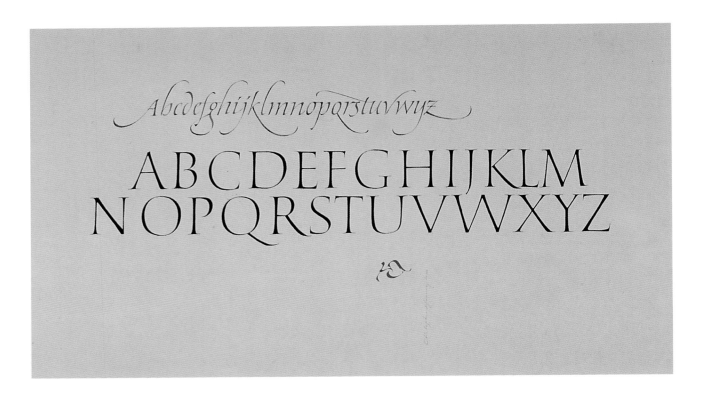

Christopher Haanes
Alphabet Missing an X

Chinese ink, gouache, Brause nibs, Zerkall paper
Width approx. 45 cm

Beautifully proportioned pen-made capitals with elegant minuscule italic

Beginning to vary the weighted letters
Once you are fairly confident of your
weighted letters and their proportions, you
can begin to make some changes that will
widen your repertoire.

The serif form of the weighted letters you
have used so far is a hook. Hooks top and
bottom give the capital a fairly informal look.
By changing the serifs you can achieve a
different effect. Figure 13 shows the same
words written out using four different
combinations of serifs. The first has hook
serifs top and bottom. The base serifs are
minimal to avoid destabilizing the letters.
The top serifs can be larger.

MONDAY'S CHILD

Figure 13

MONDAY'S CHILD

MONDAY'S CHILD

MONDAY'S CHILD

The second has hook serifs at the top and slab serifs at the bottom of the letters. This combination provides a semi-formal look. Slab serifs are made with the pen held at 30°. Lift the pen off, having made the stem, and make the slab by pushing from left to right. Be careful not to make them too large; they must just be an integral part of the letter. On the slimmer limbs, the legs of **N**, the first stroke of **A** and **M**, flatten the pen a little more so that the weight of the serif matches more nearly the weight of the stem. The final serif on the **A** and **M** is still a hook, and this will be the case with the strut of the **R**, which always ends with a hook serif, regardless of the form used elsewhere.

The third has slab serifs at both top and bottom, which makes for a more formal appearance. Slabs are not used on the apexes of **M**, **N** and **A**. The vertical slabs at the top of **C** and the top and base of **S** are made by lifting the pen at the end of the stroke, moving it slightly upwards and simply pulling down. These top serifs can be pulled slightly inwards or can be vertical.

The last combination is the most formal, consisting of built-up serifs at the top and slab serifs at the base. See Figure 14 for the construction of built-up serifs, which are

made in three strokes. Serifs are used on the apexes of **M** and **N**, added *after* the letter has been made, and can be used on the **A**. Top serifs on **C** and **S**, **F** and **E** are as in the previous combination.

You may find in the making of slab serifs that you have a small triangle of white between stem and serif. This can simply be filled in with the corner of the nib.

The differences between these combinations of serifs allow you to choose that which best suits your purpose. With regard to the phrase used, it is part of a light-hearted traditional rhyme so perhaps the first combination is the most suitable.

Manipulated serifs

Using pen manipulation in the making of the top serifs of **E**, **F** and **L** and the top and base serifs of **S** gives a further sophistication to your letters. In Figure 15 the word 'SCENT' has been written with hook serifs. Below it is the word written using manipulation of the pen. The top serifs are made by rolling the pen in an anti-clockwise direction between

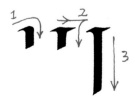

Figure 14

SCENT

SCENT

Figure 15

Figure 16

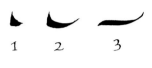

Figure 17

the thumb and forefinger, as you near the end of the stroke *and while you are moving the nib sideways*. It is important not to press too hard while doing this, and to keep the whole edge of the nib on the paper until you finally twist the nib to an angle of 90°, by which time you come on to the left-hand corner of the nib (see Figure 16). Tease the wet ink down to form the serif, and if necessary push back up to tidy up your stroke. The base serif of **S** is rather more difficult to execute. Start with the pen at 90°, press quite hard and begin to twist the nib to a flatter angle, rolling it in a clockwise direction. You will achieve a shape like that in example 1, Figure 17. Lift off, revert to an angle of around 30°, come back into the wet ink and make the rest of the base as normal. Example 2, figure 17 shows the finished stroke. Example 3, figure 17 is a horizontal stroke made at 30° with the pen being twisted at the end on to the left-hand corner of the nib, so that the stroke ends in a hairline. This can be used for the base of **E**, **F**, **L** and **Z** and for the crossbar of **T**. Be careful not to overuse this extension in the middle of a word; you will give yourself spacing problems.

Vertical and lateral compression
Compressing letters, both from top to bottom, vertical compression, and from the sides,

lateral compression, provides a rich variety of forms.

I have used the word 'AMPERSAND' for this exercise as it contains a good mix of widths of letters and the **S**, which is often a troublesome letter.

Figure 18 shows the word written conventionally at a height of 7 nib widths, using the normal pen angle of 30°. Below, the word has been written at 5 nib widths of the same nib, thus compressing the letters from top to bottom. The basic pen angle is still 30°. The letters are now heavier than in the first version, the relationship between the line that makes the letters and the space within them slightly more biased towards the line. Using letters at 5 nib widths in a text will provide a heavier tonal value on the page than those at 7 nib widths.

The third example is written at an extreme compression of 3 nib widths high, and in order to do this, several things have had to change.

The first is the pen angle. Extreme compression from the top requires the letters to be widened so that they retain the space in their counter shapes, a key factor in legibility. Flattening the pen angle means the pen more

Figure 18

naturally travels sideways, producing wider forms. It also makes horizontal strokes thinner, allowing space into letters such as **E** and **S**. The pen can be flattened a little more for the crossbars of **A** and **H**. Conversely, the angle for the legs of **N** and the first leg of **M** needs to be taken higher, to further slim these strokes. The angles used on this word have been marked; the basic angle has come down to 23° and the legs of **N** have been made at 67°. The relationship between the line and the space is now firmly biased towards the line, the space within the letters much reduced. This means, following the

golden rule of spacing, the space *between* the letters must be the same as the space *within* them, and so the spacing within the word needs to tighten. This is the second factor that has to change.

Third, when writing letters at 3 nib widths high, the classic proportions of the Trajan letters alter, the letters becoming rather more similar in widths. The **E**, for instance, is still narrower than the **D**, but not by as much as in the first example. The open form of the letter **R** has been used as it has more space within it. Letters have characteristics

30° 34° 30° 35° 58°

O O O AMPERSAND

45° 59° 40° 70°

O AMPERSAND

AMPERSAND

AMPERSAND

Figure 19

allowing their use in appropriate texts, and these small compressed letters are chubby and quite friendly. Their weight makes them forceful, but that can be reduced by using a lighter tonal value than black.

Lateral compression makes for a completely different sort of letter, austere and refined. To begin lateral compression, start with the **O** shape of a formal Roman capital. This letter allows you to arrive at the correct proportions of full and round, three-quarters, extra wide

and so on. Now make an **O** that is approximately three-quarters the width of the formal **O** and then base all your letters on this width. Figure 19 shows the two **O** shapes, and notice that in order to make a narrower **O** the pen angle has steepened. The word 'AMPERSAND' is written alongside at this compression. The pen angle can stay at 30° for vertical strokes, but it is steepened slightly for the round letter **S**. Compare this word with the formal version in Figure 18. It is subtly different, slightly darker in tonal value.

Below this is a version based on an **O** shape that is just over half the width of the formal **O**. Here the angle has steepened to 45° to facilitate the narrow **O**, and this steeper angle is carried through to the word, at least on the stems of the letters, but the angle has been flattened for the horizontals to avoid them becoming over-heavy (at 45° the vertical and horizontal strokes are the same thickness). The **S** is made at 40° and is made narrower by making the main stroke much more vertical. The **N** is made throughout at a very steep 70°. This word has a completely different character than the one above it, tighter and darker on the page, much less friendly than the chubby letters in the previous figure. At extreme compression the letters **M**, **N** and **W** can be a problem. Never try to alter the shape of the **W**, but the **M** and **N** can be altered, taking inspiration from runes, thus allowing more air into the letters, as in the next example. The strut of **R**, too, can be made more vertical, taking up less space. These two versions take up the same width, but the second has much more space within it, making it a bit more relaxed.

Becoming competent in these variations will greatly increase your ability to use letters and words in interpretative ways. Play around with letter shapes, always keeping a firm eye on where the weight is, and

Figure 20.1

WINTER·THE LANDSCAPE HAS CHANGED FROM A PAINTING TO AN ENGRAVING

Figure 20.2

WINTER·THE LANDSCAPE HAS CHANGED FROM A PAINTING TO AN ENGRAVING

remembering that if it doesn't look good, it is not worth using. Don't compress letters in both directions; you will start to lose the counter shapes and thus the legibility.

As a further example of possibilities, the last version of the word 'AMPERSAND' has been written with a no. 4 nib, using exactly the same shapes as in the weighted word, although reverting to a more conventional **R**, with the addition of fine slab serifs. Again, this has a completely different character: still refined, but much gentler.

To show how two of these variations would work in texts, a quote has been selected and written out in two of them, the first in the skeleton laterally compressed letters and the second in letters compressed vertically to 3 nib width high. They both make a pleasing pattern on the page, but ask yourself: which is the more appropriate to the words?

Interlinear space

Space between lines is a major factor in calligraphy, and capitals, with their lack of ascenders and descenders, can be packed much more tightly than minuscules. But space between lines is essential for legibility, and can also affect the way we read a text. For maximum formality, using letters written at 7 nib widths high, the space between the lines can be the full height of the letters themselves, known as the 'x' height. Reducing this measurement means the letters become more of a texture on the page, 'knitting' together more closely. What you do with capitals will depend on your intention for your piece of work, whether your prime purpose is legibility or impact. Lightweight letters, closely spaced, will produce a lace-like pattern and be quite difficult to read.

Heavier letters can be closely spaced and still retain their integrity, due to the heavier line that makes them, but unless your intention is for pure pattern on the page there will always need to be a white stripe of space between the lines to allow the reader to negotiate back to the beginning of the next line. Longer lines of writing will require more space between them than shorter lines, simply because the eye tires more quickly reading longer lines. Longer texts will require more space between lines than short; the brain assimilates short texts more readily.

As a rule of thumb, use the guidance that if you are *conscious* of the space between lines, there is too much. As with the space within letters, the space between the letters, the space between words, interlinear space needs to be a functional, integral part of your work.

The interlinear space in the lightweight version of the quote in Figure 20.1 is half the height of the letters, and with the delicacy of the letters themselves, gives enough separation to make things legible, but still knits the lines together in an overall texture. In the heavier version, the space is 5 mm against the height of the letters at 6 mm, so almost an 'x' height between lines. The interlinear space in the two lines of the children's rhyme, 'Monday's Child' (figure 21), is just over half the 'x' height of the letters, which are written at a formal 7 nib widths high. Compare the three and you will begin to see the possibilities of capitals in blocks of text.

Figure 21

MONDAY'S CHILD IS FAIR OF FACE

In tight blocks of capitals, make sure you don't put too much space between words as this can join up with a space above and below and form what are called 'rivers of space', a channel of white running through your texture, destroying it.

The capital form has more authority than the minuscule; a title for a memorial book or a heading on a certificate, for instance, will carry more weight written in capitals than in minuscules. We use capitals at the beginning of sentences and for proper nouns, and in this usage the capital letter should be no more than half the 'x' -height of the minuscule. So if you are writing Foundational at 4 nib widths high, your capital should be 6 nib widths. This is one of the few unbreakable rules of calligraphy. The capital letter is always smaller than the height of the ascender.

The script in use

LOVE IS PATIENT AND KIND
LOVE IS NOT JEALOUS OR BOASTFUL
IT IS NOT ARROGANT OR RUDE
LOVE DOES NOT INSIST ON ITS OWN WAY
IT IS NOT IRRITABLE OR RESENTFUL
IT DOES NOT REJOICE AT WRONG
BUT REJOICES IN THE RIGHT
LOVE BEARS ALL THINGS
BELIEVES ALL THINGS
HOPES ALL THINGS
1 CORINTHIANS 13 ENDURES ALL THINGS
LOVE NEVER ENDS

Gillian Hazeldine
1 Corinthians 13

Gouache and steel nibs on BFK Rives paper
23 cm x 32.5 cm

Formal proportioned Roman capitals written using some manipulation and without foot serifs

Italic

rin desto a gran giorno ;

cusa, et raddoppiando i

o del camin racquista .

uoi si prenda a scorno

e i uersi incolti et bassi ;

el sol perda la uista .

By the fifteenth century, the script of the Middle Ages, Gothic, had reached a point where it was almost indecipherable, due to lateral compression and the fact that most letters were made up of identical strokes which became individual letters only according to small linking strokes at either top or base. The Humanist scribes decided that something had to be done to restore clarity and legibility to writing and initially they looked back to Carolingian manuscripts as models. Eventually, through the sheer skill of the scribes, a new, more swiftly written, forward-sloping script emerged: Italic.

Italic is probably the most important script for the modern calligrapher as it is capable of almost endless variation, able to express on the page a huge range of emotions.

In order to be able to vary Italic, you need an absolute understanding of the form and structure of the formal script. The finest example of a formal Italic is a mid-sixteenth-century manuscript written in Italy, the Sonnets of Pietro Bembo in Italian, and an analysis of this tiny and expertly written script provides the characteristics that will make for a strong modern hand:

- The shape of the *o* is elliptical.

- The proportion of the *o* is 1½ times its width high.

- The height/weight ratio is 5 nib widths.

- The slope is 5° forward off the vertical.

- The branch point on letters, both clockwise and anti-clockwise, is at halfway.

- The ascenders and descenders are the height of the *o*, 5 nib widths.

- The serif form is a hook.

- The letters are unjoined.

- The speed of writing is faster than in a Roman minuscule with pen lifts only where necessary.

- The pen angle is a fairly consistent 40° although there is some manipulation – an indication of speed and fluency on behalf of the scribe.

Opposite:
Sonnets of Pietro Bembo,
mid-sixteenth century

Figure 1

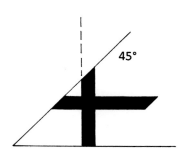

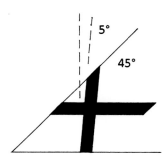

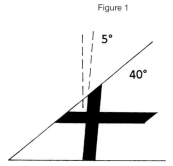

Figure 2

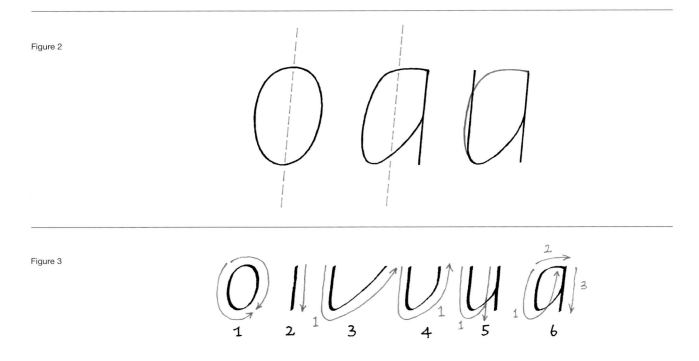

Figure 3

This last characteristic, pen angle, is very important for the writing of an elegant formal Italic. The script should be graceful and forward-moving, with a similar thickness on the stems of letters and on horizontal strokes such as the crossbars of *f* and *t* and the tops of the anti-clockwise letters *a*, *d*, *g* and *q*. At an angle of 45° a vertical and horizontal stroke are the same width. If you slope the downstroke off the vertical at an angle of only 5° it becomes thinner than the horizontal, so the weight is in the wrong place, and the elegance begins to be lost. At an angle of 40° the balance of weight is restored (see Figure 1).

Figure 2 shows a skeleton *o* alongside a skeleton *a*, and the 5° slope line drawn through both of them. On the *o*, the slope line cuts the letter top and bottom where it touches the line. On the *a* the point at which the letter touches the line at its base is to the left of the slope line. So in crude terms, the *o* is elliptical and the *a* is triangular. Next, an *a* is shown superimposed on a *u*. There is a very subtle difference in the shapes of these two letters; the curved back of the *a* is only a softening of the straight *u* and the base and stem of the letters are identical.

So the letter *o* sets the width of the alphabet in italic, but the *u* shape gives us the key letter, the **a**, which is also the basis for the *d*, the *g* and the *q*.

Figure 3 provides the steps in making a good *u* shape. 1. Establish the width of an *o*, which will govern the width of the final letter. 2. Make an *i* shape, a straight line on the 5° slope. 3. Repeat the *i* stroke, but anticipate

the line and, on touching it, turn sharply and move up towards a mental 2 o'clock. 4. Repeat the downstroke and tight turn of 3, but introduce a slight curve as you come off the base and, on reaching a halfway point, pull up to be parallel to your first stroke. 5. Repeat 4 and, on reaching the top line, pause for a second and then pull down to the baseline, parallel to the left side of the letter. Your letter should be the same visual width as the *o*. 6. The *a*, based on a *u* with a top and a subtle curve on the back of the letter.

A word about pressure

Because of the branching forms of Italic, you will have to push against the pen instead of pulling towards you. The angle of 40° helps facilitate this, and also the fact that you are not pushing directly upwards, but obliquely, to the right. It will help in your writing of this script if you introduce some variable pressure on the pen. Use normal pressure for downstrokes, but come off the pressure as you begin to push up. It is absolutely *essential* for good anti-clockwise shapes (the letters *a*, *d*, *g* and *q*) that you push all the way up to the writing line before putting the top on the letter and pulling down. By doing this, you create a rhythmic series of strokes, and also you establish the width of your letter. On the anti-clockwise letters you are pushing up on dry paper; if the ink doesn't write all the way up this stroke, don't worry; continue to the top, lift, put the top on the letter, lift again, then pull down. Your downstroke will cover the dry patch and you will have achieved a good shape. Clockwise letters are altogether easier; you are simply pushing wet ink back up the stem to form the branch, but again, a lightening of the pressure on the nib will help.

Start learning the Italic hand through the skeleton letters. Skeleton letters can be any height, the width being established by the making of a letter *o* that is 1½ times its width high. Rule up at whatever height you find comfortable and then rule a halfway line. It might also help to rule slope lines at 5° either side of a ruler for guidance. Use a no. 4 Mitchell nib or equivalent Brause with a pen angle of around 40° and remember not to press too hard. Don't use serifs at this stage. Figure 4 shows the forms, with the order and direction of strokes first, the completed letter alongside.

Group 1 is the all-important anti-clockwise letters, *a*, *d*, *q*, *g*, *u* and the *y* based on the *u*. Practise these letters, concentrating on feeling the movement of your hand and arm as it makes the same shapes over again. Start the *a* just below the line and pull to the left, with only a slight curve, touch the line and curve up to your halfway line, pull up to be parallel to the 5° slope and *push right up to the line.* Come back to your start stroke and put the pen just into the wet ink, push up and over, creating with the overlap a strong shoulder shape at the top left of the *a*. Flatten off as you reach the line. Having closed your shape, lift the pen off the paper, put it back on, and pull down for the stem. This lifting of the pen at the top right of the *a* is important; it provides a sharp point and a small serif that define the letter shape.

Look at your letter. Does the curved base stroke enter the stem at halfway? The curved base stroke is the key to the width of the letter. If your branch point is too high, it is likely that you have made too angular a turn at the base, and it is also likely that your letter will be too narrow. If your branch point is too

Figure 4

Branch point ---------

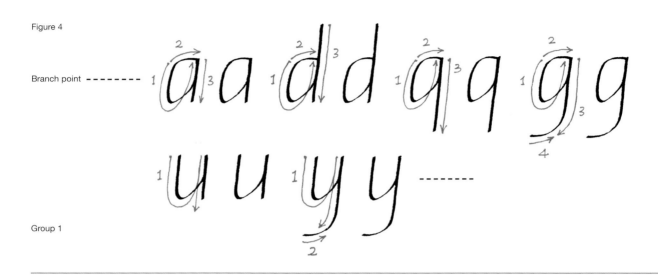

Group 1

Branch point

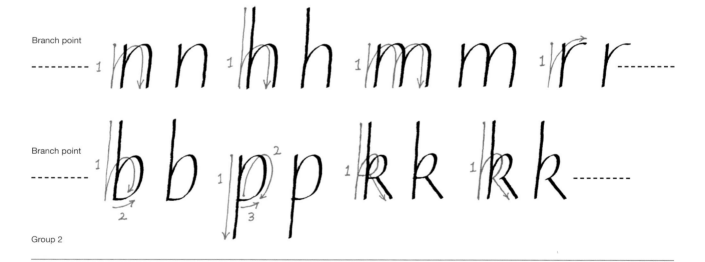

Branch point

Group 2

low, perhaps you took too long to turn off the base; your letter will probably be too wide and a bit too round. Try to analyse what you have done and practise a few more letters.

Move on to the *d*, which is an *a* with an ascender (note that in contemporary Italic the ascenders and descenders are shortened slightly from the full body height of the *o*).

The *q* is an *a* with a descender.

The *g* has a descender, a graceful curve. Make your basic *a* shape, lifting at the top of the letter. Just below the line on the downstroke, begin to pull to the left; the stroke will thin. Lift off at this point and follow through in the air, continuing the curve sideways and flattening off. At a point

just to the left of the width of the letter, put the pen back on and retrace your mental follow-through, pushing up and into where you left off. The shape you have made should echo the shoulder shape at the top left of the letter. The whole feel of this descender should be uphill. On very small Italic writing the descender of *g* and of the related *y* can be made in one stroke by pushing against the nib, but on larger weighted Italic you will need to use two strokes.

Group 2 is the clockwise letters, *n*, *h*, *m*, *r*, *b*, *p* and *k*. These are easier shapes than the anti-clockwise; what you have to concentrate on is making them the same visual width as the anti-clockwise.

The *n* is made by pulling down as if for an *i* stroke, pausing at the base of the stem and then bouncing back up, off the pressure, to the halfway line before branching off to make the arch. The arch on formal Italic is asymmetric and so, coming off the stem, aim for one o'clock on the clock face. Turn at the top with an elliptical shape and pull down, using a bit more pressure, to form the second leg. This pressure and a bit more speed than on the upward push will help to keep your strokes parallel.

Check branch point and width and move on to the *h*, an *n* with an ascender, done in one continuous stroke, starting with the ascender.

The *m* is two *n*s juxtaposed and is done in one stroke. Try very hard to make the counter spaces of *m* the same width; it is all too easy to run out of steam on the second, resulting in a narrower shape.

The *r* is the basic *n* shape, flattening off at the top and ending on the line.

The *b* and *p* are the same body shape, *b* with an ascender, *p*, a descender. The most common mistake in these letters is to make them too round. When you start the *b*, think *h* until you are pulling down from the top of the arch form. Introduce a subtle curve now, pulling in towards the base and lifting off at around 5 o'clock. Put the pen on the base of the ascender and push over and up into where you left off. The *b* must have a point at its base, and should look as if it is on tiptoe, not anchored to the line.

Start the *p* at the top writing line and pull down to make the descender. Lift off and put the pen back on the stem, at the base line. Do not push all the way up from the base of the descender. Repeat the shape of the bowl of the *b*, thinking *n* to help with the width until you pull down for the same subtle curve.

There are two forms of *k*, one closed, one open. Both are made in one stroke. The branch point is at halfway and then you pull round quite quickly for the bowl. For the closed version pull in to touch the stem at the branch point and then slide back out on your stroke and kick out for the strut. I prefer the open *k* as it is less cluttered. Take the bowl a bit below halfway before making the strut by pushing slightly back into the bowl and pushing outwards. Make sure your letter looks as if it is intentionally open, not as if you wanted a closed letter but didn't quite make it. Note that *k* should be the same visual width as the other letters in its group, barring *m*.

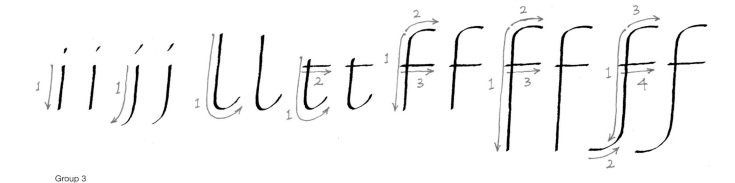

Group 3

Group 3 is *i*, *j*, *l*, *t*, and *f*. In skeleton form, *i* is straightforward, as is *j*, which is an *i* extended below the line with a slight curve to the left. The *j* can have a descender like the *g*; my preference is for the more minimal shape.

Both *l* and *t* have the elliptical shape of the letter *o* as their base. While *l* has a normal ascender, *t* rises just above the top line. The crossbar of *t* extends to align with the base of the letter on the 5° slope. There are three forms of *f*. The first is the short letter, which ends at the base writing line. This letter is useful when you are working with tight interlinear space and there is a danger of a clash with an ascender below. As with the

Foundational *f* the letter is the same height as the ascenders of *h* and *b*, so you will need to start slightly lower down than the full height, on a small curve, and then pull down to the line. The top of *f* is exactly the same upward curve as the *a* group, flattening off at its end. The letter will be the same width as an *a* or an *n*. The crossbar on an Italic *f* is on the line. The long straight *f* simply continues below the line to descender level. The classic Italic *f* is a beautiful fluid letter, with a curved descender like that of the *g* and the same uphill top as its counterparts. This letter will be the width of an *m*. It's a long pull down on this letter. Try hard to maintain the 5° slope all the way!

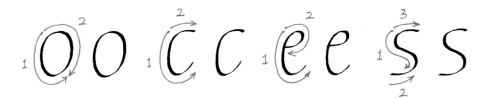

Group 4

Group 4 is *o*, *c* and *e*, the elliptical letters, plus the letter *s*. The *o*, as previously mentioned, is an ellipse that is 1½ times its width high.

The left-hand side of *c* is as the *o* and its top is the same curve as the top of *a*. Make sure you create the ellipse at the base by coming up far enough off the base with the first stroke.

The *e* has a high, tight bowl. The letter starts as the left side of the *o*. Lift off, having established an elliptical base and come back to your start point, overlap the strokes and push up and over to the line. When you touch the line, pull down sharply and tuck the bowl into the stem with a horizontal stroke. The base of the bowl should be about a third of the way down the letter. If you pull down on a diagonal for the base you will tip the letter over backwards.

A letter that causes problems in every script is *s*. The most common fault in Italic is to make the letter too round. Never put a curve on the central stroke of an Italic *s*; you will instantly create a rounded base counter. Like the *b*, this letter should look poised on tiptoe on the line. Try making an ellipse just narrower than an *o* and write the letter within it, as in Figure 5. This will help you to understand that the bowl shapes of *s* are flat ellipses. The base of *s* starts on the line and pushes up into the first stroke, so there is no hint of roundness. The top is the same shape as the *a*, *c*, etc. The top counter must be smaller than the base so that the letter looks balanced. The top of the letter should align with the bowl on the 5° slope and the base should protrude slightly beyond the top bowl on the slope.

Lastly, Group 5, the diagonal letters, which consist of straight lines. As with the diagonals in Foundational and in Roman capitals the pen angle needs to be altered on the left-to-right strokes to adjust the weight. Steepen to at least 45°, even as high as 50°. These letters must conform to the 5° slope which means your first stroke must slope down steeply; imagine a 12 o'clock to 5 o'clock track. Gauge the width of the letters, starting with *v*. The measurement across the top of

Figure 5

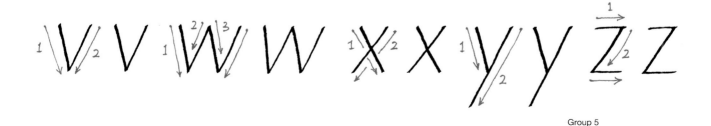

Group 5

the letter will have to be a bit wider than the *u* to compensate for the apex. Revert to your normal 40° for the right-to-left stroke.

The *w* is two *v*s juxtaposed so it will be exactly twice the width of *v*. The first stroke of *x* is less steeply downhill than *v* or *w*. For the right-to-left stroke start the top inside the base on your 5° slope and aim for just outside the top left, also on the slope, so that the top counter of the letter is smaller than the base.

The diagonal *y* is a *v* which simply continues the right-hand stroke to descender depth.

Use 40° for the top and base of *z* and flatten your pen angle to almost 0° for the central stroke.

Once you have worked your way through the letters in their groups, move on to writing words. Spacing in Italic is easier than in Foundational as the letters are all fairly flat-sided, even the elliptical ones. The same golden rule applies: put as much space between the letters as is within them, paying particular attention to two straight-sided letters together, which should have the visual space of the *n* between them. Figure 6 shows the pattern of spaced Italic, with lines drawn down from the letters. In the word 'minimum', because all the letters are straight-sided, the pattern is completely regular; the counter spaces of the letters are slightly wider than the space between the letters, as that space is open top and bottom. When elliptical and open-sided letters are introduced, the pattern changes, as in

Figure 6

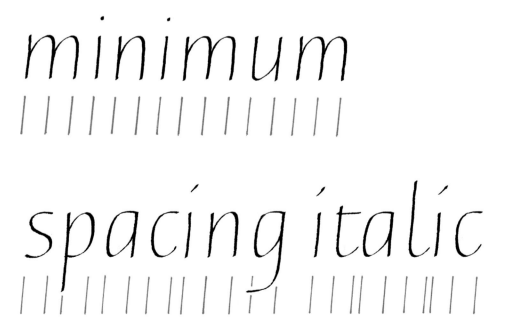

Figure 7

The snowdrops hang their delicate heads

Figure 8

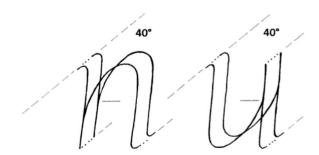

'spacing italic'. Notice the differences, especially where the open-sided letters *c, l* and *t* occur. The following letter sits much closer and the space *within* these open letters becomes the space *between* them and that which follows. Despite the now less regular red pattern, the words are an even combination of line and space.

As with Roman capitals, these letters, dressed up with slab or hook serifs, are a beautiful form in their own right, capable of expressing delicacy and fragility.

To consolidate your work to date, try making a small piece of work in skeleton Italic, choosing a text that is appropriate to the lightness of the letters using either small discreet hooks or fine slab serif similar to those used with skeleton Roman Capitals. Figure 7 shows an appropriate phrase, with slab serifs.

Weighted letters
The branch point is at halfway in formal Italic, and in the work you have done with skeleton letters your success or otherwise in

Figure 9

40°

o a d q g u y

n h m r r b p k k

i j l t f f f ff

o c e s

45° 22° 5°

v w x y z

achieving this has been easy to assess because of the monoline letters. In weighted Italic the branch becomes a more complex line and this can lead to a misconception. Look at Figure 8, which shows two letters made with double pencils. The point at which the right-hand pencil leaves the stem on the clockwise letter *n* is exactly at halfway, but because the letter is made with twin points, imitating the way the pen works, by the time the stroke fully leaves the stem the *apparent* branch is much higher, forming a triangle of space that is about one-third of the depth of the letter. The misconception is that this higher point is the branch, but this correct-sized triangular space will only occur if the true branch point is at halfway. On the anti-clockwise letter *u*, it is the left-hand pencil which enters the stem at halfway, providing a similar-sized triangle of space at the base of the letter. When you are writing Italic with an edged pen you need to try for consistency in these triangles of space, top and base.

Figure 9 shows the weighted letters in their groups. These letters conform to the characteristics gleaned from the analysis of Bembo's Sonnets, with the exception that the ascenders and descenders are slightly shorter than the 'x' height, 4 nib widths instead of 5. An *o* has been made first, 1½ times its width high so that the widths of all the letters can be established. The slope is 5° off the vertical, height/weight ratio is 5 nib widths. Branch points are at halfway. Order and direction of strokes is exactly as the skeleton letters and the pen angle is a consistent 40° apart from the left-to-right strokes of *v, w, x* and *y* where it has been steepened to around 45°. For the right-to-left stroke of *x* it has been flattened to about 25° and the centre stroke of *z* is made at a very flat 5°. There are two versions of *r*: one where the pen is lifted slightly above the line at the end of the stroke and another, where manipulation as described in the chapter on Roman capitals has been used, rolling the pen anti-clockwise

Figure 10

Much gossamer.
The air is full of floating cotton
from the willows

in the fingers to pull down a sharper serif. There are two *k*s, the first closed and the second open, my own preference. Following the three versions of *f* I have given the ligature that is used in formal Italic when two *f*s occur together. Using two long *f*s could result in too much going on below the base line. Here the long *f* is used first, but made shorter in height than the norm, although given its full width. The long straight *f* is made at the correct height and runs through the top of the first. Note that the crossbars of the letters are kept separate; running them together through this ligature makes for too strong a horizontal line.

In practising these letters, work as large as you can with comfort and try to use the changes of pressure described earlier. Check your pen angle, branch points and widths, and as soon as possible move on to writing words. Spacing is as for skeleton Italic; you are aiming for an even pattern of line and space. Space between words is approximately an *o*, less if there are open counters either side.

Formal Italic is elegant, refined and has a feeling of some movement because of its forward slope. Figure 10 shows a short piece of text by Gilbert White, the great English naturalist, written in absolutely formal Italic. The text is appropriate to the feel of the script. I have chosen to use the long straight *f* and so because of the number of ascenders and descenders the interlinear space is twice the 'x' height. It could have been closed up as there is no danger of a clash of ascender/descender, but the interlinear space helps the overall lightness of the piece. Note the treatment of the letters *fl*; the *f* is made normal height and the *l* tucks underneath it, making the space between the letters correct.

The script in use

wanted! I have never seen a rose as beautiful as this. It probably has a long Latin name.' He put out his hand and took it. Then he put on his hat and ran to the doctor's house with the rose in his hand. The doctor was a student teacher, and the student loved the doctor's daughter. She was sitting at the door, and her little ... was lying at her feet. ' You wanted me to bring you a red rose,' cried the student. Here is a reddest rose in the world. You can wear it tonight, next to your heart. Then we can dance together. And you

will know how I love you.' ' I am sorry,' said the girl. 'It will not go with the colour of my dress. And the officer sent me some real jewels. Everyone knows that jewels cost more than flowers.' 'Thank you very much!' said the student angrily. 'You are very kind!' He threw the rose into the street. ' You cannot speak to me like that,' said the girl. 'Who are you? Only a student!' She got up from her chair and went into the house. ' Love is a very silly thing!' said the student, as he walked away. ' It tells

Emiko Hashiguchi
Double page spread from *The Nightingale and the Rose*
(Text by Oscar Wilde)

Mitchell nibs, stick ink, gouache, watercolour, gold leaf and gold powder
27 cm x 29 cm closed

Beautiful semi-cursive formal italic writing with tiny capitals alongside and delicate watercolour illustrations

Beginning to vary Italic

When you feel that you have a good understanding of the formal script, you can begin to move on to some variations. The best way to do this is to take each element of formal Italic individually and change it, keeping everything else the same for the time being, with the exception of pen angle, which is not a variable in its own right. While working on these variations, be aware of how much they change the nature of the formal script, and think about their use with texts.

Variation 1: Height/weight ratio

There are two ways of varying the height/weight ratio. The first is to write the letters within the lines ruled for formal Italic at 5 nib widths of, say, a no. 2 Mitchell nib, using a range of different nibs. Choose a word with a good mix of clockwise and anti-clockwise letters for this exercise; the interpretation can come later.

Figure 11

30°
angelica
No. 0 nib

35°
angelica
No. 1 nib

angelica
No. 1½ nib

angelica
No. 2 nib

angelica
No. 2½ nib

angelica
No. 3½ nib

Figure 11 shows the word 'angelica', which will be used throughout the variations, written between lines ruled for 5 nib widths of a no. 2 nib, with Mitchell nib sizes 0, 1, 1½, 2 (the norm), 2½ and 3½, which brings the letter back almost to the skeleton. The writing with the no. 1 is 2¾ nib widths high, an extreme vertical compression. At this compression, the letters need to be widened so that the counter spaces are retained, and to do that, as you discovered with vertically compressed Roman capitals, the pen angle needs to be flattened, here to about 35°. Similarly the word written with the no. 1 nib. The letters in both these words are heavier than the norm, the ratio of line that makes the letter to space within it being weighted towards the line, and so the space between the letters tightens to match. These letters still have the characteristic elegance of shape of Italic, but they make a much more insistent mark on the page than formal Italic; they have a louder 'voice'. That voice quietens as we go through the examples, to the word written with the 3½ nib, where it is gentle in the extreme.

Figure 12 shows the second way of varying the height/weight ratio, by working with different heights of lines. Both words are written with the same nib, the first at 3 nib widths high and the second at 6 nib widths high. Thus the smaller writing is the same weight as the writing in Figure 11 with the no. 1 nib and the second the same weight as the writing with the no. 2½ nib. The smaller, denser writing makes a heavier mark on the page.

When you are working with these variations, choose at least two very different weights and take them through into texts, so that you find out how letters of different weights behave on the page.

Figure 12

angelica

3 nib widths high

angelíca

6 nib widths high

In Figure 13 I have written a text at 3 nib widths high about strong and terrible winds, so the heaviness of the letters is appropriate to the words. In layouts, heavy weights of words need less space between the lines so that the whole text knits together. Here the lines are fairly short, so the interlinear space has been tightened to just over 1 ½ 'x'

heights, helped by the fact that there are no descenders other than the **y**. In complete contrast, the phrase about the trout has been written at 6 nib widths of the same nib, so there is a lightness about the letters that matches the lightness of the words. The interlinear space here is twice the 'x' height, further contributing to a feeling of space.

Figure 13

Here the winds are so black
and so terrible.
They rush with such force that
the house shudders.

The trout leaping
in the sunshine

An important point to mention when you are changing height/weight ratio of the letters: keep the ascenders and descenders in correct proportion, just shorter than the body height of the letters.

Variation 2: slope

Formal Italic slopes at 5°, but the script can be upright, or it can slope at up to 15°. Neither of these variations is particularly attractive, but there may be occasions where there is a need for them. Figure 14 shows 'angelica' written at both a 15° slope off the vertical and upright. The most important thing to notice about these words is the pen angle. At the extreme slope of 15° the pen angle needs to flatten right down so that the weight is still in the correct place. Here it is 27°. The letters have been kept fairly flat-sided; a rounder letter would look grotesque. Conversely, the pen angle on the upright version has had to be steepened to adjust the weight distribution and to facilitate the vertical push up on the anti-clockwise letters. I've compressed the letters slightly on this upright word; again, a rounder version is unattractive.

Variation 3: Changing the proportion of the o

Altering the proportion of the **o** from 1½ times its width high produces very different forms with good interpretative possibilities. When doing this, establish your initial **o** shape first and then try to match the widths of all the letters.

Figure 14

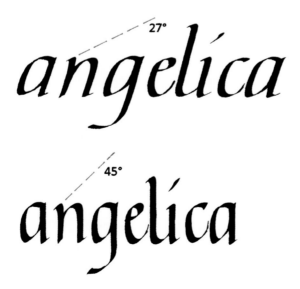

Figure 15 shows an **o** compressed to almost half its width high and 'angelica' based on this. Below this is an **o** widened to be as wide as it is tall, but because of the slope, still elliptical. Our word is written alongside based on this proportion. There is a huge difference in the way these two words look and their connotations. The first is tight, and through this, quite dark on the page; the second is open and, if you like, laid back. I've written the phrase 'north winds' in the compressed version and 'summer days' in the second. Note what should be becoming familiar to you by now, that the spacing within the words and phrases in this variation alters according to the space within the letters themselves. The pen angle on the compressed version stays at around 40°, but on the wider version it comes down to about 30°.

Note that the widening or compressing of clockwise and anti-clockwise letters happens on the parts of the strokes that form the branches; the stems of the letters are exactly the same as those in formal Italic. Letters such as **e** and **c** and **s** widen or tighten according to your **o** shape. The bases of **l** and **t** follow the **o** shape also.

Figure 15

Variation 4: Altering the serif form

The serif form in Bembo's Sonnets is a simple hook. Altering this provides subtle differences and can further enhance the type of Italic you have chosen to use.

Figure 16 shows examples of three variations of serif form.

The first (figure 16.1) is the extended tick serif. My preference is to use this only on the ascenders, retaining hooks elsewhere. This form works well with the forward movement of the writing, the making of it being a forward and upward push instead of the reverse movement to make the hook serif. When you start the ascender, push upward on your pen angle track, so that the line is a hairline, and then pull downwards as normal. Make sure the line doesn't go right through the top of the ascender; that will make an uncomfortable slab. Extended tick serifs allow speed in writing and can, in fact, be added after the word is written. Ensure they are as fine as possible.

The second (figure 16.2) form is a push serif, which gives a slightly jaunty, bouncy look. On ascenders, begin this roughly halfway up the height of the ascender at your pen angle of 40°. Push sideways and then up on the track of the ascender to the full height and then pull down to make the ascender. Instead of the hook exit serif at the base of letters, when you reach the line, come on to the *right*-hand corner of the nib and tease the wet ink up and out to form a small hairline. The example shows a manipulated base to the **g**, which seems appropriate for this degree of informality. As you come below the base line with the descender, press briefly on the nib to ensure there is sufficient ink on the paper, come on to the *left*-hand corner of the nib and tease the wet ink up into an elliptical

Figure 16.1

angelica b d h l k

Figure 16.2

angelica b d h l k

shape. Be careful not to use any pressure in the making of this. You *must* come back up on the end of this stroke so that the eye is pulled back to the word. Try to make the transition from full nib on the paper to corner as smooth as possible so that there is no break. This may take some practice!

The third variation (figure 16.3) is a change of ascender and descender shape and with the addition of what is called a 'swash'. This is a very important form, providing elegant formality to the script.

Make these ascenders starting just below the full height on a slight pull to the left so that you have a 'thin' at the beginning of the stroke. Having completed the letter, come back to the top, placing the pen in the wet ink below your start point, and push up and

over, ending in a small hook serif. This form must be upward-moving; a swash that looks down at the letter foot will collapse. The descenders can be as for formal Italic, as the **g** in the example, or can be 'swashed' as in the **p**. The swash on the **d** is kept slightly shorter than the others; too long and it will unbalance the letter, making it tend to fall forwards. Note the double **l** in the example: the first is made shorter than full height, but it is full width, running into the full height **l**.

This swash form can be made more contemporary (figure 16.4). Here the shape is made in two strokes as the formal swash, but the top is manipulated, twisting the nib anti-clockwise between thumb and forefinger, but instead of twisting to 90°, pulling off to the right on the left-hand corner of the nib. This will give a small break to the shape

Figure 16.3

Figure 16.4

where the full pen lifts off the paper, a desirable edginess in contemporary work! You can, if you wish, tidy this up by retouching with the corner of the nib while the ink is still wet, pushing back into your stroke, again on the left-hand corner. The **b**, **d** and **h** in the example have been left 'rough', the **l** and **k** have been retouched. You can use manipulation on the descenders to match the ascender shapes. On the example **p**, the right-hand corner of the nib has been used, pressing on the nib at the full depth of the

stroke then coming on to the corner to pull up a hairline. This pressure where the full nib is lifted off the paper provides a matching 'break' to those at the top. Again, this will take some practice. The final example is an **l** and a **b** with a swash made with the anti-clockwise manipulation, ending with a near-90° angled serif.

On any swashed ascender, be very careful not to curve the main stem.

Figure 17

When you choose to use any of the variations on serif forms described, in particular the swash ascenders, take the height of the ascender up to 5 nib widths instead of 4, so that the extended serifs don't interfere with legibility.

There is another variation on the serif form, the tick serif. This form has been used on the next variation, pointed Italic.

Variation 5: Pointed Italic

This variation changes the shape of the **o** to be pointed at its base. It is perfectly possible to have a version of pointed Italic where the **o** is sharp at both top and base, but carried through the alphabet, this gives a Gothicized look which is not as clean and contemporary as the version here.

Figure 17 shows the alphabet, in its family groups. The **o** is the start point, as ever, establishing the width, which for the moment is kept at formal proportions. Tick serifs have been used to further emphasize the sharpness, made with a push up on the 40° angle, sharp and fine. Ticks can be used at the base of letters, or you can use sharpened hooks.

The anti-clockwise group have the point at their base. Begin these letters exactly as you would formal Italic, with a very slight curve on the bowl, but when you reach the line turn sharply and push right up to the top line. Manipulation is not strictly necessary here, but a slight change of hand position, rolling anti-clockwise on the heel of the palm, will help you to come on to the corner of the nib, giving a thin on the upstroke. Extending the tops of the letters through the stems to the right will make a 'spur' which contributes to

the angularity. The alternative form of descender, described above in 'push' serifs, is appropriate here as it minimizes what is below the letter and allows the eye to concentrate on the sharpness of the letter above it.

The clockwise group have the point at the top of the arch. Branch as normal at halfway and then, on touching the line, pull sharply down. Retaining a hint of a curve on this downstroke will prevent the letters from looking wooden. For a better sharp **k** change its shape to give a parallel strut.

The letters **j** and **f** can take the manipulated descender, **l** and **t** have sharp bases, the long straight **f** is appropriate for a sharpened form.

The elliptical letters **o**, **c**, **e** have the point at their bases, the **o** resembling an **a** minus its stem. The change of hand position on the paper previously mentioned should enable you to keep the exit strokes of **c** and **e** hairline. The bowl of the **e** is made in two strokes, the base being pulled out from the back of the letter, extending to create a small 'tongue'. Keep the turns on **s** as angular as you can. Anti-clockwise manipulation of the pen has been used on the tops of **r**, **c** and **s**, that is, rotating the pen in the fingers anti-clockwise while moving to the end of the stroke and pulling downwards with the pen finally at an angle of 90°.

The diagonal letters are, of course, angular. Using tick serifs instead of hooks will make them even more so.

Figure 18

angelica

Figure 19

raw and cold is icy spring

Figure 18 shows the word 'angelica' in pointed Italic, for comparison with the other variations. However, this script really benefits from introducing another variation, compression, as in the phrase in Figure 19. Here the tightness and angularity of the letters and the space within and between them all contribute to emphasize the rawness and coldness of the words. If you further change the height/weight ratio, making for heavier letters, the script can become quite aggressive and harsh, suitable for texts about war and violence. Take the height/weight ratio the other way, making lightweight forms, and they will express fragility and brittle delicacy. This is a very different creature from the next variation, cursive Italic.

Variation 6: Cursive Italic

Cursive means joined, and cursive Italic is one of the most important variations, a flowing and lyrical script, written more quickly than formal writing because of the lack of pen lifts.

The spacing of cursive Italic needs to be wider than the formal script as the ligatures are a visual interruption of the space between the letters.

Figure 20

minimum

minimum

Figure 20 shows the word 'minimum' joined and unjoined. Note the tight turns at the base of the letters. The ligature (the joining stroke) enters the **i** and **u** as a sharp join, but is hooked round in a tight turn on **m** and **n**. The diagonal letters and **r** will also have this tight hook. The **p** takes a sharp join.

Figure 21 shows the cursive alphabet in groups, not in family groups this time but according to the way they join.

Here I have used extended tick serifs on the ascenders as they accentuate the forward movement of the script.

The letters **a**, **d**, **h**, **i**, **l**, **m**, **n**, **u** and **t** join from the base in a tight turn. The cursive **t** is made slightly taller than the formal letter so that a ligature can tuck in below the crossbar. The **c** and **e** also join from the base, but the elliptical shape of the letters is retained in the making of the ligature; **b**, **p** and **s** may be left unjoined, or have a false ligature, coming from the point where the bowl and base overlap. If you leave these letters unjoined

you will have to adjust the space between them and the following letter. The **o**, **r**, **v** and **w** join from the top. The **o** is made in one stroke and is left open with a sideways join from a small 'ear'. Ensure that there is sufficient closure at the top that the letter is not misread as **u**. These sideways joins must be made with a slight dip, otherwise they will look wooden. The **t** and **f** join from their crossbars (**t** can also join from its base), and the cursive form of **g** joins from its 'ear'. This letter has an elliptical top bowl, the same as the **o**, the full depth of the lines, left open, and its base is a taut curved open descender. Note the tightness of the curves on this stroke; any hint of roundness will render it weak. Both forms of **y** and **j**, the **q** and the conventional forms of **g** and **z** are left unjoined. There is an alternative form of **d** which is also unjoined. This letter can be made in one stroke at smaller sizes, but large, it is best made in two.

There are two awkward ligatures in cursive Italic, from the **k** and the **x**. Changing the shape of the **k** to have a strut parallel to its

Figure 21

a d h i l m n u t

c e b p s

o r v w t f g

y y j j q g z d

k x

stem solves the problem. Ensure that the left-to-right diagonal of **x** is steeply sloped using a high pen angle and this will enable you to turn sharply enough at the base. Alternatively, the letter can be left unjoined.

Begin your practice with a largish nib such as a Mitchell no. 2 or the equivalent Brause. Cursive italic is essentially a bookhand, written fairly small, but as ever it is best to learn through large writing. Practise the

letters individually, concentrating on achieving the tight base turns. A common fault in cursive Italic is to make this turn too round, which will mean pushing up almost vertically for the ligatures, spoiling the uniformity of their slope.

Writing words

When you feel comfortable with the shapes you are making, move on to writing words. In small writing it is perfectly possible to push against the pen to form the tops of the anti-clockwise letters and the descenders, but in larger writing this proves more difficult, so in writing words the tops of letters are left open so that there are fewer pen lifts and the speed of writing is increased. Having finished the word, come back and complete the letters. Figure 22 shows the word 'angelica' written cursively. There was a natural pen lift to make the ascender of the **l**, but otherwise the writing was continuous. Care was taken to establish the elliptical forms of **e** and **c**.

Below this is the completed word; the tops of **a**, **e** and **c** have been added and the descender of the **g**. When using this method, check your writing carefully afterwards to ensure that no letters are left unfinished. In cursive writing there should appear to be only two slopes, that of the letters themselves and that of the ligatures.

Joins

The base join into the anti-clockwise letters should come up to the point where the back of the bowl and the top overlap and there is a brief 'thin'. As you pull down to make the bowl of the letter, that stroke will overlap the ligature and the join will appear to be lower, but you must push up almost to the line to achieve the right amount of space. Joins into letters with an ascender should come up to the top writing line, then the pen is lifted to start the ascender and pulled down, again, slightly overlapping the ligature.

Figure 22

It is important to move your hand along the page as you write and to lift off as soon as you feel any strain, relax for a second and pick up where you left off. There are natural places to lift: before all the ascenders and having made the descender of **p**.

There are some difficult joins in cursive Italic, notably the sideways join into the **f**, **f** into **t**, the base ligature into **t** and **f**. Figure 23 shows the word 'often'. The sideways joins are lifted above the line to allow the crossbars the room they need. Alongside is 'st' where the false ligature from the base of **s** tucks underneath the crossbar. Similarly, the word 'daffodil' shows the join into an **f** and the double letter **f** ligature. Never run the crossbars of two **f**s or two **t**s together; you will create a strong horizontal mark which works against the slight uphill feel of this script.

After enough practice to familiarize yourself with the joins and with the movement of the hand on the page as you write, you can change to a smaller nib and try writing at a smaller size. It's a good idea to do this gradually, changing from a no. 2 to a 2½ and from there to a no. 3 and so on. Figure 24 shows two lines of a poem by Lord Byron, thoroughly appropriate to the flowing and elegant character of cursive Italic, written with a no. 4 old-style Mitchell nib, with just over 2 'x' heights between lines to emphasize the lightness of the text. Extended tick serifs have been used. Below this is the same text, written with a no. 3½ old-style Mitchell nib, using the modern swash ascenders described above. Compare the two. They are quite different, aren't they? The swash ascenders give a more open and flowing look to the writing, perhaps matching the words more effectively than the tick serifs.

Figure 23

Figure 24.1

She walks in beauty like the night
of cloudless climes and starry skies

Figure 24.2

She walks in beauty like the night
of cloudless climes and starry skies

The script in use

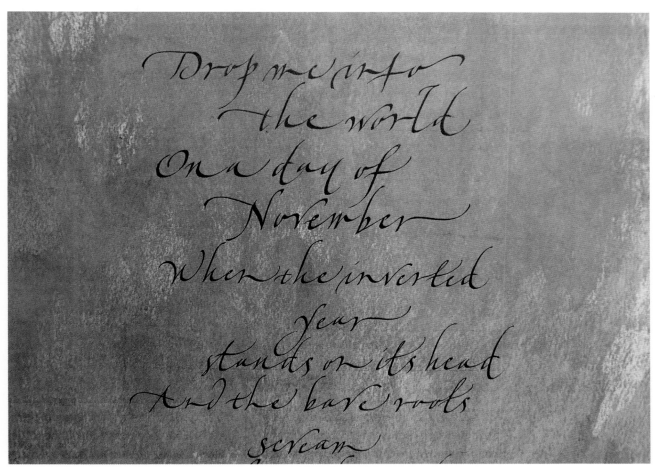

Gaynor Goffe
Poem by Liz Davies (see Chapter 13, page 186, for the full piece)

Contemporary flourished cursive italic. Ink on an acrylic background on hot-pressed paper

90 cm x 36 cm

Variation 7: Altering the branch point

Before beginning this last individual variation on formal Italic, try a small experiment: using a no. 2 nib at 5 nib widths high and with a pen angle of 40° *without manipulation*, write the letter **n**, branching off from near the bottom of the letter. You will find that the action of the pen throws you wide and you will have to make a fairly angular turn to make the second stem. Now try the opposite: having made the first stem of **n**, push right up almost to the top of the letter before branching off. You will find that unless you force it, the pen will comfortably make a tight turn and the letter you achieve will be very narrow. Finally, write a letter **n** with a branch point at halfway; the letter should be of formal proportion. This shows the importance of the branch point to Italic. Study the shapes of the arches on your three letters. That of the formal **n** will be asymmetric and elliptical. The arch on the low-branching letter will be extremely asymmetric and angular, and on the narrow letter it will be an almost symmetrical ellipse. Three very different shapes brought about by the difference in the branching point off the stem.

Figure 25

nhmrbpk

adgqu

ijltf oces

vwxyz

Throughout the variations the **o** has been used to establish the width of the letters, and then the anti-clockwise letters have come first. For this variation the **n** is the key letter, so the examples start with the clockwise letters, which form natural shapes, the anti-clockwise being designed to match, with the all-important triangles of space at top and base of the letters kept uniform.

Begin with the low-branching letters (see Figure 25). You should find that the clockwise group is relatively easy to achieve and the widths will be consistent as long as you branch from the same place at the base of the stem. Being aware of how the letter *feels* in the making is particularly important here. Be careful in making **b** and **p** to keep the bowls of the letters fairly flat-sided or you will end up with an unpleasant shape. The **k** reverts to its normal shape.

Now try the anti-clockwise letters, establishing the **a** shape first. Keep the back of the bowl of **a** as normal and the turn at the base, but travel much further sideways and up, having turned off the line, arriving at a point three-quarters of the way up the writing lines before pulling parallel to your first stroke. On reaching the top line, close the letter with its top, lift, put the pen back on and pull down for the stem. The **d**, **g**, **q** and **u** follow suit, the **u** of course being flat-sided. Examine all your letters at this point. Are they of similar width? And importantly, are the triangles of space the same size top and bottom? If they are, your branch points are accurate.

The rest of the letters, apart from **i** and **j**, need to be widened to have the same visual space within them as the **n** and **a**, the **l**, **t**, **c**

and **e** taking their base shape from the elliptical **o** and the **s** widening at its centre. The diagonal letters are widened to match.

In writing words, space the letters generously to match the space within them. This form will give you an alternative to the expanded version in Variation 3. It is light and airy, but has a slightly more edgy feel because of its angular arches, as opposed to the gentler, softer, wide ellipses of the expanded letters.

Figure 26

Figure 27

Now try the opposite of what you have just done; start with the clockwise group again so that you establish the position of the branch point and the width of the letters (see Figure 26). You will not need any manipulation, but coming off the pressure as you push up the stem will make things easier. The **k** again changes shape to keep it narrow.

For the anti-clockwise letters, turn sharply at the base and push up parallel to your first stroke, again using lighter pressure. Put the top of the letter on and pull down for the stem. Check your triangles of space. Are they consistent in size? The rest of the letters follow the width of **n**, the **o** being a compressed ellipse, the first stroke of **s** being steeply downhill to keep it narrow.

Figure 27 shows the word used throughout these variations written in both versions. The difference is extraordinary: one light and airy, the other tight and very formal. Carried through to texts, the tonal value on the page will be markedly different, very useful if you have to lighten or darken a block of text in a more complex piece of work.

Further experiments with variations
Thus far you have taken seven of the characteristics of the script in Bembo's

Sonnets and changed them individually while keeping the other elements formal, and this will have begun to build up a repertoire of different Italics that will greatly widen the interpretative possibilities of your writing. Now you can move on to introduce more than one variation into a single letterform: for instance, in my example of pointed Italic, where the shape of the **o** was the variation initially and then the proportion of the **o** was changed, compressing the letters, producing a tighter, more dynamic form. Try this initially quite methodically, choosing three characteristics and seeing what happens: for instance, a letterform that slopes more than the formal 5°, that is based on a pointed **o** and is cursive, or one that has a higher height/weight ratio than the norm of 5 nib widths, that is more upright and is compressed. You will find in your experiments that there are some very ugly combinations, in which case reject them. You are working now with aesthetics and your criterion has to be 'does it look good?' If it doesn't, it has no place in your writing. Look for the possibilities for interpretation.

Figure 28 shows a few words, written freely, some of them with manipulation, others without. Try analysing them to find out what has been done.

Figure 28

gypsophila buddleia

azalea calendula viburnum

hydrangea iris narcissus

euphorbia

The script in use

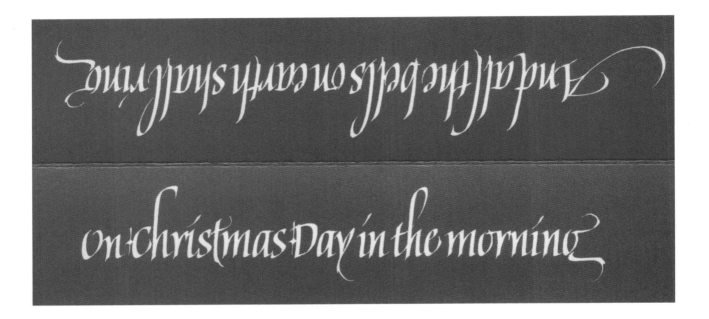

Gillian Hazeldine
Christmas Card

Compressed, sharpened italic with some manipulation and flourishing.

Original artwork ink on paper, Mitchell nib. Reversed black to white and printed in red by offset litho.
4.5 cm x 21 cm

Italic Capitals

The Italic capital form in contemporary calligraphy is a narrower, sloped version of the Roman capital. This is an important letterform in modern writing, used with minuscules where necessary, but it is capable of great variation, offering wide opportunities for work made entirely in capitals, from formal to the most expressive.

The letters fall into the same width groups as Roman capitals, but the key **O** shape is an ellipse of the same proportion as the minuscule **o**, 1½ times its width high. For construction purposes, this ellipse sits within a parallelogram that has a 5° forward slope.

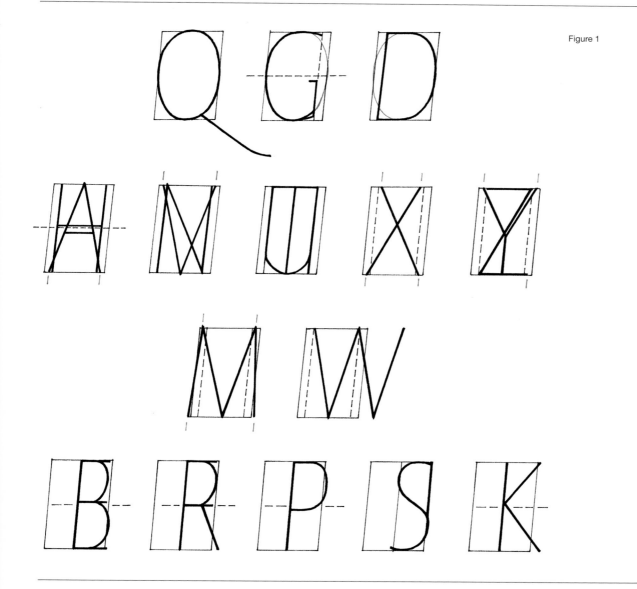

Figure 1

Figure 1 shows the letters constructed within this geometric framework. Some small adjustments are necessary for aesthetic purposes rather than a rigid fitting-in of shapes. The red lines above and below some of the diagrams indicate these and they are described below.

The letters using the full ellipse or a good part of it are **O**, **Q**, **C**, **G** and **D**. **O** and **Q** are overlaid on the same diagram. The tail of **Q** is long and elegant, flattening off at its end. **C** and **G** are overlaid: both are seven-eighths the **O** width and the base of **C** follows the ellipse round to establish the shape, while that of **G** is flattened a little to give more stability. The strut of **G** begins just below the halfway of the parallelogram and meets the flattened base. There is no strut below the base in the formal **G**. The tops of both **C** and **G** are flattened off the ellipse. **D** is a seven-eighths width letter; its bowl follows the shape of the elliptical **O**.

H, **A**, **V**, **N**, **T**, **U**, **X**, **Y** and **Z** are the three-quarter width letters. **H** and **A** are overlaid. The crossbar of **H** is just above the halfway line; that of **A** is below. The legs of **A** are taken just outside the three-quarter box to make the letter look the same width as the straight-sided letters in this group. The apex cuts the line. **V** and **N** are overlaid: the legs of **V** are taken just outside the three-quarter box, the apex cuts the line. **N** sits within the three-quarter box and both apexes just cut the lines. **U** and **T** are overlaid: **T** is straightforward, a crossbar within the three-quarter box and a central stem. **U** picks up the base shape of the ellipse of the **O**, and has a small strut at its lower right-hand side. The top of **X** is made smaller than the base by starting the strokes inside the three-quarter

box and taking them outside the box at the base. **Y** and **Z** are overlaid. The legs of **Y** sit outside the box and its apex is below the halfway line. **Z** sits within the box at its top, the base extends slightly outside the box at its end.

The legs of **M** drop from a point between the parallelogram and the three-quarter box to just outside the parallelogram at the base; a letter fitted within the parallelogram would look too narrow. **W** consists of two **V**s juxtaposed. These shapes are the width of the three-quarter box without the slight widening of the individual **V** so that the overall width of the letter is 1½ times the parallelogram.

The narrow letters are the same as those in Roman capitals: **EFL**, **BRP**, **SJK**. **I** is monoline. **E** and **B** are overlaid on the same diagram as they are built on the same framework, the middle limb of **E** and the waist of **B** lifted above the halfway line. The top and middle limb of **E** fall just short of the half box; the base protrudes very slightly beyond it. The bowls of **B** follow these widths. **R** and **F** are overlaid as they share the same framework; the lower limb of **F** and the waist of **R** sit on the exact halfway. The limbs of **F** fall just short of the box, but the bowl of **R** fills the box. The bowl of **P** is larger than that of the **R**, coming to below the halfway and breaking through the confines of the half box. The bowls of **B**, **R** and **P** are part of elliptical **O**s in the same way as the bowls of the Roman letters had the circle as their underlying shape. **S** and **J** are overlaid; **S** has shallow ellipses as its bowls; the top and base curves are very flat, the top aligns with the lower counter on the 5° slope and the base protrudes very slightly beyond the top bowl. **J** shares the shape of the base of **S**. **I** and **K**

Figure 2

O C G D Q

H A V N T U

X Y Z

M W

E F L B R P

S J K I

are overlaid; **K** is made wider than the half box at its top and is considerably wider at its base, otherwise it would look far too narrow. **I** is, of course, monoline.

Try tracing these letters with a pencil first, to accustom your hand and eye to their narrowness. Order and direction of strokes is exactly as the Roman letters, working from top to bottom and from left to right.

Move on to write the letters with a no. 4 Mitchell nib or Brause equivalent, still in their width groups. Figure 2 shows these letters. Note that although the width groups are exactly as Roman capitals, because of the narrower underlying shape of the parallelogram the differences in the visual widths of letters between the groups are not so marked.

These skeleton letters are useable forms in their own right, dressed up with small serifs, either elliptical hooks or hairline slabs.

Spacing of Italic capitals follows the same rules as Roman capitals, with the space between straight-sided letters approximately half the height of the letters themselves.

Elliptical letters will sit slightly closer to straight-sided, and two elliptical letters closer still. The space within open-sided letters will have to be taken into consideration. Figure 3 shows a short phrase written in skeleton capitals, with small slab serifs.

The weighted letters

Capitals written with minuscules must be smaller than the height of the ascender. The height/weight ratio of the minuscule is 5 nib widths and the ascender height is 4 nib widths, making an overall height of 9 nib widths. Thus the formal capital is written at 8 nib widths high.

Figure 4 shows the weighted letters in their width groups written with a Mitchell no. 2 nib. The base pen angle is 40°, or it can be slightly lower. It is flattened for the crossbars of **A** and **H**. As with Roman letters, the pen angle is steepened for left-to-right diagonal strokes; I tend to take it quite high, to around 50°–55°. Revert to 40° for right-to-left diagonals, with the exception of that of the **X**, where it needs to be flatter, around 25°. The diagonal stroke of **Z** is made with an almost flat pen angle.

Figure 3

NEW LIFE IS EVERYWHERE

I SAW
OLD AUTUMN
IN THE
MISTY MORN
STAND
SHADOW-
LESS
LIKE SILENCE
LISTENING
TO
SILENCE

Gillian Hazeldine
I saw old Autumn...
Thomas Hood.

Skeleton italic capitals,
slightly built up at the top
and base of the letters.

Gouache on Khadi paper.
Leaf made from Japanese
paper and coloured.
50 cm x 30 cm

Figure 4

OCGDQ

HAVNTU

XYZ

MW

EFL BRP

SJKI

The angle for the legs of the **N** and the first leg of **M** is high, approximately 55°, and as with the Roman **N** I use this angle for the diagonal as well. **M** requires changes of angle to achieve two pairs of same-thickness strokes: 55° or thereabouts for the first leg, 45°–50° for the left-to-right diagonal, 40° for the third and fourth strokes. The most important factor in a good letter **M** is that the tops of the two counter spaces are on the same level. **W** is two **V**s juxtaposed, keeping the base shapes slightly narrower than the individual **V**. Angles are 50°–55° for the left-to-right strokes and 40° for the right-to-left. On **M** and **W** you must have two strokes that are visually the same width as the vertical stems and two that are visually the same as the lighter-weight strokes of **A**, **V**, **N** and **X**.

The narrow letters are all done with an angle of 40°, except for the diagonal strokes of **K**, where a flatter angle, around 20°, is necessary for weight distribution. Flattening the angle very slightly from 40° for the strut of the **R** helps keep the weight similar to that of the stem.

Don't let the angle changes that are required for capitals deter you from using them in larger pieces of work. This is an elegant form, capable of great variation, from formal to dancing and from heavy to light. Layout in work that is made in capitals is easier as there are no ascenders and descenders to cope with, so interlinear space can be whatever you choose: close, giving a dense texture, or more open. It will depend on the words and your intention.

DOMINO

Figure 5

Figure 6

WELCOME TO YOU
RICH AUTUMN DAYS

Figure 7

Welcome to you rich Autumn days

Practise the weighted letters first in their width groups and then move on to writing words. Use a largish nib for this, at least a Mitchell no. 2 or equivalent, so that you learn to write moving your arm from the shoulder, not just your fingers. Spacing is as described above for the skeleton letters. The word 'DOMINO' in Figure 5 shows the three different spaces in the rule: two straight-sided letters together, a straight-sided and an elliptical and two elliptical letters. Figure 6 shows a short phrase, for spacing. Figure 7 shows this same phrase in minuscule Italic with the appropriate capitals at the correct height.

Check your work carefully to ensure that the widths are correct. Remember Italic capitals will have smaller differences between the elliptical group and the narrow group than in Roman letters, but an **E** or **R** must always be narrower than a **D** or an **O**.

The serif form I have used on the weighted examples is hooks at the tops of the letters and slabs at the base, which provides a semi-formal look. Make the slabs by lifting the pen off the paper and flattening your pen angle to about 20°. Italic capitals can take the same serif variations as detailed in the Roman capitals section.

Varying the Italic capital form
Having done sufficient practice to feel comfortable with the formal letters and to be able to write them fairly fluently, you can move on to explore the many possible variations. The process is the same as with the minuscules, varying one element at a time.

Figure 8 shows a word, chosen as it has a good combination of different-width letters, written with different nibs. I have ruled lines at 8 nib widths of a no. 2½ Mitchell and then written the word first with a Mitchell no. 0, which gives a letter that is a lot heavier than the norm. As with minuscule letters, capitals written at this vertical compression (it is in fact 3 nib widths of the no. 0) need to be widened to retain counter spaces, and to facilitate this the angle has been flattened to around 30°. The word below is written with a no. 1½ Mitchell nib; the compression is less

29°

ASPHODEL

Figure 8

32°

ASPHODEL

40°

ASPHODEL

ASPHODEL

(5 nib widths) and so although the letters are heavier than the norm, the counter spaces are more generous and the pen angle can comfortably be a bit higher.

Below this, the word is written with a no. 2½, so this is the formal weight with formal widths. The final word is written with a no. 4 nib, skeleton forms with formal widths.

Look at these four versions of the word and consider their impact on the page. I mentioned 'tones of voice' in the Italic section on weight variation and that is how you have to think here. The word written with the no. 0 nib 'shouts'. It is a black and insistent mark on the page. The level of 'volume' decreases as you come down to the writing in the no. 4 nib, which is gentle, almost a whisper. If you

have difficulty seeing this, prop the book up at some distance from you and half close your eyes so that they are not completely focused. The dark tonal value of the no. 0 writing will advance, the light tonal value of the no. 4 writing will recede. This is a very important thing to understand in order to be able to control textures and tonal values in a piece of work, be it in capitals or minuscules.

Figure 9 shows compression and expansion of the form. It is essential when you are playing with this to start with the **O** shape, so that you can gauge the widths of the rest of the letters. The first example is our word compressed slightly, based on an **O** that is around three-quarters of the formal width.

Below that is the word based on an **O** that is twice its width high, producing very compressed forms. The pen angle on both of these is around 40°. The final word is based on an **O** that is wider than the formal; the pen angle is flatter.

Consider the interpretative possibilities of these three variations. The more compressed words are tighter, denser marks on the page. Think about body language; what do you do when cold? You wrap your arms around yourself, tightening your body, pulling everything in. These letters can express that degree of discomfort, edginess, tightness. By contrast the more open letters are generous, expansive, warm, comfortable.

Figure 9

O ASPHODEL

O ASPHODEL

O ASPHODEL

Spend time experimenting on all the possibilities of weight change and form change. Write with as many nibs as possible initially, all between the same lines, and then try varying the sizes. Annotate your work; write down which nib has been used for which writing, so that you can refer to this in future.

For the moment you may still need to work in nib widths high, but this exercise should help you to understand that in varying letters for expressive purposes, you simply pick up a nib and write with it. If it is not giving you the desired weight at the height you want, move up to a bigger nib or down to a smaller. If it is only slightly too light in weight, take the height of the writing down a bit; it will then be marginally heavier. If it is too heavy, make the letters taller. Experiment, too, with compression. See how far you can push it and find out if you will have to make changes to any of the letters at extreme compression. (Refer back to the Roman capitals chapter.)

One variation which should be avoided is a large increase in the forward slope of Italic capitals. The letters will simply appear to fall over. An upright version is perfectly viable.

Using variations with texts

The next step is to start using letters to express emotions or movement. Figure 10 shows several short phrases written with interpretation very much in mind. The first one is written in formal weight capitals with a no. 3½ nib and here I actually worked out what height 8 nib widths of that nib would be. The formal letter is quite gentle at this size, appropriate to the sound of a thrush trying its voice out at the beginning of the year. Interlinear space is just over half the

letter height so that the two lines 'knit' together but are separate enough to be legible.

On all the rest of the examples, I simply picked up a nib and wrote with it, having chosen my phrase. Once happy with the weight and height, I ruled lines. 'Showers scudding past' is written with a no. 2 nib, compressed and with a very slightly increased forward slope to give a feeling of movement. The **R** has been altered to keep it narrow.

'Deep buried ...' is also written with a no. 2 nib, compressed the other way, from top to bottom. The lines have been placed very closely together to increase the tonal value on the page. This works well with just two lines of a short length, but in a text of several lines the interlinear space would need to be increased to aid legibility. However, a greater number of lines would make for a dark tonal value and texture.

'A gentle day ...' is written with a no. 3½ nib and a widened form. Here the key word is 'gentle'. Again, the interlinear space is almost the height of the letters, keeping the overall feel of lightness.

'Out of the north ...' is written with a no. 4 nib with a very compressed form, and here I have altered the **R** shape again. The word 'north' implies cold and the wind is 'shrilling', not 'gale-force', so the light form seemed appropriate but the size has been increased. Interlinear space is almost half the letter height; these compressed letters take longer to assimilate than the rounder forms above so space between the lines is important.

Figure 10

TWO THRUSHES
TRY THEIR NOTES

SHOWERS SCUDDING PAST

DEEP BURIED
IN THE DARK EARTH

A GENTLE DAY·A DAY
OF MISTS AND GLEAMS

OUT OF THE NORTH
A WIND COMES SHRILLING

BLOW WINDS·AND
CRACK YOUR CHEEKS!

Finally, Shakespeare's familiar words from *King Lear*. Here the wind is much stronger, so a darker letter is called for; this is a storm, so a tight, forbidding letter works to convey the meaning and the size has been taken up to help convey the louder 'voice'. This is extremely compressed writing; the **O** is 2½ times its width high. Any narrower than that and there would be problems with the letter **W**, and whereas the forms of **M** and **N** can change in order to narrow them, the **W** needs to retain its shape of two **V**s juxtaposed. A no. 2½ nib was used here.

There are only six phrases here, but look at the difference between them and the way they behave on the page. The different letterforms and tonal values should begin to let you know what the text is about before you actually read it and you should find that you react differently to each phrase.

For further practice on varying Italic capitals, find small pieces of text that you like and play around with what you can do with them. Remember to write down what you have done, and which nib you have used.

Freeing up the capital form
We move on now to something that will add greatly to your ability to express meanings in Italic capitals: freeing up the form.

Thus far we have worked with a capital form based on an ellipse within a parallelogram, the sides of which slope at 5° and the base and top of which are horizontal. To free up the form, we are going to change the parallelogram to have a top and base which slope uphill. Figure 11 shows the basic skeleton forms of **O**, **H**, **A** and **E** contained within the formal parallelogram and, underneath, the changed shape. These letters instantly look livelier as the left-hand side is lower than the right, making them look poised to move. Crossbars and horizontal limbs will follow the slope of top and base. To further free up the shape, you can dispense

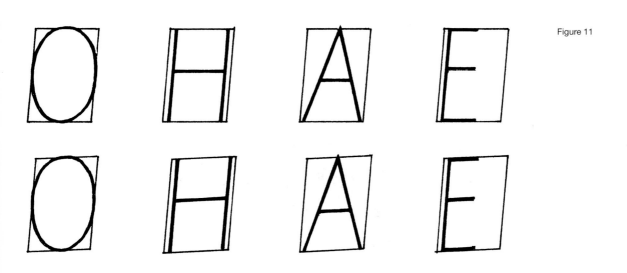

Figure 11

Figure 12

A B B C D D E E
F G H I J K L L
M N O P Q
R S S T U U
V W X Y Z

with foot serifs on letters, which act as an anchor to the line. To ensure that the forms are still fairly stable, use a small amount of pressure as you reach the base line and pull off slightly to the left. This produces a swelling and a fairly elegant shape, and allows the letters to appear to dance. You can also play around with top serifs: for instance, the letter **H** is a somewhat pedestrian letter owing to its absolute symmetry; altering the serifs to make them asymmetric makes it a much more interesting shape.

Figure 12 shows a full alphabet written using these changes. Notice that I use a flatter pen angle than the norm for these letters as it lightens the tops and horizontals further.

The pen angle is kept fairly high for the right-to-left stroke of **A**, keeping it thin. There are two versions of **B**, one closed, one open. In making the open **B** be very careful about the white shape you create as its counter. The second **E** shows a flourished base stroke, up on to the left-hand side of the nib. Don't use this in the middle of a word; it will throw out your spacing. **G** has a strut, made with manipulation on to the right side of the nib. **I** and **J** have built-up tops as described in the Roman capitals chapter. Without these, both letters could look weak. The base of **L** can be flourished like the **E**. **O** and **Q** are left open and the tail of **Q** can be flourished. An open form of **R** is used for preference. Leave this letter open enough for it to be clear that this

Figure 13

SUNLIGHT WEAVES IN THE CORN

DARK THUNDERCLOUDS GATHERING TENSION BEFORE THE STORM

is your intention. The base of the second form of **S** has been made with fast manipulation on to the right-hand side of the nib and then the shape has been retouched with the corner of the nib. There are two forms of **U**; the second shape must be asymmetric. Make this in one stroke so that you achieve a good shape at the base, and then pull back down from the line to retouch the right-hand side if necessary.

Free capitals are capable of all the variations of weight, height, compression or expansion and serif form of the formal letter.

Figure 13 has two examples. The first, 'Sunlight weaves ...' is written between lines ruled at 8 nib widths of a no. 2½ using a no. 2½. The letters look open and elegant, poised on the line. In complete contrast, 'Dark thunderclouds ...' is very compressed vertically, to about 3½ nib widths high of the same 2½. These letters have been written without lines, so there is a natural variation in the heights of the letters. Compare these freely written forms with the phrase 'Deep buried in the dark earth' on page 112. The compression is about the same, but they look markedly different.

To make these letters successfully you will have to be very confident of your formal Italic capitals and your ability to handle the pen. They may take a lot of practice, but they are a dynamic and dancing form that is worth mastering.

Figure 14 shows free capitals taken a bit further in a short text written by Dag Hammarskjold. The letters are written freely, with a form that is compressed vertically and is widened slightly from the 'norm'. I have used quite a lot of manipulation on to both sides of the nib and two sizes to give contrast and emphasis to the key word in the phrase.

Italic or Roman?

I've often been asked in workshops about the difference between a Roman capital and an Italic capital. The answer to this in formal terms is simple: the Roman capital is based on a circle sitting inside a square, the Italic on an ellipse 1½ times its width high, within a parallelogram. Once you start to vary the forms, the differences become less apparent. A letter could be a sloped, compressed Roman letter or an Italic letter. Similarly it could be a widened, upright Italic form, or a Roman capital compressed slightly from the norm. Don't worry about this. Just use these letters to the full. Enjoy their endless possibilities for interpretative work.

Figure 14

MORNING CLEAR AS SPRING ROUSES TO LIFE THE BUTTERFLY COTILLIONS

The script in use

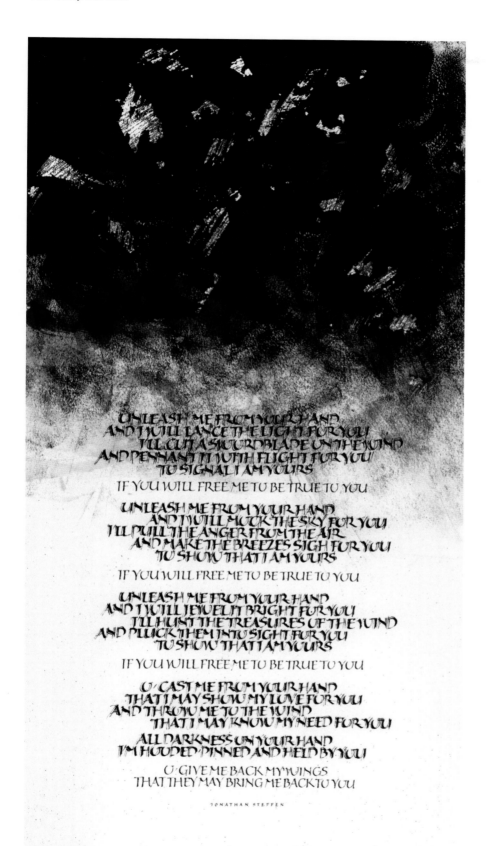

Gillian Hazeldine
The Falcon to the Falconer
(Text by Jonathan Steffen)

Freely written italic capitals,
some with an underlay of
skeleton letters to give a
feeling of agitation.

Acrylic paints, gold and silver
leaf, gouache and steel nibs
on BFK Rives paper
71.5 cm x 36.5 cm

Uncials

The Uncial developed during the Roman period and by the fifth century was the dominant bookhand of the West, in use until the eighth century and continuing to be used in headings and for important passages right up to the early Middle Ages. The earliest examples of Greek and Roman Uncials are directly written forms, made with a square-edged tool. The later, fully developed Uncial script is known as 'artificial' and uses much manipulation and the corner of the pen to form serifs and hairlines, making it a more slowly written script.

Uncials are a complete letterform, not strictly speaking a capital, as some letters have short ascenders and descenders, but there are no minuscules; the true minuscule didn't emerge until the eighth century and was perfected during the reign of Charlemagne.

The form that provides a contemporary letterform capable of variation is that of the Stonyhurst Gospel, the small and exquisite book found in the tomb of Cuthbert in AD 1105, but written long before that, before Cuthbert's death in AD 687. This is a 'natural'

Below:
Stonyhurst Gospel, AD 687

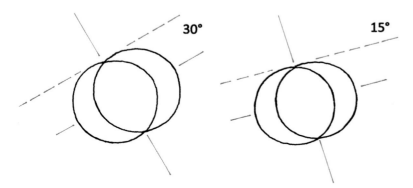

Figure 1

Uncial, written with a quill pen held at an angle of about 15° to the writing line. The height/weight ratio of the Stonyhurst script is around 3½ nib widths.

Figure 1 shows, for comparison, a double pencil o made at a height/weight ratio of 4 nib widths using an angle of 30° as in the Foundational Hand and one made at 3½ nib widths using an angle of 15° as in Uncials. The flatter 'pen' angle allows the tool to travel sideways, so the Uncial **o** is wider relative to its height, and that is what you must keep in mind when writing this script; its forms are wide, curved and majestic. Look at the differences in where the weight is (i.e. the full thickness of the nib) and the tilt of the counter space.

Figure 2 shows the weighted letters in their groups.

Group 1, the round letters: **O**, **C**, **G**, **E**, **D**, **P** and **Q**. The C has a flattened top to keep the counter space open. **G** has a strut. Make the letter as you would a **C**, but come up a little further at the base, pause and pull down and slightly to the left. **E** looks similar to a Foundational **e**, a minuscule. Keep the bowl high and tight. **D** is one of the two more challenging letters in Uncials, the other being the **N**. Begin the letter with the pen on the line, not below it as is customary, and make a shape that is the left-hand side of the **O**. Lift off and come about 1 nib width above the letter, aligned with the left-hand curve. Push up for the serif and then pull over, travelling

along a 10 o'clock/ 4 o'clock track, keeping this stroke straight until you can comfortably tuck into making the circular right-hand side. The direction your stroke travels in is crucial: too steep, and you will cut the counter shape of the letter in half. The height of the ascenders in Uncial should be no more than 1½ nib widths. There is an alternative form of **D** where the start stroke of the ascender loops back on itself. If you decide to use this letter, be careful to keep the start of the ascender over at the left-hand side. Allow it to come towards the centre and you will achieve a squashed tomato! **Q** and **P** look similar to the minuscule **q** and **p** of the Foundational Hand, but written at 15° instead of 30° they are wider and their descenders are shorter, no more than 1½ nib widths deep.

Group 2 comprises the straight-sided letters, **I**, **J**, **F**, **L**, **T** and **N**. **I** and **J** are straightforward,

but note they are not dotted. **F** has a short extension below the line; the top is the characteristic branched stroke of the Uncial, as opposed to the strong straight top that is required in Roman capitals. The lower limb of the **F** sits above the writing line; placing it on the base line puts too much space into the letter. **L** has an extension above the line. Make this letter in one stroke, with a short pause before pushing sideways for the base, so that the shape is softened at the left-hand side. **T** is similar in shape to the Roman **T**, but the flatness of the pen angle makes the top much thinner than the stem. The **N**, as mentioned, is a little more of a challenge. You *must* in this case make the legs of the letter first. Steepen the angle slightly for the legs, to about 25°. The left leg has a hook to start and finish, the right starts with a hook but just cuts the line at the base, finishing without a serif. The width of the letter is

Figure 2

Group 1

Group 2

approximately 4½ nib widths. Revert to a pen angle of 15°, place the pen on the top of the left leg and then pull down and sideways for the central stroke. Don't change your angle; the direction of the stroke, flattening off as it meets the second leg, will thin it as necessary. Note that it meets the right leg above the line. This is very important. If you come too low down you will take the space out of the lower counter and the letter will sag.

Group 3 consists of the branched letters, **H**, **M** and **U**. **H** has a small ascender and then the bowl is a similar shape to the right-hand side of **O**, but flattened off the circle at the base. The stroke ends without a serif and it slightly cuts the line. This is to make the letter look balanced. Do not be tempted to flourish this stroke and don't curve it round too much; the counter space must be left open. **M** is a

beautiful letter, resembling a ram's horns. Start just below the line and make a stroke that begins like an **O** but flattens off at the base, ending with a small serif. Come back to your start and push over with a flat stroke, turn down and make the central stem, again ending with a small serif. The final stroke is exactly as the bowl of the **H**, cutting the line. You must balance the counter spaces within the **M** for it to be successful, and keep them open. The width of the letter is 6 nib widths. **U** starts with a wedge serif. Push sideways and then use a circular shape, much like the **O**. The strut ends with a serif.

Group 4 is the small-bowled letters, **B**, **R**, **S** and **A**. Start the **B** with a hook and pull downwards almost to the base line, pause, and then push sideways to form the base. The top is branched, and the lower bowl is larger than the top. Keep an eye on the white

h m u

Group 3

B R S a

Group 4

v w x y z k

Group 5

space you are creating as you make this stroke. It should form a heart shape. The bowl of **R** is much larger, reaching to two-thirds of the way down the height, and then the stem kicks out quite well beyond it. Never close the Uncial **B** or **R**. **S** is similar to a Foundational **s**, with a more horizontal central stroke to achieve the correct width. The top counter is made smaller than the

base. **A** resembles a minuscule **a**, and it leans backwards. Be careful not to lean too much; the letter will look unstable and you will set up spacing problems. The bowl is done in one stroke, starting just over halfway down the stem, pulling out beyond the top by a small amount and then pushing back up into the stem. This will produce a slight thickening of the stroke where it meets the stem.

Figure 3

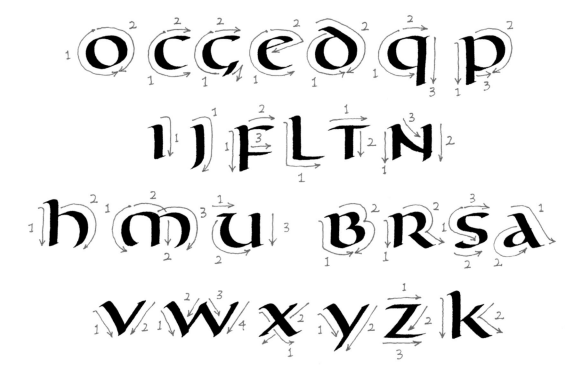

The final group, Group 5, is the diagonal letters. Steepen the pen angle of the left-to-right strokes, in this case to around 35°, and flatten to 20° for the right-to-left. Flatten the angle down below 15° for the right-to-left stroke of **X** and for the whole of the diagonal stroke of **K**. Flatten the angle to 0° for the centre of **Z**. Be careful to match the visual widths of the other letters with the diagonals.

Figure 3 shows the order and direction of strokes.

Formal Uncials in use

Uncials are a wide, static letterform and they look their best in longer lines of text, with good interlinear space. The example, Figure 4, uses a Welsh englyn written by Gwilym Cowlyd, which fits perfectly the calm, still feel of formal Uncials. The interlinear space here is approximately 1½ times the 'x' height of the letters. Spacing Uncials follows the usual rule, as much space between the letters as is within them. Circular letters will sit quite close together, with more space between the straight-sided letters. The space around the **a** needs to be carefully judged.

Figure 4

The calm green lakes are sleeping,
in the mountain shadow
and on the water's canvas bright sunshine
paints the picture of the day

Sue Hufton
Words by Thomas Aquinas

Quill and watercolour on vellum

11 cm x 35 cm

BESTOW
UPON ME
O LORD
MY GOD,
UNDER-
STANDING
TO KNOW
THEE,
DILIGENCE
TO SEEK
THEE,
WISDOM
TO FIND
THEE
AND A
FAITH-
FULNESS
THAT MAY
FINALLY
EMBRACE
THEE

Variations on formal Uncials

As with the previous scripts, the Uncial form is capable of variation, but make sure that you are completely confident of your formal letters before beginning to change them in any way.

Uncials have a very strong identity and are usually used with texts that reflect their time and provenance. As mentioned above, they are a static form, which you may find limits their use somewhat. It is possible to alter this and still keep some of the flavour of the original, widening the possibilities for interpretative work. But a word of warning: *never* lengthen the extensions of **D**, **F**, **H**, **K**, **L**, **P** and **Q**.

You should by now be familiar with the methods of varying letters: changing the height/weight ratio, changing the slope, changing some forms if necessary. Uncials are no exception to this.

The following stages will take you through the process of arriving at a useable modern form, using the first phrase from the Welsh englyn. Some of them are more successful than others, but all are useable.

Stage 1 (Figure 5): A simple change of height/weight ratio from 3½ nib widths to 3 nib widths high, written with a Mitchell no. 2 nib. The form becomes heavier, denser. The spacing is tightened because of the reduced counter spaces. Two short lines can work with a tighter interlinear space, 1 'x' height, than the longer lines of the whole text.

Stage 2 (Figure 6):A smaller nib, a no. 3, has been used between lines at the same height as Figure 5. This makes for a much lighter-weight letter, but it still works as an Uncial. The pen angle has been steepened to distribute the weight more evenly round the lightweight form. The interlinear space has been widened slightly to match the lighter letters.

Figure 5

The calm green lakes
are sleeping

Figure 6

The calm green lakes
are sleeping

Figure 7

the calm green lakes are sleeping

Figure 8

The calm green lakes are sleeping

Stage 3 (Figure 7): The form has been compressed, based on an elliptical **O** and written with the same nib as Figure 6 at a higher height/weight ratio, making the letters taller. Other than the weight and shape of **O**, the main characteristics of Uncial have been retained. Pen angle is around 30°. Interlinear space is the same as in Figure 6, but because of the taller letters it appears smaller.

Stage 4 (Figure 8): The same form as Figure 7, written with a no. 3, but given a forward slope. Here you may find that the backward-leaning **A** looks out of place, so you could experiment with a different form of **A** that

would be more appropriate in a forward-sloping script. Pen angle is around 35°. Interlinear space is the same as in Figure 7.

Stage 5 (Figure 9): Two suggested forms of **A** that are based on an artificial Uncial form, one retaining the top serif, the other having a minimal top serif that pulls in from the right. This was my preference and I have used it in the words 'calm lakes', where I think it is an improvement.

Figure 9

a a a calm lakes

Figure 10

THE CALM GREEN LAKES
ARE SLEEPING

Figure 11

THE CALM GREEN LAKES
ARE SLEEPING

Stage 6 (Figure 10): Here the variation is still sloped, still fairly lightweight, but the letters with extensions have been replaced with Italic capitals, with the exception of the **G**. Retained Uncial characteristics are the branched tops to the letters **R** and **P**, the forms of **M**, **N** and **G** and the minuscule-type form of **E**. Pen angle is around 30°. The interlinear space has been tightened as there are no extensions above the line.

Here I have also begun to play with the letter **E**, using three different forms, which adds a quirkiness to the text. This is a lively form.

Stage 7 (Figure 11): The weight has been increased; this was written with a no. 2 nib and is almost the same form as in Figure 10, with the exception of the **A**, which is now an Italic capital, left open at its top. Note that because of the heavier and wider form the pen angle is down to 20°. Interlinear space is tightened slightly from the lighter version.

Figure 12

THE CALM GREEN LAKES ARE SLEEPING

Stage 8 (Figure 12): Finally, a version written at the heavier weight, reintroducing the extensions on the letters **L**, **K** and **P**, reverting to the 'artificial' form of **A**. The round form of **M** has been used throughout all these experiments and here I have used an alternative **N** form based on the **M**, alongside the more Uncial-like **N** in 'green'. A bit of manipulation has been used on the bases of **M** and **N** and instead of finishing on a hairline, they have a small internal serif, made by flipping the pen on to its right corner and pulling sharply upwards. Pen angle is again 20°.

Both Figure 11 and Figure 12 provide lively contemporary forms, *but* they no longer work with the text. There is nothing calm and sleepy about a vigorous, heavyweight forward-moving letterform. They both, however, retain some of the 'feel' of an Uncial, in particular Figure 12.

The script in use

Vivien Lunnis
Star book
(Words from Genesis)

Various papers, Chinese stick ink, watercolour, steel nibs, silver metallic pen, perle thread, organza ribbon

9 cm x 8 cm closed

Versals

The term 'Versals' was coined by the palaeographer E. F. Strange to describe the built-up letters used at the beginning of verses in Carolingian manuscripts such as the Grandval Bible, and this period provides some of the most beautiful examples of these letters.

This is the most challenging letterform in calligraphy; instead of making letters directly, you have to construct them, using a small nib and multiple strokes. Before attempting to write Versals you must have a good knowledge of Roman capitals, as the proportions are the same, and you must have good pen control. Do persevere with these letters; they are supremely versatile, and the ability to construct them will open up all sorts of possibilities for contemporary work.

You will need a flexible nib, so Brause nibs are not very suitable for Versals. You can use ink, in which case a reservoir may be necessary, but gouache, mixed to the correct consistency of single cream, will give you better results. Using gouache, you will not need a reservoir.

Pen angle

The pen angle in Versals for all straight strokes is flat to the direction of travel, so that at all times you are producing the full thickness of the nib. For inner curved strokes, to avoid weakness at the top and base of letters such as **O**, **C** etc., a slight angle is used, 5°–10°. The angle reverts to 0° for the outside curves that build the weight. Serifs are hairline, 0° (flat to the writing line) for horizontal serifs, and 90° for vertical serifs. See Figure 1.

Horizontal strokes such as the crossbars of **H** and **A** and the limbs of **E**, **F**, **L** are made with a single thickness of the nib and the pen held at 90°. This gives problems for the left-handed calligrapher. There are two ways round this: one is to work from right to left, being careful not to smudge what you have already written; the other is to use a pen angle of 45° and to build the stem up with two overlapping strokes. As a last resort, you could turn the paper.

Figure 1

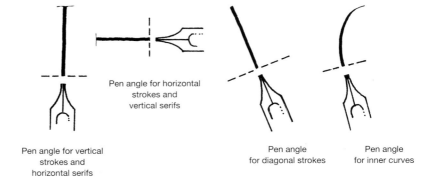

Pen angle for horizontal
strokes and
vertical serifs

Pen angle for vertical
strokes and
horizontal serifs

Pen angle
for diagonal strokes

Pen angle
for inner curves

Figure 2

Parallel strokes; the finished
letter looks wooden

Waisted strokes; the finished
letter is elegant

Stems

Straight stems are constructed by making two strokes, 1 nib width apart and flooding the pigment down between them to fill in. If you make these two strokes parallel to each other, the finished stem will look wooden, even appearing to bulge slightly at its middle. To counteract this, the two strokes have to curve slightly inwards so that the stem 'waists'. This must not be overdone, or you will end up with grotesque shapes. See Figure 2.

Proportion

The measurement used for the proportion of Versals is the stem width and this is multiplied to provide the height of the letters. Generally the stem width is 3 nib widths and this is often multiplied by eight to set the height. When I first learned Versals, I was taught to use a higher number of stem widths, and as I like the lightweight elegance of these letters I'm going to start with them, based on the proportions of the supremely beautiful Carolingian capitals found in the Second Bible of Charles the Bald, a French manuscript written between AD 871 and 877, which are 12 stem widths high.

The height of your Versals will depend on the nib you use. Formal Versals are usually written with a no. 4 nib, and there is a big difference in size between a Leonardt no. 4 and a Mitchell no. 4. There is also a difference between an old-style Mitchell no. 4 nib (the silver one, which I used for the exemplar) and the modern bronze no. 4. Measure three accurate nib widths of whatever nib you choose, multiply that measurement by twelve and rule up at this height. The letters in the example are 24 mm high.

Use good quality paper for your practice; the tooth on good paper will help you to control your strokes and you will avoid picking up fibres from the paper in the flooding-in process. If you are using gouache, fill the underside of the nib with a brush.

Spend some time practising the letter **I**, which is the most basic set of strokes. Using a completely flat angle, pull down from top line to bottom, curving very slightly to the right at the middle of the stroke. Come back to the top, and leaving an empty space that is 1 nib width wide, make another vertical stroke, this time curving to the left at the middle and back out again at the base. The middle of the stem should be approximately 2½ nib widths

wide. Come back to the top again and place your pen on the white space between the strokes. Press briefly to express some paint and pull this puddle down to the bottom, flooding in the gap quickly. Don't scrub this: the marks will show when the letter is dry, and you run the risk of picking up fibres off the surface of the paper. The filling-in needs to be done while the construction strokes are still wet so that all the paint merges together. Finally, to complete the letter, using the same flat pen angle, put horizontal serifs at the top and bottom. These must be hairline. Steepen your pen *hold* for these, so that you are on the edge of the nib, and make them at the end of each completed stroke. Serifs in Versals add to the elegance of the form; they also tidy up the ends of the strokes. Do sufficient practice on this basic stroke to begin to build a consistency of width, which is one of the most important features of good Versals.

Figure 3 shows the letters written but not filled in so that you can see the construction, with the order and direction of strokes. I have omitted serifs in the order of strokes as they made the diagram too complicated.

Start your work with letters which consist of vertical and horizontal strokes: **I**, **H**, **T**, **J**, **L**, **F** and **E**. Proportions are exactly as for Trajan capitals. Refer back to the chapter on Roman capitals if you need a reminder.

I and **H** are fairly straightforward. Turn your pen to 90° for the crossbar of **H**, placing it just above halfway. Make the crossbar of **T** first, then add the weight below it. The weight on the single-stroke limbs should be approximately 2 nib widths. Start at the left just below your original stroke and push up

to coincide with it. Lift and move to just over halfway along the crossbar, place the pen on it and pull sideways and down to match the weight on the left. Add the serifs at 90° and fill the spaces. It's useful to mark a centre point on the crossbar and then make the stem either side of that, waisting as you have practised. Fill and add the serif. **J** comes just below the line, ending in a point. **L** has the basic stroke as its stem and the base is made at 90°. Weight on all single-stroke limbs must be subtle, and I find the easiest way to achieve this is to come back almost to the stem, putting the pen on the original stroke, and retrace it, pulling up slightly at the end. The serif on the bases of **L** and **E** pulls back at a slight angle. The weight on the horizontal limbs of **F** is underneath the original stroke. Serifs are vertical. The weight on the top two limbs of **E** is underneath, it is above on the base, as the **L**.

Move on to the letters that use diagonal strokes. If you are right-handed you will have to twist your wrist round a bit to achieve a right-to-left stroke of the **A** that is the full width of the nib. Add the weight on the inside of the stroke as described above, by retracing the stem from halfway and pulling out slightly at the base. Again, this weight should be less than the thickness of the basic stem. Come back up to start the right-to-left stem *below* the line and make the second stroke by starting *on* the line, so that your letter has a flat top. The tops of **A**, **M**, **N** and the middle of the **W** are all flat in Versals. Add the serif to the top of your **A** to the left side only.

Make the first stroke of the left-to-right stem of **V** as normal. When you make the second stroke, stop short of the line, as the right-to-left stroke is going to cross it to make the

Opposite:
Second Bible of Charles the Bald, AD 871–7

Figure 3

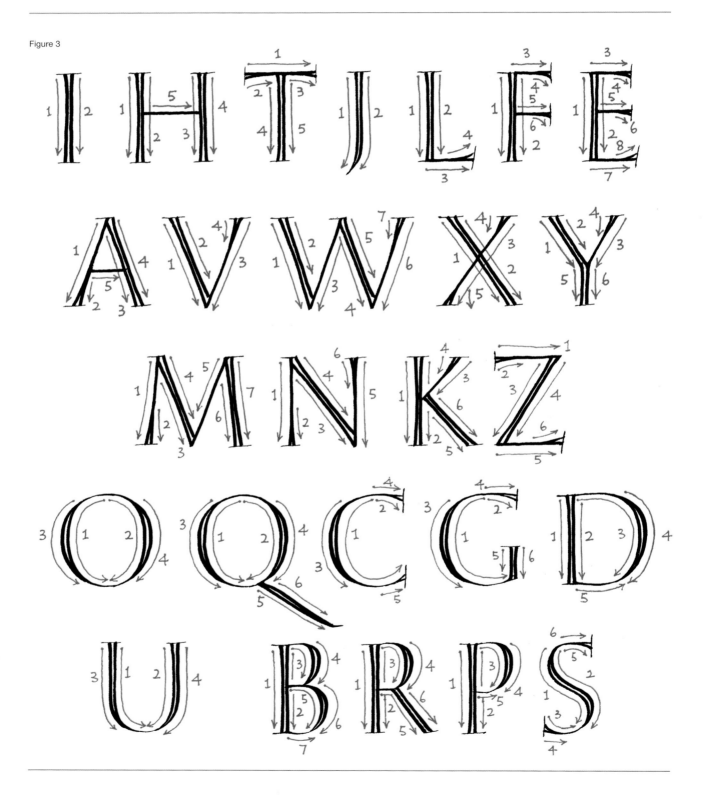

apex. Fill the first stem as far as you can while the paint is wet, make the second single-stroke stem to form a clean apex and quickly fill any white space that is left. The weight on the right-to-left stroke is added inside. The **W** is made in the same way, treating the first counter as a **V**, but with no weight at the top of the second stroke. The second counter begins as the **A**, below the line for the first stroke and on the line for the second, producing a flat top. The last stem is as the **V**, with weight inside. The serifs on the first and fourth legs of **W** go through the strokes; that on the centre is only to the left. The weight on the right-to-left stroke of **X** is inside, both top and at the base. Try to avoid an exaggerated curve on this stroke once the weight is on.

Y should be fairly straightforward; make the **V** shape first, bring the apex below halfway, adding the weight inside on the right-to-left stroke, and then make the stem, which will need a bit of waisting.

The **M** is one of the more challenging letters in Versals. Remember the proportion of the Roman capital: the letter should measure the same across its base as its height. Begin the first stroke just off the vertical and add weight subtly inside. Treat the second stem as that of the **A**, so that the top is flat, and stop short on the second diagonal stroke as you did in the making of **V**. Fill as far as you can, gauge the width of a **V** and make the third stroke to cut across the second stem, forming a neat apex, just cutting the base line. Tidy up the filling-in. Now carefully match the start point of the last stem to the start of the second, *below* the line so that your counter spaces are exactly the same height, and make the last stroke starting *on* the line to form another flat top.

As with a pen-made Roman capital, the secret of a successful letter is the matching of the crossover points at the top of the counter spaces. Add the serifs, at the top only to the left and right respectively, through the stems at the base, but if you can, a little more on the outside than on the inside will make for elegance.

The weight on the legs of **N** is on the inside and this can make the letter appear bowed, so if you can, as you make the left-hand leg, flare out slightly at the base. Add the weight by retracing the stroke somewhat and pull out to the right. This should make a stem that has weight balanced on both sides. The top of **N** is flat, as the **A** and **M**, and you will need to stop short on the second stroke of the diagonal. Fill as far as you can, then make the second leg, pulling inwards at the top to provide a flared start; join the diagonal to form a neat apex that just cuts the line, tidy up the filling and add the weight inside the second leg. The serif on the flat top will be only to the left, those on the legs through them but, as on the **M**, a little more on the outside than on the inside.

K has the basic stroke as its stem. Right-handers will have to twist the wrist back to make the right-to-left diagonal at full nib width and add the weight. Make the underside of the left-to-right diagonal first. Waist this strut and add a flat serif only to the right of the stem. Treat the top of **Z** as the crossbar of **T**, with weight only at the left-hand side. **Z** has points top and bottom of the diagonal stem, so begin this inside the top by 3 nib widths and make the second stroke to coincide with the end of your top bar. The base weight is as the **E** and the serif pulls back slightly. The top serif is vertical.

The curved Versal letters are challenging, as the inside curve must be made first, with the weight added afterwards. Your finished letters **O** and **Q** should be fully circular, so your inner shape is flat-sided, with the arcs of the circle top and bottom. Use a slight angle for the inner curve, to avoid an extreme 'thin' at top and bottom. Start the left side at 12 o'clock and pull round to 6. Do the same on the right-hand curve. Try just to cut the lines top and bottom. Now flatten your pen angle back to 0° and add the weight on the left, starting at about 11 o'clock. Full weight on circular Versals is on the 9 o'clock/3 o'clock track. The weight at the fullness of the curves needs to be slightly thicker than that on the stems so that it visually matches the stems, and I find the easiest way to achieve this is simply to press a bit harder on the nib as you reach full width. This allows you to gauge the empty nib width correctly and to make the correct weight. Pull out to 9 o'clock and press on the nib, then pull in to coincide with the inner stroke at about 7 on the clock face. Fill. Begin the weight on the right-hand side matching the level on the left and repeat the procedure, pulling in to end at the same level as the left. The tail of the **Q** is long and straight, as the Roman letter. The weight blossoms from the start and pulls in to a point at the end.

C is easier than **O** and **Q** as it is open. It has the same flat curve to start, beginning at 12 o'clock, but continue from 6 o'clock, curving up, finishing when you think the letter is the correct width. Make the underside of the top curve, pulling downwards so that you have a complete skeleton form, albeit one that is too curved top and bottom in Roman capital terms. Add the weight on the bowl as the **O**, then come back to the top and add the weight on top of the curve, with a flat shape and a flat pen angle. Because the fill-in area is small, I find it easier to make the serif first and fill afterwards. Finally add the weight on the base, underneath the initial curve. Adding the weight top and bottom will restore the buoyant shape of a good **C** from the rather unpromising skeleton shape. **G** has the same basic shape as **C**. Once you have made the top, move down aligned with the top and make the stem, which will be waisted, starting just below halfway on the letter height, and fill. Dragging a little wet paint from the base of the stem into the curve will add a small amount of weight and improve the look of your letter. Complete the stem with a hairline serif on the inside only.

D has the basic stroke as its stem and then the top and inner curve of the bowl made with a slight angle. Remember to travel far enough along the top before beginning the bowl. Pull in to 5 o'clock, add the weight with a flat pen and a bit more pressure at 3 o'clock, coinciding at 5 o'clock, and then pull back out from the stem at the base with a slight angle to complete the bowl. A gentle lift to the top as you begin the bowl and a slight dip at the base will make for a more elegant letter.

The inside of **U** is made first, and it may take some practice to be able to gauge the width of the inner shape so that the finished letter is the correct proportion. Try for a symmetrical base and then add the weight to finish at the same levels as the **O**. Note there is no strut on the Versal **U**. Put a little more serif on the outside of the stems than on the inside.

Figure 4

A B C D
E F G H I J
K L M
N O P Q
R S T U V
W X Y Z

The proportions of the small-bowled letters **B**, **R** and **P** are the same as their Roman counterparts. All three will have the basic stroke as stem, and for all three use a slight angle for the inner curves. The inner stroke of the top bowl of **B** should be left in mid-air, coming to just above halfway. Add the weight to coincide with the end of the first stroke. Now come in to the stem and pull out, again with a slight angle, join up with the top bowl and continue out and down to make the inner bottom bowl, finishing at around 5 o'clock. I work on the basis that the inner curve of the lower bowl should align with the outer curve of the top bowl, which gives a good balance of sizes of bowl. Finish the base by using a slight dip out from the stem and push up to meet the weighted stroke. Make the bowl of **R** in the same way, but wider and deeper, coming to exactly halfway down the stem. Use an angle of around 40° to make the waist and to pull down for the underside of the strut, which should give you full thickness of nib. Add the weight above with the same angle, waisting slightly. The serif on the strut should lift a little off horizontal and be only to the right side. In making the **R**, be careful with the width of the waist: too small and the letter will look weak, too wide and it will look dumpy. The bowl of **P** is made in the same way, but is made wider and deeper still,

coming to below the halfway of the stem. The bowls of all three letters must be circular in appearance.

I make the underside of the main stem of **S** first, which means that the initial shape needs to be slightly top-heavy. Start the stroke at around 11 o'clock, but finish well above the base line with the pen flat to the direction of travel. Add the weight above, blossoming from the start to full stem width and pulling in to coincide at the end of the stroke and fill. Begin the base with a considerable curve down and put the weight on as an almost flat stroke, with a flat angle. Add the vertical serif and carefully fill in the small triangle of space. Make the top with a curve down and add the weight, flat. Make the serif and fill.

Figure 4 shows the complete letters in alphabetical order.

Spacing Versals

Versals require careful spacing. The principle is the same as for Roman capitals, the space between straight-sided letters being about half the height of the letters themselves, a little less between straight-sided and circular, with two circular letters closer still. When spacing, it might help initially to lightly pencil in the letters as you go along,

SPACING

especially with circular letters as you will be starting with the inner shape. Figure 5 shows the word 'SPACING', which has several difficult combinations.

These graceful letters can be used in many ways: in headings, on title pages of books, to emphasize a word or phrase in a piece of work. They form a lovely contrast used with Italic minuscules.

Varying Versals

Versals are as versatile as Roman and Italic capitals in changes of weight and form. Thus far you have been working on letters that are 12 stem widths high. The reproduction shows Versal letters from the Benedictional

of St Aethelwold, written in England towards the end of the tenth century. These beautiful letters are 6 stem widths tall, making them much sturdier than those in the Second Bible of Charles the Bald. They are also more directly written.

When you can make letters with consistent widths on stems and curves you can begin the process of varying the forms, firstly through changing their weight.

Figure 6 shows this done quite formally by altering the height, using the same nib initially, which increases the weight, and then taking this a stage further by using different nibs, making heavier and lighter letters.

Below:
Benedictional of St
Aethelwold, tenth century

Figure 6.1

Height: 10 stem widths
using a no.4 nib, written
with a no. 4

WEIGHT

Figure 6.2

Height: 8 stem widths
using a no.4 nib, written
with a no. 4

WEIGHT

Figure 6.3

Height: 10 stem widths
using a no.4 nib, written
with a no. 3½

WEIGHT

Figure 6.4

Height: 8 stem widths
using a no.4 nib, written
with a no. 3½

WEIGHT

Figure 6.5

Height: 10 stem widths
using a no.4 nib, written
with a no. 5

WEIGHT

Figure 6.6

Height: 8 stem widths
using a no.4 nib, written
with a no. 5

WEIGHT

Figure 6.1 brings the height down to 10 stem widths (20 mm) and is written with the same old-style no. 4 Mitchell nib as the previous exemplars.

Figure 6.2 takes the height down further, to 8 stem widths, (16 mm), written with the same nib.

Figure 6.3 is the same height as 6.1, but the letters are written with a no. 3½ nib and so are much heavier.

Figure 6.4 is the height of 6.2, written with the no. 3½.

Below that, Figure 6.5 has been written with a no. 5 nib at 20 mm high and Figure 6.6 with a No. 5 at 16 mm high.

You can see from this that the change in weight alters the impact on the page and therefore provides scope for interpretative use.

Play around with the possibilities, picking up a pen and writing with it, experimenting with weights. Versals are difficult to write well very small and they must never be over-heavy.

In Figure 7 I have written the word 'LETTERS' 18 mm high with a no. 4 nib. I wanted 'MINGLE SOULS' to be smaller, but to harmonize with the weight of the larger word to make a cohesive little design, so I had to play around, trying different nibs and heights until I arrived at a pleasing solution, which was a no. 5 nib with letters at 12 mm high. The two lines knit together nicely, giving an emphasis to the key word. This could be a basis for a card design or a small piece for framing. The difficult combination of two Ts in 'LETTERS' has been handled by shortening the crossbar on the right of the first letter and the left of the second a little and placing the letters as closely as they will go. I'm not keen on joining the crossbars to minimize the space; it seems to do the opposite and draw attention to it.

Further variations
Slope
Versals can be sloped to give a more dynamic form. Establish an **O** shape and base your letters on its width. Sloped Versals are capable of weight and height change in the same way as the upright letters. Don't overdo the forward lean; 4° to 5° is enough.

LETTERS

MINGLE SOULS

Figure 7

FORWARD SLOPE

SLANTING PILLARS OF LIGHT

GATHERING STORM

I SANG IN MY CHAINS LIKE THE SEA

Figure 9

Figure 8 shows the words 'Forward Slope' written at 10 stem widths high using a no. 4 nib and a wider **O** form than classic Italic capital proportions; the rest of the letters are based on this **O**. 'Gathering Storm' has been written with a no. 3½ nib at 8 stem widths of a no. 4. In contrast, 'Slanting pillars of light' is written at the same size but with a no. 5 nib. The respective weights help to suggest the underlying meaning of the words.

Top weighting

When you are confident that you can achieve constant stroke widths, you can try top-weighting the stems, as in Figure 9. Instead of waisting the stems, they taper from top to base, from a start of 3 nib widths wide to approximately 2 nib widths at the base line. This tapering occurs only on the main stems of the letters; the slimmer limbs of the **A**, **M** and **N** and the top of the **K** are as normal, as are the horizontal strokes. Full weight on the circular letters can be lifted above the usual 9

o'clock/3 o'clock track. This is a dramatic and powerful variation, probably best used at heavier weights.

Omitting serifs

Versals without serifs are sometimes called compound letters. If you omit the serifs you must take great care with the finishing off of strokes. Once again, these letters can be varied in weight, slope and compression. Figure 10 shows three variations. In the first, the phrase has been based on a fairly round **O**, sloped, at approximately 11 stem widths high. Below, the letters have been compressed, with a very slight slope. In the third example, the base **O** shape has been widened to one wider than it is high and the height has been reduced so that the letters are now 8 stem widths high. The same nib, a Mitchell no. 4, was used for all three variations.

Figure 10

DEW SPARKLES ON THE SHINGLE

DEW SPARKLES

DEW SPARKLES

Freeing up the form

As your skill in writing these letters increases with practice, you may want to free them up. Writing without lines is difficult and requires an ability to keep the letters more or less the same height, and great confidence. You could try using just a central guideline, drawn through the middle of the letters, which allows you to gauge similar heights, but you can also go about freeing up in exactly the same way as described in the Italic capitals chapter, by basing the letters on a parallelogram instead of a square or rectangle, so that all horizontal strokes slope upwards and the left side of the letters is lower than the right. Figure 11 shows the three letters **H**, **A**, **E**, first conventionally, then written within an underlying parallelogram. Below that the same phrase from Figure 10 is written using this principle. The letters look more lively, appearing to dance, and the letterform is now much more appropriate for the words. Carry the uphill feel through to the finishing off at the ends of the stems.

Figure 11

HAE HAE

DEW SPARKLES

Stan Knight
Wait

(Text by T.S. Eliot)
Mitchell nibs, watercolour,
on Hannemühle Black Ingres
paper. Freely written versals

58.5 cm x 28 cm

I SAID
TO MY SOUL
BE STILL

AND WAIT
WITHOUT HOPE
FOR HOPE WOULD BE
HOPE FOR THE WRONG THING

WAIT
WITHOUT LOVE
FOR LOVE WOULD BE
LOVE OF THE WRONG THING

THERE IS YET FAITH
BUT THE FAITH
AND THE LOVE
AND THE HOPE
ARE ALL IN THE WAITING

WAIT
WITHOUT THOUGHT
FOR YOU ARE NOT READY
FOR THOUGHT

SO THE DARKNESS
SHALL BE THE LIGHT
AND THE STILLNESS
THE DANCING

EAST COKER
THE FOUR QUARTETS
T.S. ELIOT

Adding a slight curve to stems

This last variation is something I enjoy and use in my own work. The curve must be subtle, otherwise the letters will be grotesque. The stems are made by using a straight stroke for the left-hand side of the stem and curving the second stroke inwards as you would for a formal Versal. There is a slight gap between strokes at top and base and they overlap at the centre, so that the centre of the stem is just one nib width wide. Figure 12 shows the two separate strokes and the finished stem. I use a slightly angled nib for these letters instead of the flat angle for formal letters and I base them on a parallelogram, so that the horizontal strokes move upwards. The weight, added to the horizontal limbs of **E**, **F** and **L**, gives the appearance of a curve. Figure 13 shows a selection of letters made using this technique, using a no. 4 Mitchell nib. Note that the legs of the **H** are no longer parallel, making a more interesting letter than the purely symmetrical **H**. The curve on the right-hand stem of **A** can be on the inside or the outside. Beware putting outward curvature on both strokes of **A** or both legs of **N**. This will give a bowed, unpleasant shape. Circular letters will be normally weighted.

Figure 12

Figure 13

Figure 14

GREEN
CLOTHES THE EARTH
IN TRANQUILLITY

Figure 14 shows a small design, similar to the 'Letters Mingle Souls' earlier, in that two sizes of nib have been used. The word 'GREEN' has been made with a no. 5 Mitchell and the two smaller lines with a no. 6. I also used a slightly textured paper to draw these letters as the 'tooth' helped the control of the nib. Despite the movement that is in these letters, they have an open generous feel, suiting the words well.

You may have noticed that I used the word 'draw' in describing the making of these letters, and with these modern 'built-up' letters that is exactly what you are doing. They are very different from the directly written formal Versals.

Painting letters

If you prefer or find it easier, you can paint Versals instead of writing them directly. Initially it is possibly better to work the letters out with pencil and trace them down accurately with a sharp hard pencil, but once you have got used to the technique of painting you can work with a single pencil outline and build the width as much as is required on either side of the guideline.

Use gouache, mixed to a creamy consistency, and a very good small brush, either sable or synthetic according to preference. When you load the brush, 'point' it before painting: that is, twirl the brush in your fingers on its side either on your palette or on a piece of card so that the hairs come to a good point. Hold the brush almost vertically to the paper and use small fine strokes to build the letters rather than outlining and filling in. Work slowly.

IRGSNE
ASNY

Figure 15

Painting letters allows you to work on surfaces which would not be suitable for edged-pen writing, such as very rough paper, tissue and fabric. It also lets you experiment further with letter design. In designing your own letters, start as you would with pen-made variations, by establishing the **O** shape. Think carefully about the weighting on circular letters, deciding whether you want 'calligraphic weighting', i.e. on the 8 o'clock/2 o'clock track, or on the more usual Versal track of 9 o'clock/3 o'clock.

Figure 15 shows a selection of letters made with a brush, from the classical Versal **I** to a Greek **Y** shape, which would be quite difficult to make with a pen. Try, as an exercise, taking one or two of these suggested shapes and developing a few more letters from it, based on its width, weight, slope and serif form. Use a pencil for your initial sketches and then move on to using a brush. A no. 0 sable brush was used for all these letters. For writing on fabric, I prefer to use a synthetic brush as it has a bit more 'spring' than pure sable.

The script in use

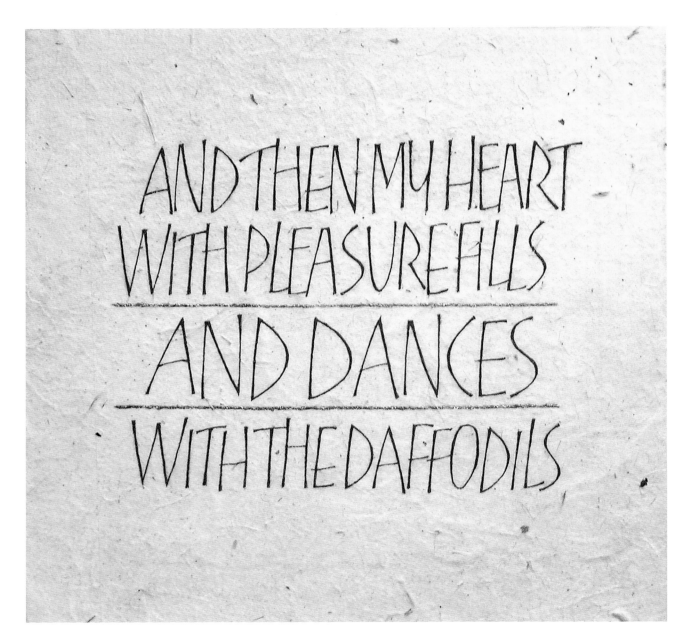

Gillian Hazeldine
And then my heart…

(Text by William Wordsworth)
Wordsworth's words painted on tissue with a brush.
The tissue is wrapped round a piece of MDF. Pointed brush, gouache, bronze powder

15.3 cm x 15 cm

Drawing letters with a pencil

When using a pencil to create letters, there are several things you will need to take into consideration. The first is the pencil itself, and there is a bewildering array of pencils available in art shops and online: graphite and water-soluble coloured pencils, water-soluble graphite pencils and more. Water-soluble coloured pencils are waxier than graphite. Most art shops sell pencils singly, so it is a good idea to buy several different types made by different manufacturers and try them for yourself. Buy the best pencils you can afford.

Needless to say, your pencil must be sharp. Never use a pencil sharpener; they make a mess of the wood and frequently break the lead. Use a scalpel or craft knife, so that you can hone the point by rotating the pencil in your left hand (right, if you are left-handed) and refining with the blade. A well-sharpened pencil should have a lead of at least 6 or 7 mm. While working, you can re-hone the point on a spare piece of paper or on a piece of fine wet and dry paper, but frequently re-sharpen. Be prepared to use a substantial amount of a pencil on even a small piece of work.

The major disadvantage of using drawn letters in a finished piece is that you will not be able to rule lines, as rubbing them out will endanger your work, and you will possibly not be able to rub out any errors. This will depend on how far you have got with the letter before you decide it needs alteration, and also on the pencil you are using. The advantage is the pleasure of using a drawing tool, and being able to *feel* the creation of the letter bit by bit.

The paper you use will be important too. I prefer to use a fairly hard paper as then there is a difference between tool and surface. I also like a paper with a slight tooth rather than the almost polished surface of hot-pressed paper. Printmaking papers have softer surfaces and erasing is almost impossible as it disturbs the surface. If you do try to erase, use a very good quality plastic eraser, and ensure that it is clean. The 'click' pencil erasers on the market now can be sharpened to a point so that small precise areas can be removed.

Different people will have different ways of drawing letters. Mine is to work in a very similar way to painting, by building up with tiny strokes, starting at the top of the letter and working down, for the straight-sided or diagonal letters. For the circular letters, I will very lightly pencil in the outline first, treating it as a Versal – that is, making the inside shape first – and then I build the weight from there.

Having been through Versals and all their possible variations you will have some idea of the range of drawn letters you can create. I usually work with capitals, but there is no reason why you should not use minuscule forms.

Figure 16 shows some letters made with different types and grades of pencils. Number 1 is a skeleton form written with an HB, 2 a weighted letter made with the same HB. Number 3 was made with a B pencil, 4 with a 3B. This last was too soft for me; it was difficult to maintain a point, even in making one letter and it created quite a lot of dust in the making, which can smudge. To obtain a sharp outline, I had to use an HB after I had finished the form. Number 5 was made with a

Figure 16

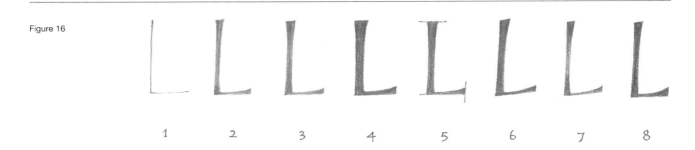

1 2 3 4 5 6 7 8

water-soluble graphite pencil, medium grade, 6 with a soft grade water-soluble graphite pencil, also just a bit too soft. Number 7 was made with the medium water-soluble pencil, working the top and base of the stem more than the centre to create a lightness there. This produces the equivalent of 'press and release' technique with a pen, and for me is a much more subtle way of weighting a letter than actually pressing harder on the pencil. Number 8 was made with an indigo water-soluble crayon.

In the small design in Figure 17 the intention was that all the letters should touch each other, both sideways and above and below, and to create a block of pattern, so they vary in size. To help define the letters a thinner line has been used between the lines, and this line has been allowed to drift up and down rather than be rigid. The letters themselves are based on waisted Versal shapes, with the round E as an alternative form. I used an HB pencil on a slightly textured paper and fixed the whole with fixative at the end to prevent smudging.

This is a very different technique to drawing letters for design purposes which will then be used in another medium, for instance cutting them in stone.

Figure 17

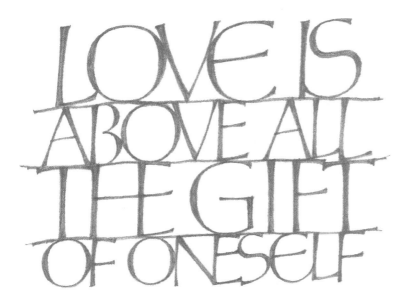

Layout and design

Very occasionally a piece of calligraphy can be done spontaneously as a finished piece of work, but for the most part calligraphic work needs careful planning and design.

There are four main things to consider in making a piece of work: scale, format, arrangement of lines on the page, and the texture and tonal value of your writing on the page.

You should decide at the outset whether your work is going to be a panel for framing, a book or a three-dimensional object. Scale will come into this; you will need to consider the size of the work, and this will very much be dictated by your text and its 'tone of voice'. Are the words loud, emphatic, even aggressive? In this case the work probably needs to be viewed from some distance. Or are they quiet, intimate, requiring the reader to be pulled in, even to hold the work in their hands? In either case the writing will need to be of an appropriate size and weight.

Format

A vertical/portrait design will be longer in depth than in width. This will mean the lines of writing will be short. A horizontal/lateral piece will be wider than it is deep. This will mean the lines will be longer. Don't mix lengths of line in one piece of work. A short line in the middle of long lines will assume too much importance as it will have a 'finger' of space either side pointing at it. A long line in the middle of short lines will throw the margins out and unbalance the whole.

Sometimes the words will suggest the format; for instance if you are using a text about tall trees a portrait format will help enhance the words, whereas a text about the sea will probably be better in a horizontal shape. Often, though, the words themselves dictate the shape of the work simply by the way they break into lines, especially if you are working with prose.

Think carefully how you break lines; never leave the definite or indefinite article hanging at the end of a line. It's a good idea to read your text aloud, so you can hear the way it works.

Working with poetry is completely different, and there is an ongoing argument as to whether you can change the poet's line breaks or not. You will have to make up your own mind on this. My view is that there is no point in writing out a poem exactly as it is on the printed page; you are adding nothing to it. But don't snip bits out because they don't fit your layout, and if you do change line breaks, keep the poet's capitals and punctuation in their place.

Be aware of copyright if you are exhibiting work or posting it on to the internet. The assumption that the author has been dead for 75 years and therefore you don't have to get permission to use work can be wrong. The estate can apply to retain copyright when it expires. Sometimes work that was published during a lifetime can be out of copyright but other work published posthumously is still in copyright. Some authors refuse point blank to allow any of their work to be used calligraphically. It's best to check beforehand.

Texture

Texture is the density of writing on the page, the pattern it makes and its tonal value. Size and weight of writing, length of line, interlinear space and the length of the text itself all contribute to texture.

Text written in minuscules could have as interlinear space 1, 1½ or 2 'x' heights between lines (the 'x' height is the height of any letter without a descender or ascender). Two 'x' heights between lines is the optimum space for minuscules as it avoids the disaster of a clash of ascender and descender. With interlinear space of either 1½ or 1 'x' heights you will need to do a very careful initial layout to avoid any potential clashes. Respect the ascender and descender heights; shortening them in order to be able to close the lines up will make the letters appear stunted and uncomfortable.

Text written in capitals can have anything from almost no interlinear space to 1 or 1½ 'x' heights between lines. ('x' height in capitals is the height of the X or indeed any letter.) One or 1½ 'x' heights will make for legibility and formality. Closer line spacing will 'knit' the text together more as a block, and almost no interlinear space will make for pure texture, perhaps sacrificing legibility. If you choose to use a very small amount of space, ensure that there is sufficient to separate an E and a T sitting one above the other with the potential merging of horizontal strokes. In formal arrangements of capitals, word spacing will be approximately an O taking into consideration the counter spaces of the letters either side of it. In textural arrangements, space the words a bit more tightly to avoid what are called 'rivers of space' where several word spaces above

and below each other join together and create a disconcerting white space running through the work, spoiling its texture.

More than 1½ 'x' heights in capitals and more than 2 in minuscules can start to destroy legibility as the space becomes more important than the lines of writing. As I mentioned previously, use the general rule of thumb that if you are *conscious* of the interlinear space, it is too much. It should be an integral part of your design, fulfilling your intention for the words.

Long lines of writing require more space between them than short lines, so that the reader can use the strip of white to negotiate their way back to the beginning of the next line. The optimum number of words per line for comfortable reading is eight to ten words, but the eye and brain can cope with more than this as long as there aren't too many lines and they are well spaced.

Try an interesting experiment: write out a fairly lengthy text of prose using minuscules and long lines, to make at least six, with an interlinear space of 2 'x' heights. Then cover half of your writing with a piece of paper and photocopy the remaining half. Put the photocopy and the original layout together and compare them. Although the interlinear space is the same, the shorter lines will appear to have more space between them than the longer as the space 'bleeds' in from the sides on the less dense text of shorter lines.

Size of writing

If your intention is to create a dense and dark texture on the page, you will achieve this more successfully by using letters that are

compressed from the 'norm' so that the balance between the line that makes the letter and the space within it is weighted towards the line. There is often a misconception that large writing will be darker than small. Try writing a capital D at a height/weight ratio of 7 nib widths with a no. 3A automatic pen. Alongside that write a capital D with a smaller nib, say a Mitchell 1½ at a height/weight ratio of 3 nib widths. Which is the darker of the two?

Arrangement on the page

There are three basic forms of layout: aligned to a margin, left or right; centred; and asymmetric.

Aligning to a left margin

Aligning to a left margin works best when all the lines are of similar length. Long line against short will leave a large hole in the texture on the page. With poetry you can help the line lengths by indenting alternate

Will you see the infancy of this sublime and celestial greatness? I was a stranger, which at my entrance into the world, was saluted and surrounded with innumerable joys. My knowledge was divine.

Figure 1.
A left-aligned layout with a large capital. The line round the piece indicates the margins

lines by 10–20 mm depending on the scale of the work. This doesn't work with prose.

The main problem with a left-aligned layout is the strong vertical-'zip line' that is created by the alignment. It pulls the eye of the reader down from top to bottom and off the page. Consider breaking this line by the use of a larger capital at the start of the text and moving it into the margin (see Figure 1). You will have to experiment with the size of the capital so that it does its job but doesn't overwhelm the rest of the layout. Placement of the letter is important too; sit it visually centred on the first line and it will settle into place. Sit it on the same base line and it will look much bigger. This device is called a 'drop cap'.

Aligning to a right margin requires great skill and accuracy in writing so that all the lines end up the right length.

Putting together two blocks of writing, one left-aligned and the other right-aligned, can give a powerful layout, but you will have to be careful about the channel of space that you create between them. White space is immensely powerful, made more so by being created by the juxtaposition of blocks of text, and this channel can have the same effect as the 'zip line' of the left-aligned layout, pulling the eye down it and off the page. If you stagger the line endings slightly, the left block at its right side and the right block at its left, the white space will not be quite so defined. This is also easier to write!

If you are writing a formal manuscript book of prose, the conventional layout is left-aligned, ragged right edge. Set your right-hand margins and allow your writing to over-run into them as much as you under-run and the margin will work visually as planned. Breaking words in the writing of a manuscript book is acceptable, but try not to do it too often.

Centred layout

A centred layout has all the lines centred on an axis. Human beings relate well to the orderliness of symmetry, so this is often a favourite arrangement, not suitable for 'edgier' texts. Your lines need to be of varying lengths to avoid 'blocking', but don't have too much difference in lengths. A centred layout is difficult to write as a finished piece as it requires your finished writing to be exactly the same as your rough. Writing varies according to the surface of the paper and the rhythm you use in the making of your letters. To avoid problems, either do your layout on the paper you intend to use for finish, or do a trial finished rough on your good paper. Rule a centre line on your good paper and use your final rough as a guide, taped either above or below your line of writing with centre lines aligned. Fold the rough so that the line you are writing is repeated directly above or below. This 'transfer' of writing helps eliminate the scourge of the calligrapher, the spelling mistake. Don't panic if you are beginning to go off-centre; a fair amount of adjustment can be made to correct this, either tightening or widening the remaining spacing slightly. Your work will be viewed as a whole, so if, in the end, a line is not quite centred, it will not spoil your work.

Figure 2 shows two paste-ups of a text that has been centred. The one on the left is not very successful as lines 2, 3, 4 and 5 are almost the same length, creating a block. In the right-hand version the word 'out' has

The colour of the dawn
is lead and white—
white snow falling
out of a leaden sky
to the white earth.
The rose branches bend
in sharper
and sharper curves
to the ground,
the loaded yew sprays
sweep the snow
with white plumes

EDWARD THOMAS

The colour of the dawn
is lead and white—
white snow falling out
of a leaden sky
to the white earth.
The rose branches bend
in sharper
and sharper curves
to the ground,
the loaded yew sprays
sweep the snow
with white plumes

EDWARD THOMAS

Above:
Figure 2

been taken up to the line above and the layout is instantly improved. The first layout breaks the text better, but with short lines the brain assimilates easily and in the second the layout is so much better that it is worth the break. There is a short line, 'in sharper', but the alternative was to have too long a line 'in sharper and sharper curves' which would have upset the balance of the whole layout. You will probably find that small compromises have to be made in almost every layout you make. Both of these layouts have strips of neutral-coloured paper marking where the margins will be.

Asymmetric layout

This type of layout is the most difficult to arrange successfully, but in general it gives a freer, more informal look than either aligning or centring. The overall effect should be of balance, with an even distribution of text and white space on either side of a central axis. Lines are staggered so that no two lines either start or finish in the same place, which

would result in 'blocking', the text beginning to form a block. Lines *can* begin or end in the same place as long as there are several other lines between them. Try to avoid holes in your layout and ensure a good length of line either side of the central axis or a weak centre will result. For this reason, this type of arrangement is often more successful in a lateral format where the lines are of longer length.

Figure 3 shows the piece of work used as an example in the Roman capitals chapter. This

was initially the first rough for a commission for a 25th wedding anniversary. The text was difficult to arrange as there is a lot of repetition, and an asymmetric layout was the best option to avoid the same word above or below itself, which sets up a distracting pattern. The lines towards the end had to be broken otherwise they would have been too long. These are the positive statements, so I felt the shortness of them helped this, but I had to close up the line spacing a fraction between these short lines as they looked further apart than the longer ones; see the

Figure 3

LOVE IS PATIENT AND KIND
LOVE IS NOT JEALOUS OR BOASTFUL
IT IS NOT ARROGANT OR RUDE
LOVE DOES NOT INSIST ON ITS OWN WAY
IT IS NOT IRRITABLE OR RESENTFUL
IT DOES NOT REJOICE AT WRONG
BUT REJOICES IN THE RIGHT
LOVE BEARS ALL THINGS
BELIEVES ALL THINGS
HOPES ALL THINGS
ENDURES ALL THINGS
1 CORINTHIANS 13
LOVE NEVER ENDS

experiment with line lengths and interlinear space above. Slightly more space between the last two lines helps emphasize the key line of the text. The placing of the credit is important as it helps to balance the whole. I chose formal Roman capitals for the first rough as the whole piece is a statement about commitment, but the finished work for the clients was done in built-up capitals, which was their preference.

Beginning to design

Some calligraphers work with a 'thumbnail' sketch as a first step. I've never found this a satisfactory method as the transition from small scale to large scale often destroys the initial intention. The approach to a piece that works for me is to sit down and write the text right through with a reasonable size of nib, in any script. By physically writing the words I begin to get a feeling for them and ideas present themselves as to letterform, weight, size and pattern of lines on the page. However, this is a personal thing, and you will have to find a working method that suits you. But don't do too much planning before writing the words you have chosen; often they simply won't be pushed into the shape you have decided upon. You will also need to be flexible; if the text simply won't work as you had planned it, you will have to try something else. A text that won't make a good vertical layout will sometimes make a much more successful horizontal one. Do make more than one layout to give yourself choice. Photocopy your writing so that you can cut it up and try different arrangements, compare them and make a considered decision. Photocopying your final rough is a good idea, too, if you have used cut-and-paste, as the cut lines give a false impression of the space between the lines and you may

find in the writing of the finished work that there is too much space.

If you use cut-and-paste, try to buy a repositionable glue stick, which will allow you to change your mind. More complex layouts and those with tight interlinear space are probably best worked on by rewriting, working with semi-transparent paper over your original rough.

If you are working on a more complex piece of work, such as a broadsheet involving several texts, you will need to be aware of the shape that you create by putting two or more blocks of writing together. I call this 'negative space' as it comes about by putting positive tonal values together. If you are working with cut-and-paste on this type of project, keep checking the size and shape of spaces by photocopying to eliminate the cut lines.

Placing the author and/or the source

If your work is fairly formal then you will need to include either the author's name or the source/title of the text. In more contemporary work this is more difficult, but if you do intend to exhibit the work or sell it, ensure that the author is credited, at the side of the work in an exhibition and on the back of the frame.

The credit must be much smaller and lighter in weight than the body of the text. Remember small writing can be darker than large and your credit is likely to be surrounded by space, both ways of giving something emphasis. My preference for credits is small capitals, spaced out very well, putting almost a letter space between each letter.

In a centred layout the credit should be centred underneath the text; in an aligned-left text it should align with the text. With asymmetric layout there are several options. If your last line is short, the author's name can follow the last word. Don't sit it on the same base line as the text as, being smaller writing, the space above it will visually push it down and it will appear to be lower. Centre it on the final line of text. You can inset the name or credit within the text, but be careful with this device; ensure that it is completely different in size and writing style to the text so that it is not mistaken for part of it. The final option is underneath the work, and I find it best to set the side margins for the work and centre the credit within the overall width of the work, not on the block of text itself.

Never, ever, put an author's name in the right- or left-hand corner of a piece of work. It simply creates a distraction for the eye of the viewer and will prevent them from reading.

The space between the credit underneath the text and the text itself should be slightly more than the interlinear space in the work.

Margins

The space you put around your writing is of crucial importance. Inadequate margins make a piece look uncomfortable and cramped, and it is better to err on the generous side. Lightweight writing needs more space around it than heavyweight. With a piece that is to have a mount and a frame, the margins can be a bit smaller than a piece that is simply to be framed; the mount gives 'breathing space'.

As soon as you begin to put writing together to form a piece of work, work with neutral-coloured strips of card around the work to form margins. This will often help to show up holes or blocking in your design.

In general terms, in a portrait piece the top margin will be the smallest, the base margin being one and a half to two times this and the side margins gauged to appear similar to the space at the top. A horizontally stressed piece will need the widest margins at the sides, the base the next largest and the top the smallest. These are guidelines only; it will depend on your intention for the piece.

Aligned layouts where the left- and right-hand sides of the text are so different from each other will require the side margins to be visually matched. Look again at Figure 1 with the dropped cap. Here the margin at the left-hand side is quite tight on the swash capital, but the space below it matches that on the right.

Try to avoid ending up with a piece of work that is neither portrait nor horizontal. Square designs can be very successful if the intention is clear, but something that just ends up square is not attractive. Other things to try to avoid are either top-heavy layouts or bottom-heavy ones, and creating distractions in the design through several line ends creating a strong diagonal. This pulls the eye off the page.

Book margins

Book margins are calculated in a different way from those of a panel. It is essential when the book is open and a double-page spread on show, that the three margins, the left-hand, the centre and the right-hand, are

all visually the same. A simple format to follow is shown in Figure 4, where the top margin is half the base and the joint central margin the same as the outer. This is a good starting point; you can adjust slightly as you design the book.

If your book has a title page, the convention is that it is on the recto (right-hand) page, with the verso (left-hand) page blank. If you centre your title on the page, you will find that the space on the left visually pushes it to the right and it will not *look* centred. To avoid this, pencil in the text area with the margins that you have decided upon for the recto pages in the book and centre the title within this.

Using a focal point

Not every piece of work needs a focal point, but this can be a useful device to attract the attention of the viewer and to make him or her begin to read. Two of the examples in this chapter have used a focal point: the first, a larger capital, and in the second, the first word is larger. You will have to do trials to ascertain the correct size for these. Too large and they will overwhelm the rest of the work, too small and they may look as if you picked up the wrong pen by mistake.

Figure 4

Using contrast

Using two dramatically different sizes, weights or scripts in a piece of work can lend interest, especially if you want to put two texts together or two verses of a poem. The best known example of this is the Lindisfarne Gospels, where the Latin text was translated, 'glossed' between the lines in Anglo-Saxon.

Figure 5 shows several rough ideas for this, using one text. Inevitably on trying ideas out, some will be more successful than others. The eye tends to be drawn by heavyweight writing first, so figure 5.3 is probably the least successful, as the heavier Italic is read first and in fact it is the second part of the text. Make sure you have enough contrast between the two texts so that the viewer understands that one text is to be read first and the other subsequently.

The more you work with layout, the more skilled you will become in design and in the ability to bend or even break the rules and make the piece work.

Figure 5.1

WILL YOU SEE THE INFANCY
I WAS A STRANGER · WHICH AT MY ENTRANCE INTO THE WORLD
OF THIS SUBLIME
WAS SALUTED AND SURROUNDED WITH INNUMERABLE JOYS
AND CELESTIAL GREATNESS

Figure 5.2

WILL YOU SEE THE INFANCY
I WAS A STRANGER · WHICH AT MY ENTRANCE INTO THE WORLD
OF THIS SUBLIME
WAS SALUTED AND SURROUNDED WITH INNUMERABLE JOYS
AND CELESTIAL GREATNESS

Figure 5.3

WILL YOU SEE THE INFANCY
I was a stranger, which at my entrance into the world
OF THIS SUBLIME
was saluted and surrounded with innumerable joys
AND CELESTIAL GREATNESS

Figure 5.4

Will you see the infancy
I WAS A STRANGER · WHICH AT MY ENTRANCE INTO THE WORLD
of this sublime
WAS SALUTED AND SURROUNDED WITH INNUMERABLE JOYS
and celestial greatness

Figure 5.5

I WAS
A STRANGER
WHICH
AT MY
ENTRANCE
INTO
THE WORLD
WAS
SALUTED AND
SURROUNDED
WITH
INNUMERABLE
JOYS

WILL YOU SEE
THE INFANCY
OF THIS SUBLIME
AND CELESTIAL
GREATNESS

Colour

Throughout this book, the emphasis has been on using variations on scripts to enhance the meaning of the words you have chosen to use. This enhancement can be taken a lot further by the use of colour.

Colour is a very personal thing; you probably have a favourite colour in terms of the clothes you wear and there will be those that you would not wear in any circumstances. How you present yourself to the world in the colours you choose to wear will influence the way people perceive you. The same thing can be said about work; people will react to colours, so you can influence the way your work is approached by those who see it by your choice of colour.

For writing with colour in the pen, you have two options, watercolour and gouache. Watercolour is pure pigment and its main property is transparency. Gouache is watercolour with a binder, usually chalk, and also with gum arabic. The main property of gouache is that it dries opaque on the page when mixed with a small amount of water. It can of course be watered right down to be transparent, but it will never have quite the pure clarity of colour of watercolour itself. Gouache, because of its opacity, is the more usual pigment for use with the pen.

Don't try to save money by buying cheap gouache, it simply isn't worth it. Cheap paint is a small amount of pigment with a large amount of filler so it is chalky and difficult to work with.

I use Winsor & Newton's gouache, which is classified by series numbers from 1 to 4, Series 1 being the cheapest and 4 the most expensive. All the colours which I will recommend are Series 1. Even so, gouache is expensive, so make sure you put the tops back on to the tubes tightly after use.

For colour work you will also need palettes, ceramic for preference as they don't stain. Small individual palettes with three divisions are very useful, as are the 'daisy wheel' type, which have seven wells. Brushes for mixing paint and loading it into the pen need not be expensive, but don't economize too much; very cheap brushes shed hairs. Good squirrel mix brushes will serve you well.

Colour theory

There are three primary colours, so called because they cannot be mixed from other colours. They are red, blue and yellow. By mixing two primaries together, you will achieve secondary colours. The secondary colours are orange, being a mix of red and yellow; violet or purple, a mixture of red and blue; and green, a mix of blue and yellow. Tertiary colours are made by mixing a primary with its adjacent secondary on the colour wheel; for instance, red with orange will produce an orangey-red.

Complementary colours are those opposite each other on the colour wheel. Green is the complementary of red, orange of blue and purple of yellow. Complementary colours neutralize each other. It is not possible to mix black (in purist terms, not a colour), but mix all three of the primaries together, i.e. one primary and its complementary, and you will achieve a neutral grey. A complementary colour can be used to 'knock back' a colour: that is, to make it more muted. A small amount of black added to a colour will darken and change it in a different way. Mixing black with yellow has the surprising

result of making green and, similarly, mixing black with red produces a rich range of autumnal browns.

Complementary colours, put together in similar proportions, will have a disturbing effect on the eye, appearing to 'jump'. This is particularly the case with red and green, if both the middle tonal values are used, i.e. an orangey-red and the green that is made from Phthalo Blue and yellow. Yellow and purple, being of such different tonal values, don't behave in quite the same way. Used in very different proportions, complementary colours can have the effect of making each colour work harder. Look at the way the Impressionist painters use colour in landscapes. There will very often be a tiny amount of red in a green landscape; without this, the painting would not have the same impact at all.

Using just the basic information of primary and secondary colours for mixing can lead to endless frustration and waste of paint as pure mixes depend on the colours you choose. To be able to mix almost any colour you want, you will need two versions of each primary. You will need a red that has a bias towards orange, and a red that is biased towards purple. You will need a blue that is biased towards green and one that is biased towards purple, and a yellow that is biased towards orange and a yellow biased towards green.

Thus, to mix a pure orange, you need to choose the two primaries that are biased towards orange, and so on.

The colours I recommend are Flame Red and Alizarin Crimson, Ultramarine and Phthalo Blue, and Spectrum Yellow and Lemon Yellow. Add to this, black – I prefer Lamp Black – and white – for mixing tints choose Zinc White – and you have the wherewithal to mix any colour except a dark cold blue. For that, I would recommend buying Winsor Blue.

Beginning to use colour: considerations and colour terms
Pure colour is called a *hue*.

If white is added to a hue the result is a *tint*.

If black is added to a hue the result is a *shade*.

To make a tint always start with the white and add the colour in small amounts.

Tints dry darker on the page than they appear in the palette, while hues and shades dry lighter, so you will always need to test carefully what the end result will be before writing.

Use small amounts of colour for experimenting and for painting on to paper and, for this purpose, small amounts of water. A dropper of some sort is an essential in colour mixing so that you can add tiny amounts of water. If you make a colour too dilute it takes a large amount of pigment to get it back to the correct consistency. Remember the property of gouache is its opacity. If you can see the paper through your colour swatch, the mix is too thin. Paint for writing will have to be thinner, of which more later.

Pigments in paints have different properties, which can lead to separation in the palette. White will also rise to the top of a mix, so every time you use a brush to make a swatch of colour or load the pen to write, ensure that you stir the paint well first.

The *tonal value* of a colour is how light or dark it is. White has no tonal value: black is the darkest tonal value. Of the actual colours, purple or violet is the darkest value, yellow is the lightest. You will have to understand this when choosing colours to mix; for instance, if you want to mix a true orange, you will need less Flame Red than Spectrum Yellow as the red has a stronger tonal value than the yellow. If you want a dark green, you will have to use the darker of the two blues, Ultramarine. Phthalo Blue is a mid-tonal value and so any colour it mixes will be of that range.

Dark tonal colours advance on the page, lighter tonal values recede. If you want to make part of your work more important you can make it bigger than the rest or you can make it darker in colour.

All colours can be warm or cold. Of your six colours Flame Red is warm, Alizarin is cold, Ultramarine is warm, Phthalo Blue is cold, Spectrum Yellow is warm and sunny, Lemon Yellow sharp and acidic and cold. Warm colours advance, cold colours recede.

Colour connotations

- Red: heat, anger, aggression

- Blue: calmness, cold, sadness

- Warm yellow: sunshine, warmth, happiness

- Orange: autumnal, warmth, happiness

- Green: freshness, life, vitality, nature

- Purple: wealth, nobility, mourning

Colour schemes

- Monochromatic: a scheme using one colour plus its tints and shades

- Polychromatic: a scheme using many different colours

- Analogous: a scheme using two or more colours that are close to each other on the colour wheel

Colour permanence

On the back of the tubes of paint there is a permanence grading. Lamp Black is Permanence AA, which means it is completely lightfast. Ultramarine, Phthalo Blue, Flame Red and Zinc White and both the yellows are Permanence A, lightfast. Alizarin Crimson is Permanence B, meaning it is fugitive and will fade in strong light. Alizarin Crimson on its own is a not very pleasant colour and it is a thin pigment, but it is an essential mixing colour and mixed with another colour of a higher permanence its resistance to light will be improved.

Never hang work done in gouache where it will be exposed to sunlight.

Experimenting with mixing

The only way to learn about colour is to play around for yourself and discover what happens. Make sure that you write down next to any colour you have mixed what its constituent parts are, and roughly in what proportion, so that you can get close to it again.

Begin by mixing the pure secondaries, as on the colour wheel (Figure 1). Learn which are the 'right' colours to make each secondary and then begin to explore what colours arise from mixes of 'right' with 'wrong'. Now you will start to make beautiful subtle colours which will be more useable for calligraphy than the purer mixes. The colours you achieve will depend on the proportions you use. Look at Figure 2.

Greys

Ask someone who knows nothing about colour how to mix grey and they will reply, 'White plus black'. This does indeed produce grey, but a grey that is totally dead. Mix greys from complementary colours and white and you will discover a wonderful range of real colours. See no. 9 in Figure 2.

Figure 1

FLAME RED

ALIZARIN CRIMSON

ORANGE

PURPLE

SPECTRUM YELLOW

ULTRAMARINE

LEMON YELLOW

PHTHALO BLUE

GREEN

When you have done enough experimenting not to be surprised at what colour you have achieved, start to consider how you would use colour in your work. Try always, when you begin a piece of work, to think about what colour you will use for the end result, especially if you tend to work on roughs in black ink. This will avoid 'Now, what colour shall I use?' when the good paper is ruled up for finish.

Writing with colour

When you buy a tube of paint and take the top off it, you may find there is a pool of a transparent substance over the colour. This is glycerine, put in by the manufacturer to keep the paint moist in the tube, so it needs to be there. But it is sticky and can impair the flow in writing. Put the top back on tightly and massage the tube between your fingers and thumbs. This will distribute the glycerine around the tube. Having done this, if there is

still some there when you open the tube again, discard it.

It's advisable to mix paint some time before you need to use it. The sticky glycerine breaks down with contact with the air, so paint that has been mixed and left for up to twelve hours will flow better than newly mixed paint. Mix your colour and cover the palette with clingfilm to stop dust getting into it. You will need to add a drop more water before use as it will have dried out somewhat.

There are two substances you will need when working with gouache. The first is ox gall, which destroys the surface tension of water and thus makes paint flow a little more easily. I add a drop of ox gall to paint as a matter of course. The second substance is gum arabic (which is already present in the paint in small quantities). If you use gouache in a greetings card or a book, the colour can offset to the

Below:
Figure 2. 1 The 'right + right' mix for orange: Flame Red + Spectrum Yellow; 2 A tint of this mix, approximately 50/50 Orange + Zinc White; 3 Another tint of mix 1: Zinc White with a touch of Orange; 4 The same colours as no. 1, but with approximately 85% Spectrum Yellow, 15% Flame Red; 5 The 'wrong + wrong' mix for orange, Alizarin Crimson + Lemon Yellow. This mix produces terracotta; 6 A 50/50 tint of this mix; 7 The same mix with Zinc White + a tiny amount of the hue; 8 The same colours as no. 5, but with approximately 90% Lemon Yellow, 10% Alizarin Crimson; 9 The beautiful grey produced by mixing Alizarin Crimson + Lemon Yellow + Phthalo Blue (the complementary) and white

Figure 2

1 2 3 4

5 6 7 8

9

opposite page, so you will get a ghost image of the writing. This happens especially if the item is put under pressure, for example a book during the binding process, and this can be a disaster. Gum arabic helps prevent offsetting. Beware of using too much of either of these substances. Both will make paint flow more difficult if overused. You should also use gum arabic in paint to prevent smudging if you need to rub out lines, but never rub over gouache if you can avoid it, even with gum arabic present, as the eraser burnishes the paint, leaving shiny streaks. Lines can be removed where necessary with a pencil eraser sharpened to a point.

Paint for writing will need to be thinner than paint for painting trial swatches, so that it flows well through the pen. Start the mix with just a drop of water in the gouache and mix well to a paste-like consistency. Begin adding more water drop by drop, stirring with the brush after every addition, until the brush leaves no trails in the paint as you stir. Your nib and reservoir will need to be cleaned of all traces of ink. Fill the nib by brushing paint on the underside towards the tip so that it flows underneath the reservoir. Use only small amounts of paint and refill frequently rather than overloading the nib. Using your guard sheet or a spare scrap of paper, start the paint flowing with the same 'wobble' that you use with ink. If it won't flow, it is probably too thick. Add a drop more water to the mix and try again. Work with a flatter board than you use when writing with ink, so that gravity helps the flow. If the paint is too thin, it will dry semi-transparent and the mix will flood to the bottom of the letter and accumulate where strokes overlap, resulting in patchy letters.

Have a jar of clean water beside you and every now and then clean the nib and reservoir out, dry them thoroughly and refill with paint. This will be particularly important in warm weather, when the paint dries quickly in the pen. Remember too, if you clean your brush out, to dry it before using it to mix or load paint again. A wet brush will render the mix too thin.

Always mix enough of the colour you want to last you through the piece of work. It is nigh on impossible to mix the same colour again.

When you have finished your piece, if you still have a substantial amount of colour left, keep it for future use, either by decanting it into a small container or simply covering the palette with clingfilm. Reconstitute it when you need it by dropping some water on to it, allowing it to soften and then mixing it back to the correct consistency for writing. Old paint will behave better than newly mixed as the glycerine content will have gone.

Working on coloured paper
If you choose to work on coloured paper, think hard about the tonal values of both your paint and the paper. Figure 3 shows the colours of the spectrum – red, orange, yellow, green, mid-blue, dark blue (here I have used ultramarine instead of indigo) and violet – on white paper, on a light grey and on black. The dark tonal values, indigo and violet, are the strongest on white paper, but the mid-tones, red, orange, green and mid-blue, hold their own. Yellow has no impact at all. On the grey paper it is the middle tonal values that are less successful, in particular the colder colours. The warmth of orange and red helps them to hold their ground and the yellow improves in impact. The dark colours also

Figure 3

work. On black the dark colours simply disappear, yellow sings out and the warmer mid-tones are better in impact than the cold.

Colour change in the pen

This technique involves feeding one colour into the pen, writing with it for a few words and then feeding another colour in behind what is left, allowing the two colours to mix in the reservoir as you write so that there is a gradual colour change from one to the next with a mix of the two in between. It is quite a difficult technique to master and you need to choose your colours very carefully, keeping in mind what happens when complementary colours are mixed.

I use a technique which helps with this process, where all the colours have the same base and therefore they are harmonious because of their common ground. Five or six colours work well. Begin with a colour, for instance orange, made from Flame Red and Spectrum Yellow, the right + right mix. Put a small amount of this colour into six wells in a palette. Now begin to change five of the colours, leaving one as the basic mix. To Well 1, add a bit more Flame Red; to Well 2 more yellow, either Spectrum or Lemon; to Well 3 add a bit of Alizarin Crimson; to Well 4 a small amount of the complementary, Phthalo Blue, and perhaps some white; and to Well 5 Alizarin Crimson mixed with a lot of Spectrum Yellow. You will have to ensure that all your mixes are at more or less the same consistency, as a wetter colour will force its way to the front; a thicker one will impair flow. Use six different brushes for feeding and be disciplined about their use to avoid changing the colours inadvertently. Use very

small amounts of colour in the pen; overloading it will cause blobs. Every now and then wash the nib out and begin again.

These six mixes will give you a piece of writing that has many more variations on the colour orange through those that mixed in the pen. Choose a text that requires a happy, optimistic or autumnal theme and you will have an attractive piece of work.

The example shown in Figure 4 is part of a first trial for a commission. The words are about shells on the beach, so I wanted colours to reflect the delicacy of shells but that would hold their own on white paper. I used the technique I describe above, beginning with six wells of a pale blue, made from Ultramarine and Zinc White, in this case

changing all the colours with additions, for the most part, of the complementaries.

Backgrounds
There are endless possibilities for background colours, using gouache watered right down, watercolour or acrylic paint and painterly techniques such as wet-on-dry, wet-in-wet, juxtaposing two washes and allowing them to bleed into each other. You can also use pastels to create background colour, and water-soluble colour pencils. This area is beyond the scope of this book and the information appears in many other publications. Suffice it to say that the background should come about as part of your concept and should be used only if it is going to enhance your text and your writing. Don't create a background and then wonder what text to put on to it.

Figure 4

One cannot collect
all the beautiful shells
on the beach.
One can collect only a few
and they are more beautiful
if they are few.

Paper

Contemporary calligraphers write on many different surfaces – vellum, wood, stone and cloth – but the more usual surface is paper.

Papermaking arrived in England in the 1490s, the medium having already been used for 200 years, but imported from the continent.

The best paper is made from cellulose, in the form of cotton linters, which are the short fibres left over after the long fibres have been removed for the textile industry. The traditional source is cotton and linen rags.

There are three different forms of paper: handmade, mouldmade and machine-made. Handmade sheets are formed individually; mouldmade paper is made on a cylinder-mould machine, but with the characteristics of handmade. Machine-made paper is made on a flat bed Fourdrinier machine, allowing large quantities to be made more quickly.

The apparatus for papermaking by hand is called a mould and deckle. The mould is a sturdy frame covered with a fine wire mesh, over the top of which fits a second frame, the deckle, which keeps the pulp in place. This frame causes the pulp to thin towards the edges of the mould, forming a wavy edge to the finished sheet, known as the deckle. The 'vatman' dips the mould into the solution of fibres, the pulp, places the deckle on top and shakes it front to back and left to right, making the fibres settle in four different directions.

The wet sheets of paper are interleaved between felts – 'couched' – and the pile of sheets is pressed, which removes as much water as possible and compacts the fibres. The sheets are then separated and either cylinder-dried or hung to dry naturally before the finishing stages.

There are two types of mould, wove and laid, and the papers that are made in them use the same terms. 'Wove' paper is similar to a woven fabric, with a smooth, even surface. 'Laid' paper has, when held up to the light, semi-translucent parallel lines running from one edge to its opposite, where copper wires in the mould have held less pulp and the paper is thinner.

Surfaces

Paper that has gone through the process described above with no further pressing has the surface texture of the felts. This is 'rough' surface and is not suitable for calligraphy.

'Not' surface is where the paper has had one further pressing. This surface is also called 'cold-pressed'. This is suitable for calligraphy, particularly if you want to use a wash as a background, as the texture of the surface holds the paint well. It will not give absolutely crisp edges to writing but in less formal work this may not matter.

The best surface for formal calligraphy is 'hot-pressed' where the paper has been passed between either heated or highly polished metal rollers to produce a perfectly smooth surface.

Sizes and weights of paper

Traditionally, names such as Royal (20 x 25 in or 51 x 64 cm), Imperial (22 x 30 in or 56 x 76 cm) and Double Elephant (27 x 40 in or 68.8 x 101.6 cm) are used. Some papers are sold on a roll to cater for very large work.

Since metrication, weights of paper are given in grams per square metre, abbreviated to gsm or g/m^2. Paper weight used traditionally to be measured in pounds per ream, where the weight of 500 sheets of paper was given to the individual sheet, and I find many art shops still don't use the metric system so if you ask for a sheet of 190 gsm paper they will ask if you mean 90 lb. The lower the number of gsm, the lighter-weight the paper. Layout paper, for instance, is usually around 50 gsm.

If you are simply writing on paper, the weight should not matter too much, providing it is thick enough to take ink or paint without cockling, especially if the work is to be framed. But if you intend to use a wash as part of the work, you will either have to stretch the paper or choose a heavier weight, at least 300 gsm.

Sizing

Size is a solution used in papermaking to make the paper moisture-resistant in varying degrees. Size can be added at two stages of the making process. Internally sized describes paper which has been sized during the process itself. Surface sized describes paper which after manufacture has been passed through a solution of gelatine or another substance such as glue. Watercolour papers are internally sized and surface or 'tub' sized, producing a 'hard' paper, printmaking papers are only internally sized

so that they are softer. Both of these papers are suitable for calligraphy, but a paper that is not surface sized will often not take kindly to the use of a rubber as this will disturb the surface fibres. Erasing mistakes is difficult on a soft paper.

Grain

You will need to take the grain of paper into consideration depending on the nature of your work.

Handmade paper has no grain as the fibres that have made it have been distributed in four directions. Mouldmade paper does have a grain as, through the method of manufacture, the fibres lie in one direction only. Machine-made paper will have a marked grain. Grain is important if you want to fold the paper, in bookmaking for instance. Paper will only fold successfully with the grain. To find out which direction the grain is in, take a sheet and fold it over short edge to short edge, forming a loose curve, and press lightly down on the curve. The paper will bounce back. Fold it the other way, long edge to long edge, and press down again. The curve with the least resistance is the direction in which the grain lies. If it is difficult to determine the grain from this method, try tearing a small piece in both directions. It will tear more easily with the grain. Failing that, damp a small piece. It will curl up, with the grain running with the curl. Paper that has the grain running from short edge to short edge is known as long grain and from long edge to long edge, short grain.

If you are rolling paper for transport, roll it with the grain and then it will flatten out well before use.

Folding a large sheet of paper can be difficult. Fold over edge to edge and then place a long ruler on the curve and press sharply down. This will start the fold and you can then reinforce it with a bone folder. Protect the fold with a piece of spare paper if it is likely to burnish.

With heavier papers you will need to score first, by running the point of a bone folder down a ruler. Put a long ruler right against the score line, grasp the edge of the sheet and pull up sharply against the ruler. Reinforce the fold with a bone folder as above.

Sandarac

Sandarac is a gum resin which has the property of repelling water-based liquids. It is usually bought from a specialist supplier in lump form and needs to be ground as finely as possible in a pestle and mortar. It is then put into a small piece of muslin (or old tights) and the edges gathered up and tied with cotton.

Use sandarac on any paper that you suspect might be even slightly absorbent, causing the ink or paint to sink into the surface and the edges of your carefully made letter to feather. Dab your little bag of sandarac over the paper and then get rid of all the excess with a brush. I use a small decorator's brush for this. If you don't remove all the excess you will find your ink retracts. Sandarac will show if used on dark-coloured papers and you will also not be able to rub out lines once sandarac has been applied.

Sandarac is absolutely essential if you have made a wash with dilute gouache and want to write on top of this with gouache paint. Without sandarac the top layer of paint will spread and you will have no sharpness. A wash made with acrylic paint or inks will not require sandarac.

Erasing mistakes

Mistakes happen. Don't despair; with care, it is possible to erase and write again. If you realize the mistake as it happens, stop, calm down and let the ink or paint dry. Then take a deep breath and write the correct letter over the wrong one and continue with the rest of the word or sentence. When everything is absolutely dry, you will need to remove the offending bits of the wrong letter that are still on show. I use a small curved scalpel blade for this, a Swan Morton no. 15. Hold the scalpel so that the blade is almost flat to the paper and very gently begin to remove the surface of the paper where the error is by pushing away from you and then pulling back; this pulling-back motion burnishes the fibres of the paper down. Do not allow the blade to cut the paper. The ink or paint will come off as a fine dust which you will need to remove either with a brush or with a very good eraser as you go along. Be patient; it may take you a long time to do this, but it will be less time than it would take to redo the piece of work. The advantage of this is that you don't have to rewrite over disturbed fibres.

If you discover the mistake after the word has been written, the process is exactly the same, removing the wrong letters, but you will need to burnish the surface of the paper once the erasure is complete. Again, I use the small scalpel blade for this, but you could use a bone folder or even a clean fingernail. Dust the area with sandarac to stop feathering and write the correct word using a small amount of pigment in the nib.

On soft papers it is much more difficult to erase, but if your writing is in gouache you may be able to erase by rubbing very gently with a good quality eraser, sharpened to a point. Use sandarac before rewriting.

Handling and storing paper

Paper bruises easily and it needs to be handled carefully. The best way to pick up a piece is to use opposite edges and allow the sheet to curve between them with its own weight. Touch the surface as little as possible; even clean hands have natural grease in them which can transfer to the paper, creating 'grease spots' where the ink or paint will be repelled. Try to store it flat, in a plan chest if you have the space for one, or wrapped in polythene under the bed. If you do have to roll it, it *must* be rolled with the grain otherwise it will never flatten out.

Always buy more paper than you need for a piece of work. Having only one sheet of paper for finished work is a recipe for disaster. Batches of mouldmade and machine-made paper can vary slightly in surface and in colour, so if you are doing a job which requires a lot of paper, calculate what you think you will need and buy some spare.

Availability

Most art shops will sell hot-pressed watercolour paper in individual sheets. The three most readily available are Saunders Waterford, Arches and Fabriano Artistico, all of which come in a weight of around 190 gsm and in the heavier weight of 300 gsm. You will also probably find a coloured paper called Canson Mi-teintes, an Ingres paper made for pastel painting, with a heavily pitted surface on the 'right' side. The 'wrong' side is smoother, perhaps more suitable for writing. Mi-teintes has a wide range of colours.

Ingres is a generic term for coloured pastel paper which is manufactured by several mills such as Fabriano, Zerkall and Canson. It is sold in two weights, 100 gsm and 190 gsm, and usually has a laid surface. Be careful with coloured paper; the dye is not always stable and the colour can fade alarmingly. Test before use by putting a sample on a sunny windowsill with part of it covered. After a couple of weeks remove the cover and see what has happened. If the exposed part has faded, the paper is not suitable for work that is likely to be exposed to strong light.

Handmade paper has no right or wrong side, but mouldmade and machine-made papers do. In the case of hot-pressed watercolour paper it can be quite difficult to detect which side is right or wrong; you will need to examine it in good light. In Saunders and Fabriano the watermark will help you; if you can read it, that is the right side. Confusingly, Arches Aquarelle, a high quality French paper, is the other way round: the right side of the paper is that on which the watermark is back to front. If you are folding pages for a multi-section book, you will need to fold the folios alternate ways, sitting one with the right side on the *outside* in one with the right side on the *inside*, so that when a double spread is open both pages are the same.

For writing a one-off piece, choose the side of the paper you prefer.

Handmade paper has four deckle edges, mouldmade paper has two deckle and two cut edges and machine-made paper has four cut edges. If you want the deckles on work, you can create a false deckle by tearing the paper against a ruler. Place a heavy ruler on your sheet where you want the edge, press down hard on it with one hand, grasp the corner of the paper with the other and pull up sharply and firmly. Tearing paper like this will produce a straight edge where the edge of the ruler has been and a feathered edge beyond that. The other side will not have the mark of the ruler, so tear with the wrong side towards you.

You can create a more realistic deckle by folding the paper where you want the edge, burnishing it down very well with a bone folder and then saturating the paper along the fold with a clean paint brush and clean water. Give the water time to soak in thoroughly, reapply if necessary and then ease the paper apart at the fold using gentle pressure with both hands.

Paper is personal; it depends on the type of writing you do, your touch and the tools you prefer. But do experiment. If you are not doing absolutely formal work there is a wonderful range to choose from, including papers from India that have 'inclusions', pieces of bark or straw or fibres of wool or even flower petals, which are surprisingly pleasant to write on, and some beautiful coloured papers from Nepal.

Paper is not cheap, but it is such an important part of the work of the calligrapher that paying for and working on good paper will add greatly to the quality of what you do.

Gallery

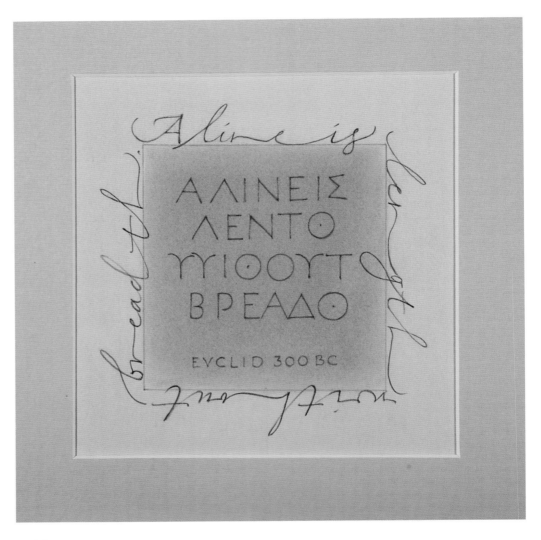

Jan Jeffreys
A Line Is Length Without Breadth

Graphite pencil and soft pastel on BFK Rives paper
14.5 cm x 14 cm

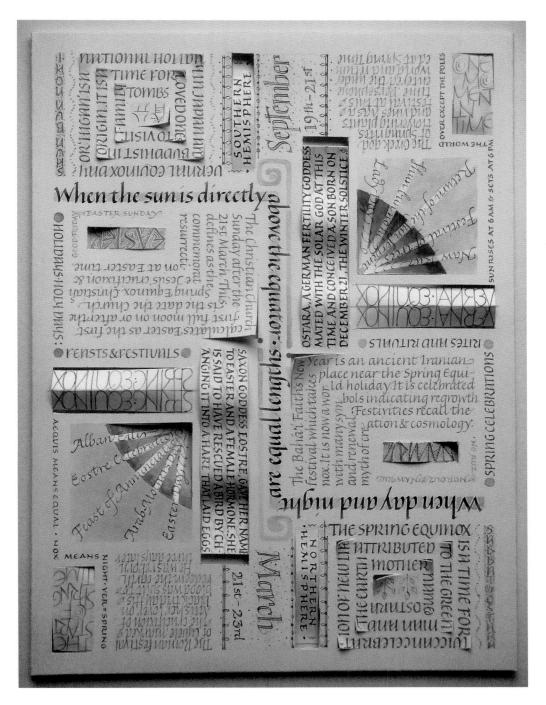

Cherrell Avery
Spring Equinox

Mitchell nibs, watercolour and gouache paint on Fabriano Artistico paper
43 cm x 34 cm

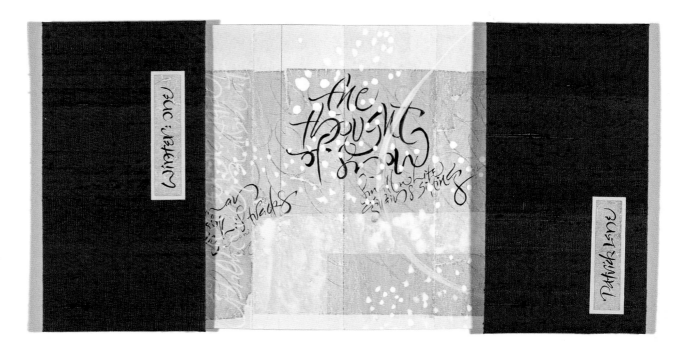

Susie Leiper
Winter One
(Text by Patrick Lane)

Chinese-style concertina book. Brush, pencil, ink and Plaka
on Chinese metallic papers, covers of raw silk

Closed 9.5 cm x 19 cm, open 19 x 40 cm

Winter One detail

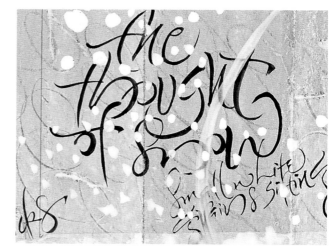

Christopher Haanes
Shatter Me Music
(Text by Rainer Maria Rilke)

Pointed pen, Chinese ink on
Zerkall paper
Width approx. 19 cm

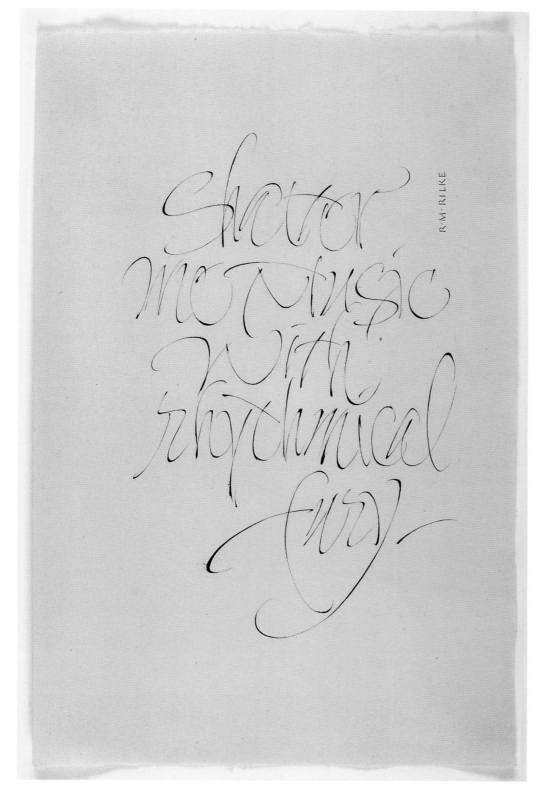

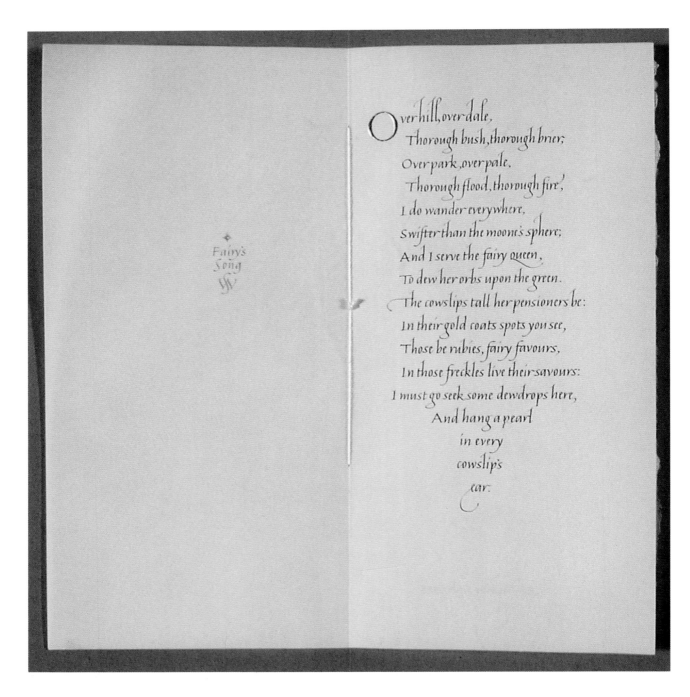

Joan Pilsbury
Shakespeare's Fairy Song

Double opening on vellum. Chinese stick ink, colour and gold leaf on gesso
24.7 cm x 25.3 cm

Reproduced by kind permission of the syndics of the Fitzwilliam Museum.
From the Fitzwilliam Collection of Contemporary Calligraphy.

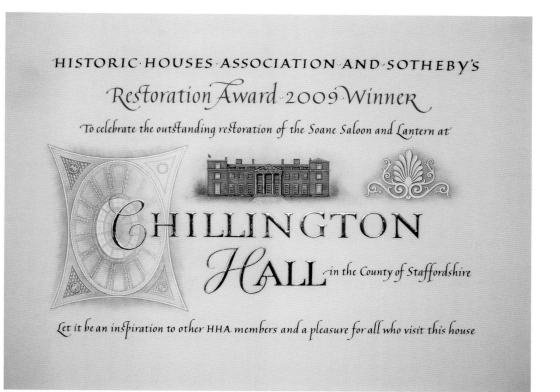

HISTORIC·HOUSES·ASSOCIATION·AND·SOTHEBY'S

Restoration Award 2009 Winner

To celebrate the outstanding restoration of the Soane Saloon and Lantern at

CHILLINGTON HALL *in the County of Staffordshire*

Let it be an inspiration to other HHA members and a pleasure for all who visit this house

Tim Noad
Chillington Hall

Panel of stretched vellum.
Chinese ink, gouache and raised
gold leaf on gesso
51 cm x 38 cm

A presentation awarded to the
historic house which had been
judged to have completed the
most outstanding restoration
project of 2009. The styles of
script were chosen to reflect the
neo-classical architecture of Sir
John Soane.

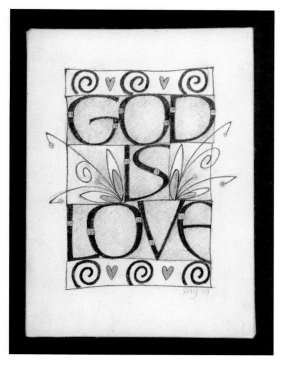

Sally-Mae Joseph
God is Love

Pencil and shell gold on Khadi paper
wrapped round board
14 cm x 10 cm

AND THE COVENANT
NOW MADE ON EARTH
LET IT BE RATIFIED
IN HEAVEN ⊕ AMEN

Sue Hufton
Covenant

(Words from the Methodist Covenant Service)

Letters painted with a pointed brush on Ingres paper
15 cm x 25 cm

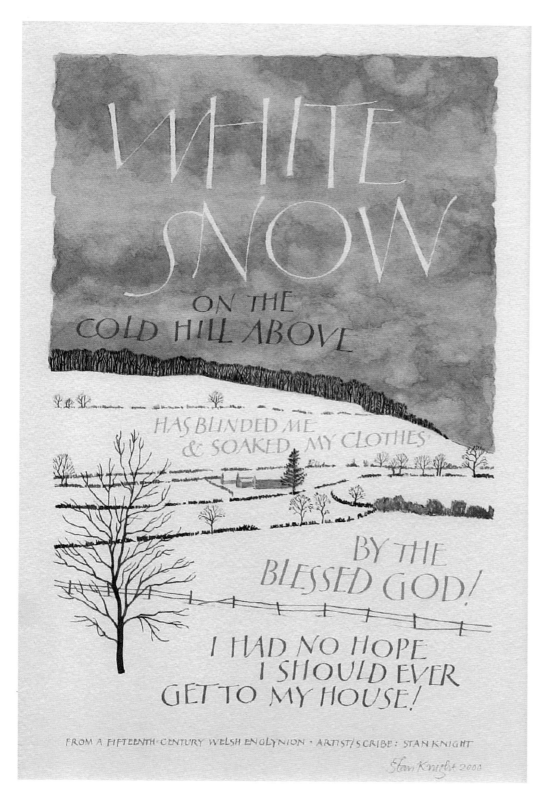

Stan Knight
White Snow

Resist, Mitchell nibs,
watercolour on Arches
Aquarelle Not paper
31.5 cm x 20.2 cm

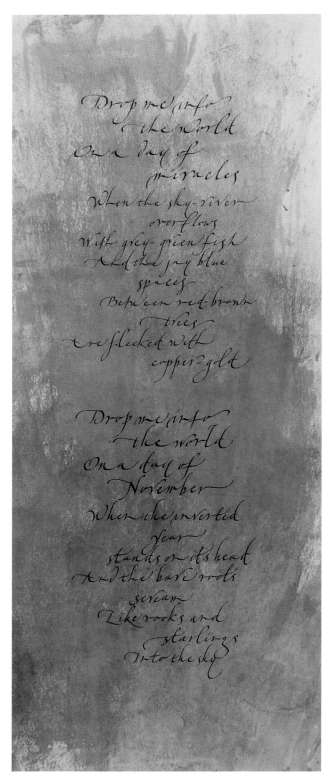

Gaynor Goffe
Poem by Liz Davies

Ink on acrylic background.
Hot-pressed paper
90 cm x 36 cm

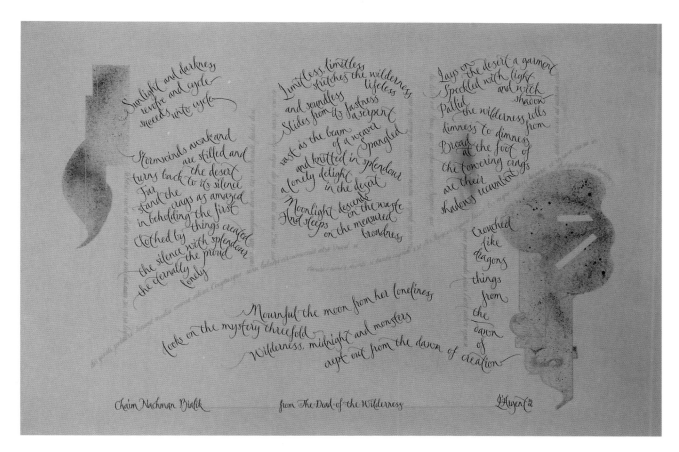

Mark L'Argent
From *The Dead of the Wilderness*

(Text by Chaim Nachman Bialik)
Pointed pen, gouache and gold powder
61 cm x 82.5 cm

PART-TIME DAD

Like summer rain,
Or glimpses from a train:
My son appears and disappears.

Heleen Franken-Gill
Haiku
(Text by Norman Cho)

Metal nibs, Chinese ink and gouache on paper
13.5 cm x 36 cm

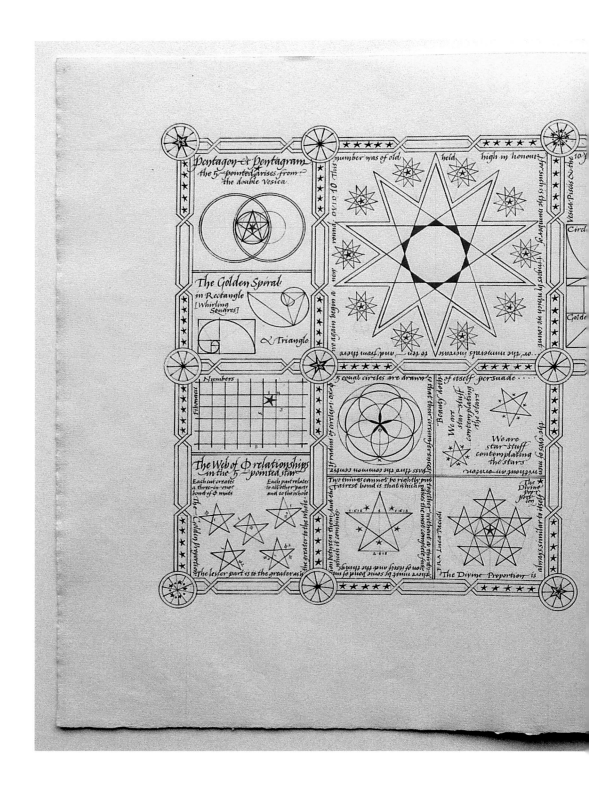

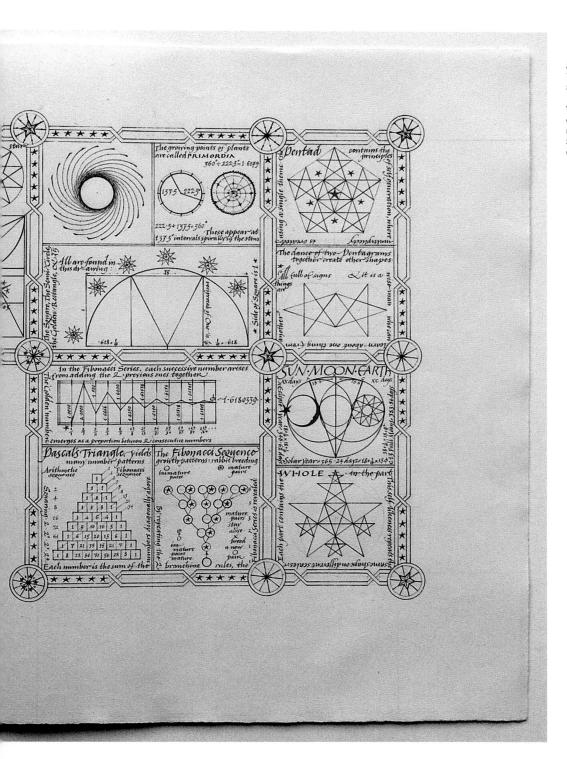

Ann Hechle
The Golden Proportion, from the journal Figures of Speech

Watercolour and steel nibs on cream coloured hand-made paper (F.J. Head)
36 cm x 58.6 cm open (a Golden rectangle)

Gillian Hazeldine
Christmas Card
Original artwork, metal nib on paper.
Reversed black to white. Digitally printed in red on card
13 cm x 5 cm

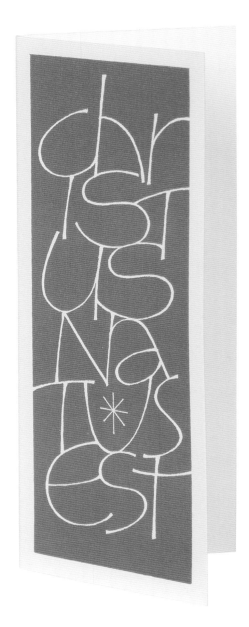

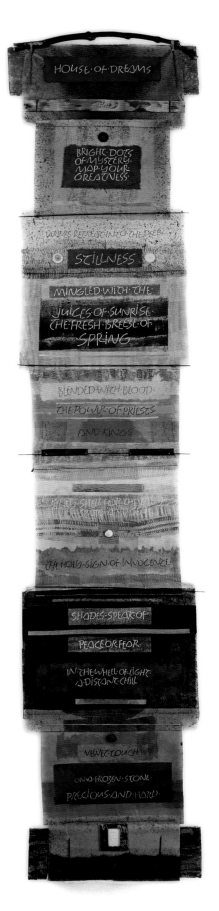

Opposite:
Rosella Garavaglia
House of Dreams
(Text by Rosella Garavaglia)

Collage of various tissue papers. Brush-written text.
Handmade silk threads, copper rods, twigs, beads, buttons and copper sheets
165 cm x 32 cm
Below:
House of Dreams detail

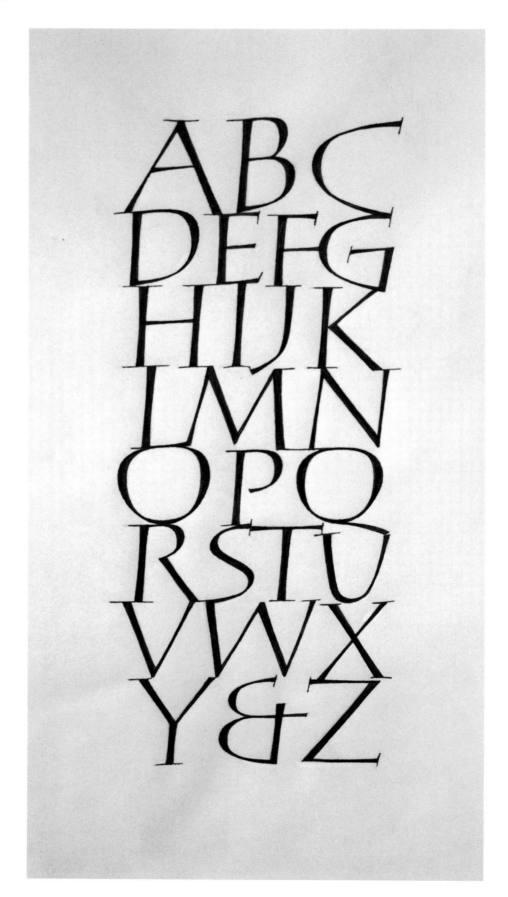

Tom Perkins
Alphabet

Drawn and built-up
letters on paper
29 cm x 15.4 cm

DET MOSAISKE TROSSAMFUND·OSLO·
& DET MOSAISKE TROSSAMFUND·TRONDHEIM
VIL MED DETTE DIPLOM ÆRE

·ROBERT·KATZ

Gjennom det norske Stortings beslutning av 11. mars 1999 om
«det historiske og moralske oppgjør med behandlingen i Norge av
den økonomiske likvidasjon av den jødiske minoritet under den 2.verdens-
krig» fikk jødene i Norge sin rettmessige oppreisning og plass i nasjonens
historie, 54 år etter Holocaust. Robert Katz har med sin helt
spesielle innsats, rettferdighetssans og sitt mot gjort dette mulig, og
ved det bidratt til å sikre fortsatt jødisk liv i Norge.

OSLO DESEMBER 2000 · KISLEV 5761

Christopher Haanes
Diploma made for the Norwegian mosaic Community

Brause nibs, Chinese ink, gouache, Barcham Green Handmade paper
Width approx. 45 cm

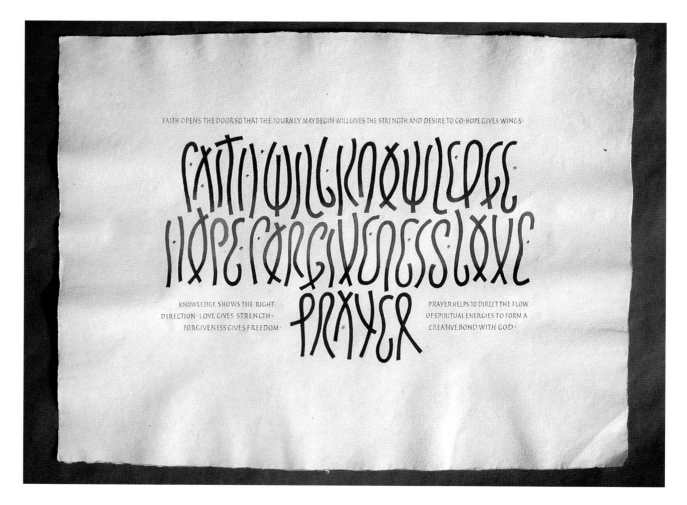

Veiko Kespersaks
Faith Will Knowledge

Metal nib, brush, gouache and artificial
gold on Indian hand-made paper
45 cm x 57 cm

Alexandra Spencer
Birthday Card

Embellished felt, coloured threads, beads, gouache
17 cm x 13 cm

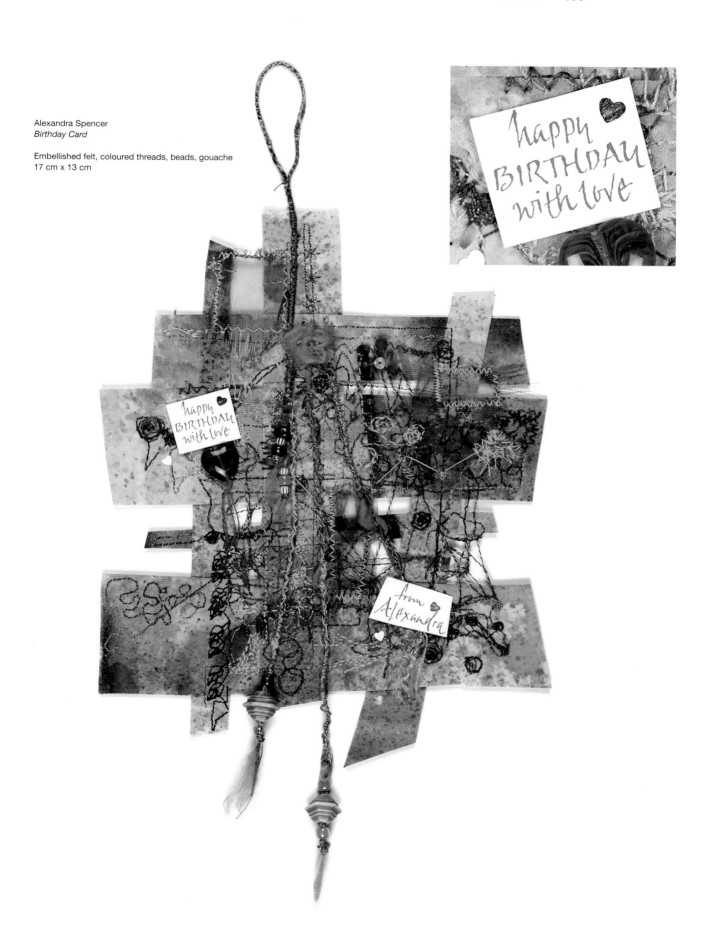

Bibliography

The history of writing

Alexander, J.J.G., *The Decorated Letter* (Thames & Hudson, 1978)

Backhouse, Janet, *The Lindisfarne Gospels* (Phaidon, 1987)

Backhouse, Janet, *The Illuminated Manuscript* (Phaidon, 1998)

Brown, Michelle, *The Lindisfarne Gospels, Society Spirituality and the Scribe* (British Library, 2003)

Catich, Edward M., *The Origin of the Serif* (Catich Gallery, 1991)

Child, Heather (ed.), *Calligraphy Today* (A&C Black, 1988)

Degering Hermann, *Lettering* (Pentalic, 1965)

De Hamel, Christopher, *A History of Illuminated Manuscripts* (Phaidon, 1997)

De Hamel, Christopher, *The Book. A History of the Bible* (Phaidon, 2001)

Gray, Nicolete, *A History of Lettering* (Phaidon, 1986)

Jackson, Donald, *The Story of Writing* (Taplinger, 1981)

Knight, Stan, *Historical Scripts* (Oak Knoll Press, 2009)

Knight, Stan and Woodcock, John, *A Book of Formal Scripts* (A&C Black, 1992)

Osley, A.S., *Scribes and Sources* (Faber and Faber, 1980)

Whalley, Joyce Irene, *The Art of Calligraphy, Western Europe and America* (Bloomsbury Books, 1980)

Manuals/books for stimulus

Burgert, Hans Joachim, translated by Brody Neuenschwander, *The Calligraphic Line* (Burgert Handpresse, Berlin, 2002)

Child, Heather (ed.), *The Calligrapher's Handbook* (A&C Black, 1986)

Child, Heather, Collins, Heather, Hechle, Ann and Jackson, Donald, *More than Fine Writing: Irene Wellington, Calligrapher (1904–84)* (Pelham Books, 1986)

Fink, Joanne and Kastin, Judy, *Lettering Arts* (PBC International, New York, 1993)

Gray, Nicolete, *Lettering as Drawing* (Taplinger, New York, 1982)

Haines, Susanne, *The Calligrapher's Project Book* (HarperCollins, 1994)

Hufton, Susan, *Step by Step Calligraphy* (Phoenix Illustrated, 1997)

Johnston, Edward, *Writing &Illuminating & Lettering* (A&C Black, 1980)

Johnston, Edward, *Formal Penmanship and Other Papers* (Lund Humphries, 1980)

Books on special subjects

Angel, Marie, *Painting for Calligraphers* (Pelham Books, 1985)

Itten, Johannes, *The Elements of Colour* (John Wiley & Sons, 1970)

Noad, Timothy and Seligman, Patricia, *The Art of Illuminated Letters* (Quarto, 1994)

Perkins, Tom, *The Art of Letter Cutting in Stone* (The Crowood Press, 2007)

Reaves, Marilyn and Schulte, Eliza, *Brush Lettering* (Design Books, 1994)

Webberley, Marilyn and Forsyth, JoAn, *Books, Boxes & Wraps* (Bifocal Publishing, Kirkland, Washington, 1998)

Societies

The Society of Scribes & Illuminators,
 6 Queen Square, London WC1N 3AT
Website: www.calligraphyonline.org
Letter Exchange, c/o Michael Rust, Hon.
 Secretary, Sycamore Cottage, Tamley Lane,
 Hastingleigh, Ashford, Kent TN25 5HW
Website: www.letterexchange.org
Calligraphy and Lettering Arts Society,
 54 Boileau Road, London SW13 9BL
Website: www.clas.co.uk

Index